BLOCK WONDERS

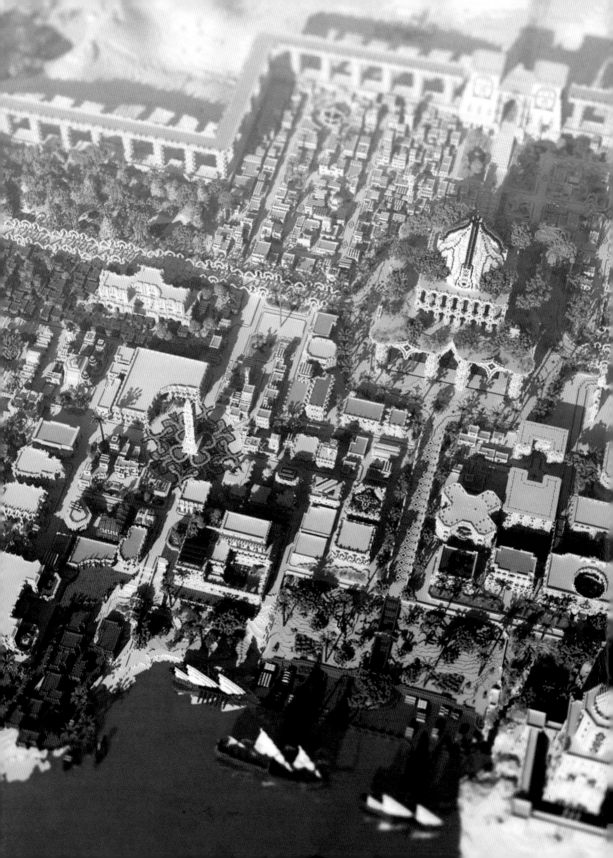

BLOCK WONDERS
HOW TO BUILD SUPER STRUCTURES IN
MINECRAFT®

KIRSTEN KEARNEY

ABRAMS, NEW YORK

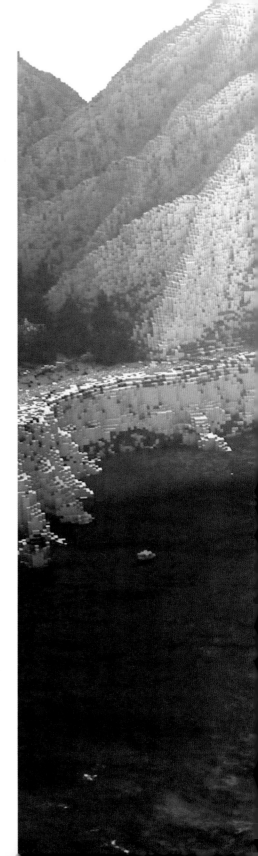

Minecraft® is a trademark of Mojang, who
do not sponsor, authorize, or endorse this book.
Minecraft®/TM & © 2009-2013 Mojang / Notch

Block Wonders: How to Build Super
Structures in Minecraft®

Library of Congress Control Number: 2015946913

ISBN: 978-1-4197-2016-1

Copyright © 2016 Quintet Publishing Ltd

This book was conceived, designed, and produced by
Quintet Publishing Limited
4th Floor, Sheridan House
114–116 Western Road
Hove BN3 1DD
United Kingdom

Front cover images, clockwise from top: Space
Shuttle, Felix Kristinä; Tank Cathedral, Pacôme
Pretet; Tamashi Kyaria, BlockWorks.

Back cover images, clockwise from top:
Hungarian Parliament, Christian Uhl; La Momie,
Rastammole; Animals, Ricard Michel.

Printed and bound in China
10 9 8 7 6 5 4 3 2 1

Abrams books are available at special discounts when
purchased in quantity for premiums and promotions as
well as fundraising or educational use. Special editions
can also be created to specification. For details, contact
specialsales@abramsbooks.com or the address below.

ABRAMS
THE ART OF BOOKS SINCE 1949

115 West 18th Street
New York, NY 10011
www.abramsbooks.com

CONTENTS

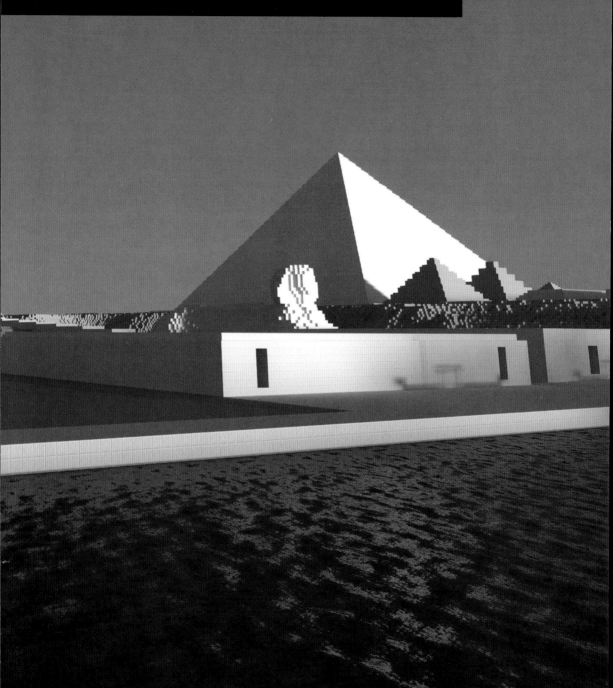

WELCOME TO BLOCK WONDERS

I remember visiting the Great Pyramids in Egypt, and, like so many others who've made the pilgrimage before me, mentally grappling with their size, the incredible time put into building them, and the feat of engineering required to bring them to fruition. What sense of achievement must the builders have felt? The hardest thing to grasp is the passage of time since their completion, and how they've weathered everything the world has thrown at them.

I took a walk over to the Great Sphinx of Giza. There's something about a structure with a face that helps you make sense of its place in the world. As I looked up at the huge, serene visage, it looked back at me and all the other little people milling around below. I had a momentary vision from the point of view of the Sphinx, watching on, as millennia upon millennia of civilizations passed before it, while it remained still and solid, never changing.

Block Wonders explores great edifices and superstructures, visits architectural and natural wonders of the world, and delves into the sandcastles of the mind, created by the greatest builders in Minecraft®. I had many assumptions about the motivations of each builder for why they chose to make the structures they created. "They must be really into sport," I thought. "This guy must be obsessed with technology. I bet this team specializes in organic structures." I was rarely correct. Often the reason was simplest of all: "Why did you build it?" "Because I could." It's the same reason why we all take on the challenge of building wonders—because we can.

To me, the wonders in this book represent endeavor. Many of the structures show humanity's search for spiritual enlightenment in the holy sanctums and tombs built centuries ago. Others show the rise of civilization, with edifices dedicated to knowledge and governing. More still show our desire to explore with ways and means to expand our horizons. Some of my favorites are the ones that reach for the impossible: imaginary worlds and ideas brought to life. It's just a simple building-block game, but within Minecraft, everything we are, and everything we want, is made and remade, forged and sculpted, by people from every walk of life.

Having spoken to Minecrafters from all over the world, I've heard so many different points of view on the game and why it is so special. And how it engenders such loyalty firing the imagination of players in a way no other game manages. One comment that really sums it up came from James, the manager of professional build team BlockWorks—he noted that Minecraft has always inspired players, and will continue to do so, because it has created a starting point but no end. Along with the game, I hope this book creates a starting point for you. Welcome to *Block Wonders*.

— Kirsten Kearney

THE PHYSICS OF MINECRAFT®

Minecraft may be a simple block building game, but its physics, or lack of them, provides a clever set of rules and logic of its own, which makes building fun and intuitive. Simply put, if you build three blocks high and then knock out the lowest block, the ones above will not fall. Instead, they will stay in their position. You can pass under floating blocks and stand on top of them, and they won't be affected by weight. This simple rule, applied to most of the blocks in-game, provides a way of building that is fast and allows for processes that anyone can easily master. A good example of this is creating a solid wall and then punching out blocks for entranceways and windows. Even though building in the real world—with bricks and mortar, or even toy blocks—doesn't work like this, in the digital world it makes perfect sense.

There are a number of exceptions to this lack of physics in Minecraft. The few blocks that do have rules attached to them bring with them opportunities to add movement and interaction with what would otherwise be a lifeless model. As beautiful as a perfectly sculpted object is, almost all builders like to add dynamic entities to their structures. One of the most common is fire. Torches offer a simple light source and fluids like water and lava can be directed to flow in certain ways—all lending a natural sense to builds.

Stairs are one of the most common building blocks. They can be merged at right angles to create transitions in builds that can't quite be achieved with normal blocks. Gravel and sand offer the more traditional physical element of having weight. They will not float when dug out from underneath like other blocks do.

There are many other blocks with complex properties that can be used in infinitely imaginative ways, such as TNT explosive blocks and pressure pads, but probably the most interesting is redstone. Redstone is a signal block. It transmits power through redstone circuits like an electrical signal, traveling through these circuits to power objects. This means contraptions made in the game can work like machines.

While new objects, tools, and mods have become available over the years, changing Minecraft little by little, the fundamental physics remain the same, and, with just a few simple guidelines, almost anything can be created without the player or the build being overwhelmed by contradicting rules.

WHO MADE MINECRAFT?

At just 36 years old, Swedish game developer Markus Persson is a billionaire. He began creating one of the most successful games in history just six years ago, and his life has since changed beyond all recognition. It's little wonder he has all but retreated from the public eye and vowed to never make a successful game again!

Markus began programming as a child on his father's Commodore 128, creating his first simple text adventure by the age of eight. Although he became a great supporter of independent developers, he initially worked for four years for the highly successful games company King, who make popular titles such as Candy Crush Saga and Bubble Witch Saga. Once he struck out on his own and formed Mojang, along with his developer friend, Jakob Porsér and former boss Carl Manneh, his more outgoing alter ego, Notch, took over. Notch became known around the world, not just for his game, but also for his opinions and support of the independent game scene.

Behind the scenes, the real Markus Persson had difficulties in his personal life, and the pressure of Minecraft's success and the attention he—or at least his online persona, Notch—was getting overwhelming. He stepped down from developing for the game.

The new lead designer, Jens Bergensten, took over in 2011. Like Markus, he's 36 and from Sweden. He joined Mojang to work on their game Scrolls, but quickly became more and more involved with programming for Minecraft.

Markus, along with Jakob Porsér and Carl Manneh, left Mojang in 2014. Markus now lives in California. He formed a company called Rubberbrain with Jakob Porsér, just in case they have another great idea for a game, but right now he's spending much of his time enjoying his freedom. Minecraft continues to evolve under the steady hand of Jens Bergensten.

MINECON

As the popularity of Minecraft® grew, and the global community of fans became more established, it seemed inevitable that they would end up organizing international events around the game. The first gathering was called MinecraftCon and was held in 2010 in Washington State in the U.S. It was organized by Markus Persson.

The following year, in Las Vegas, 200 people gathered for the first official MineCon, celebrating the release of the game and hosting talks, building contests, cosplay competitions, and a party.

The first European MineCon was held in 2012 at Disneyland Paris. It marked an evolution of the event, which became much bigger, with 4,500 fans attending. The convention was used to announce new additions to the game. The following year, in 2013, the convention yet

again leapt in size, to 7,500 attendees. Tickets had to be sold in batches, with the first batch selling out in seconds. This time, MineCon was back in the United States, taking place in Orlando, Florida.

After skipping a year, the 2015 MineCon was held in London. More than 10,000 gamers attended, setting a Guinness World Record for the largest convention for a single video game. Video game conventions are not a new thing by any means, and many attract tens of thousands of visitors, but for a single game to have so many flocking to meet designers and YouTubers, and take part in competitions and team-building events, shows that the enthusiasm of the community is still growing.

At every MineCon, attendees are given an exclusive in-game cape for their character to wear, to prove to the Minecraft world that they were there!

TEXTURE AND RESOURCE PACKS

The simple block building concept in Minecraft® isn't the only reason that it has become such a popular game and built up a huge worldwide community. Not only can you create what you want within the game, you can also alter the gameplay mechanics, items available to use, and how the game actually looks while you play it, on the most fundamental level.

Texture packs are a type of game modification made by some players, and downloaded by others, to change how every surface in the game appears. Texture packs were replaced by resource packs in the 1.6.1 update in the summer of 2013. This meant other modifications could be bundled with new texture files, such as sound mods and font mods.

Different texture packs offer entirely different looks for the game and for any map you view in-game. You can download packs that make the game cartoon-like in appearance, such as Sphax PureBDcraft. A pack like Equanimity 3D Models creates a rounded, less blocky look. S&K Photo Realism creates high-definition detailed textures, which may make your build look fabulous but will likely push your computer to the point of slowing down everything on screen. Of course, that's not so important if you're looking to take screenshots of your finished work. John Smith Legacy is one of the most popular and well-known packs and gives your game a traditional medieval role-player appearance. Anyone can make a texture pack with a little knowledge, and you can get some really unusual ones too. One of the weirdest has to be the Nicolas Cage pack, which gives all the mobs in the game the face of the Hollywood actor!

Sphax PureBDcraft pack.

S&K Photo Realism pack.

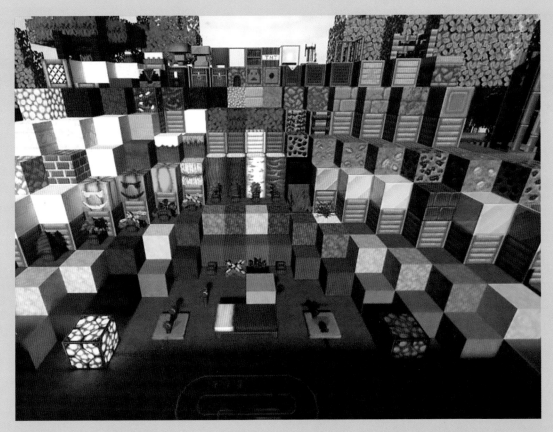

Equanimity pack.

Nicolas Cage pack.

John Smith Legacy pack.

SKINS

Although Minecraft® is played from a first-person viewpoint, you do have a blocky character that you play as. Everyone starts out with a default skin—the texture and colors that cover your body and give you your look. The skin in the PC version of the game is known as "Steve." If you play Minecraft on a console, you can choose between 16 default skins, although half of them are based on Steve, and the other half on a slightly different design, known as "Alex." The different designs change their outfits and skin color. If you play the Pocket Edition, you can choose between Steve and Alex.

The real fun begins when you either download a new skin designed by another player or create your own skin. For the console and pocket editions, you can download skin packs with a number of designs. On a PC you can manually edit your Steve skin, using an image editor like Photoshop, and change the color and pattern on every surface of the character. There are also programs online, such as Skincraft, that you can use to edit your character.

There is an incredible array of skin designs created by Minecrafters and available online to download. Just as there are builders who create beautiful structures in the game, there are players who specialize in creating skins and have made an art out of it. Just about any design you can think of is available somewhere, perfectly picked out pixel by pixel to create a funny little blocky version of it for Minecraft. Making these designs instantly recognizable with such a basic character shape and tiny pattern layout is a kind of alchemy some players have mastered. You can be Santa, a penguin, or Notch himself. If you really want to be unusual, you can wear a skin that blends in with the environment, become the ancient entity Cthulhu, or even be a pencil!

steve pattern

Over World

Owls

Sak_Kraft

Notch

glowing skeleton

pencil

Santa

anonymous

cthulhu

Penguin

LouizZ

Patrix

oakley

lewismarkey

Corpeh

Danny

Lmdohar

cjrainbolt

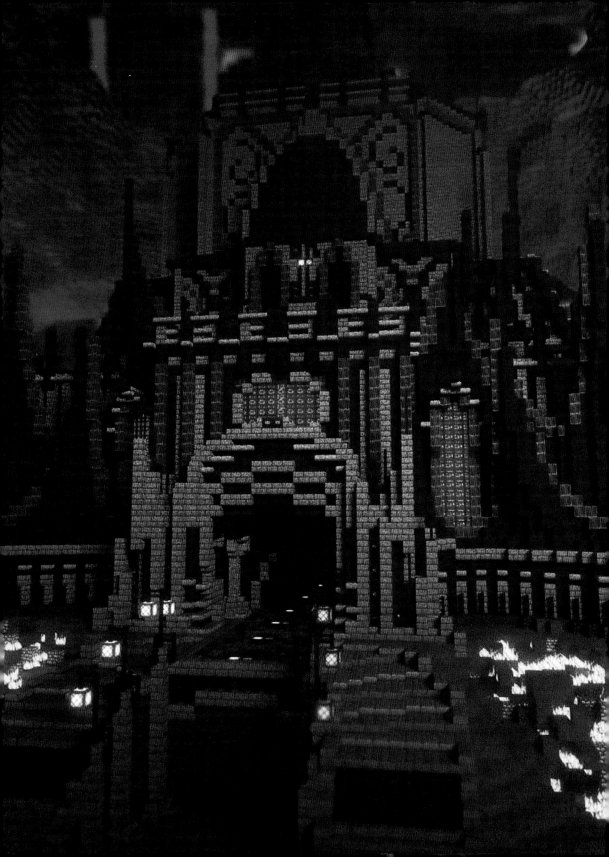

INTERVIEW: HYPIXEL ADVENTURE MAPS TEAM

WHAT EXACTLY IS HYPIXEL, IN A NUTSHELL?

Hypixel is a community of content creators and fans who use their collective talents to produce the best adventure maps and mini-game server experiences in the world. For many, the game is all about building and creating structures, but the survival and adventure elements are hugely popular too.

WHY DO YOU THINK PLAYERS ENJOY THIS ELEMENT IN MINECRAFT®, RATHER THAN IN MORE TRADITIONAL GAMES?

For the same reason that role-playing games like Skyrim are popular. Your own choices affect the story. Survival mode is a story where you write your own narrative. Adventure maps are stories where you follow your own path around a world someone has created for you to journey through.

WHAT SORT OF SKILLS DOES YOUR TEAM BRING TO CREATING MAPS FOR PLAYERS? IS IT HARD TO KEEP EVERYONE WORKING TO THE SAME PLAN, WITH THE MEMBERS LIVING ALL OVER THE WORLD?

The Internet is a great tool for organization. Using online project-management apps and shared-document programs helps provide a bridge between worlds, as far as passing along tasks and information goes. Every once in a while though, someone has to sacrifice their sleep schedule to catch up directly with other members of the team!

CAN YOU TELL ME ABOUT A FEW OF YOUR MOST POPULAR GAMES?

One popular game is Build Battle, which uses the classic creative mode competitively. It allows you to compete against friends or strangers in a battle of who can make the best build in limited time, based on a theme. It provides an opportunity for people of different building skill levels to compete, since it's not often the most attractive build that wins but the most creative!

Another favorite is Turbo Kart Racers, a retro-styled racing game which draws inspiration from many of our childhood favorites. In it, you will race against 11 others in a variety of purpose-built maps to determine who is the fastest and to win parts to upgrade your racer.

WHAT'S THE HARDEST THING ABOUT CREATING ADVENTURE MAPS?

The hardest part of creating an adventure map is time. Herobrine's Origin—the third and last of our Herobrine series—will possibly be the largest adventure map ever attempted in Minecraft and has been in progress across several Minecraft versions for over a year.

HOW CAN SOMEONE IMPROVE THEIR ADVENTURE MAP-MAKING ABILITIES? WHAT ARE YOUR TOP TIPS?

Work with others. It might seem appealing to get all the credit for doing a huge project on your own, but you won't enjoy it as much, and you will be missing out on the friendships that form when completing such a large project with people, as well as the skills those people will bring.

Watch YouTube videos. "SethBling" has so many redstone videos that if you're stuck with something, it's probably on his channel, and that's just one guy. There are so many awesome Minecraft YouTubers who work with redstone, such as "Aypierre" and "MinecraftZephirr," to name two!

Don't start with a giant project. If things don't go how you want them to and you're still learning, you'll have lost months of time rather than weeks, and that isn't very motivating. Start with small, fun concepts and build up your skills, and your team, over time.

IF SOMEONE WANTED TO JOIN YOUR TEAM, WHAT SKILLS WOULD THEY NEED TO DEVELOP?

The key thing is just to get used to delivering projects in a completed format. All too often, people go into the project with the best of intentions and ambitions, only to lose motivation halfway through. At Hypixel, we focus on making sure that we finish what we set out to do, and anyone who joins needs to have a provable history of doing that as well.

HOW CAN GAMERS PLAY ON YOUR SERVER?

You can join by using mc.hypixel.net in your server list. We always aim to support the latest Minecraft version, but if you have any issues connecting, you should check our forums over at http://hypixel.net.

Redstone block.

Redstone lamp.

Depending on what you want to build in Minecraft®, you'll have to consider which materials will be useful. Although at the most fundamental level you can just build block upon block to create the structure you want, in order to hone your skills and produce the sort of wonders you see in this book, you'll want to know about the different properties blocks have and learn how to make the best use of them. There are many different properties and a lot of technical details you can learn to help you, but here are just a few simple pointers to get you started.

COLOR

Consider the color of materials when creating your structure. Not only are you making an object, you are also carving a visual sculpture. Where blocks can often be a little unforgiving and unwieldy in their shape, color gradations and shading can help to give roundness and angles to an otherwise blocky shape. Decide on a palette too. Like a painter, sculptor, or architect does, picking a style will give your build cohesion. Random colors all over your building or structure will be hard for the eye to make sense of.

TEXTURES

Textures play an important role in the game too. While the default textures in Minecraft® aren't particularly varied, you can download packs that offer alternative looks. Choose which pack to apply wisely. Using a pack designed to accentuate the texture of wood will reap benefits in a medieval village, while other packs will feature stone and glass textures—ideal for a modern home build.

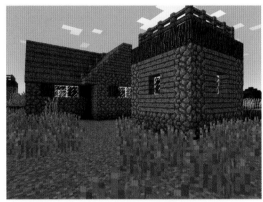

The default textures in Minecraft.

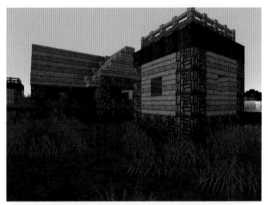

Flows HD pack textures.

Jolicraft pack textures.

PROPERTIES

Not all blocks have the same properties. Sand and gravel blocks, for example, have weight and will fall if not supported, while most other blocks will stay suspended in the air after a block below is removed. One of the most interesting block properties is that of redstone. Redstone can transmit power. This means that it can be used in circuits to operate mechanism components like doors, pistons, and lamps and activated using buttons and levers. Redstone dust can be used to create wires and repeaters, used to strengthen a weakening signal that results from increased distance of wires. Although simpler than creating electric circuits in the real world, using redstone to make mechanisms takes a little time to get the hang of. The results can be spectacular though, as you can create moving robots, computers, and even musical instruments.

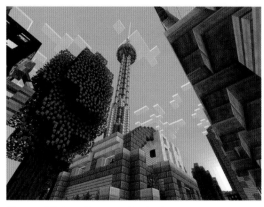

Minecraft® has its own physics!

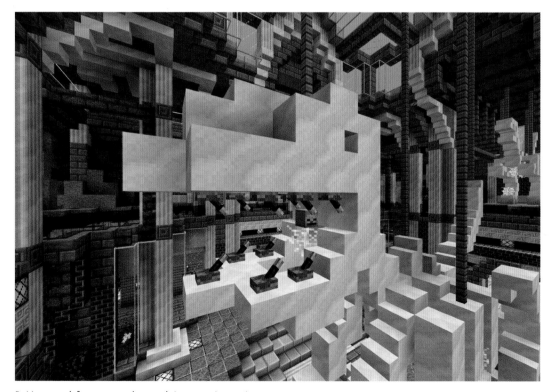

Buttons and levers can be used to operate systems.

BUILDING TIPS

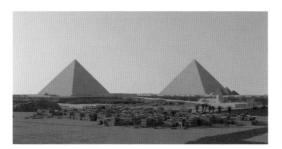

LOCATION

Use the right location for your structure. While a pyramid looks great in the desert, a cathedral doesn't!

BEAUTY ON THE INSIDE

If your structure has an interior, make sure you line the inside walls with a material that suits your inner rooms, rather than using stone walls on a room that wouldn't normally have them.

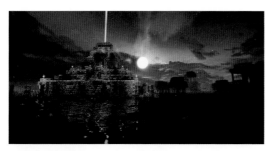

SEEING THE LIGHT

Lighting your structure can add drama and even help alter the appearance of its shape. Lights aren't just for interiors. You can use them on the outside to highlight areas.

THE DEVIL IN THE DETAILS

Details are important. A house doesn't just have a roof, a door, and windows. It has a chimney, vents, bins, and a doormat. It's the little things that bring it to life.

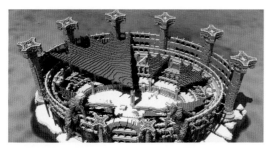

ROUND AND ROUND

Practice making circles and curves. Learning to make round things out of blocks opens up a whole new world of possibilities.

LAY OF THE LAND

You don't have to use the natural formation of the land. You can terraform using a tool like VoxelSniper to create mountains and valleys to your liking.

BUILDING TIPS

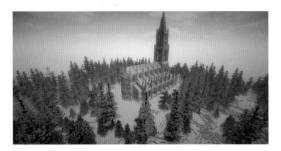

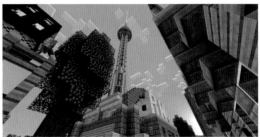

DO IT YOURSELF

There are many items you can make, such as chairs and beds, that don't work that well. The default trees are likewise not particularly realistic looking. It is often better to create your own to get a more detailed shape and better scale with your build.

HEAD FOR HEIGHTS

It's easy to lose your sense of proportion when building a tall structure like a skyscraper or tower. Have a sensible number of floors and a height that works with the width of your structure and fits in with its surroundings.

TOOLS OF THE TRADE

Using tools for building is not cheating! Unless you're challenging yourself to make everything in your wonder brick by brick, you can have a lot of fun using tools like WorldEdit to speed up your build by copying and pasting elements.

BREAK THE RULES

There are no rules. If you want to mix up your colors, not use lighting, and put your building in a weird environment, go right ahead—it's your build, and Minecraft® is your game!

COMMUNITY PROJECTS

It's easy to think of Minecraft® as just a game, even if it is a game that allows you to do what you want and has a massive global community of fans. That success though, and the power it gives people to wield a simplistic 3-D modeling tool, has been turned by some into a force for good. It has also inspired members of the community to challenge one another to produce builds based around different themes or restrictions and really stretch players' skills and imaginations.

One of the most ambitious projects has been the re-creation of Denmark—an initiative by the Danish government to use the game as an educational tool, allowing people to visit some of the more remote and hard-to-reach places in the country in a virtual way.

In Australia, school children have been encouraged to design a national park, with the potential for their ideas to be incorporated in parks in Adelaide. This project is an example of one of the most interesting potential uses for Minecraft, which is the application of in-game ideas into a real-world environment. The game offers a cheap and accessible way to visualize huge real-world design issues, and crosses the boundaries of age, ability, and experience. Many people have ideas but no means to express them because of their age, location, or access to funding and communication. With Minecraft, those ideas need no longer be lost.

The Guardian Media Group asked build team BlockWorks to create a modern vision of urban living in a clean and sustainable city. The most interesting element was the in-game use of existing green and prototype technologies, which were actually achievable if applied to the real world. Climate Hope City included the biodome design for Amazon's new Seattle headquarters, multistory farms, hydrogen-powered boats, driverless cars, and kinetic pavements, that convert footsteps into electricity.

Many other large community projects focus on the art of the game, bringing people together who appreciate the aesthetic possibilities. The Tate Gallery worked with Minecrafters on the Tate Worlds project to interpret and re-create some of the gallery's works of art, including Christopher Nevinson's *The Soul of the Soulless City* and Peter Blake's *The Toy Shop*.

It's not just when commissioned by outside sources that the Minecraft community members are inspired to work together. Often teams challenge each other on a theme, giving both established builders and new talent the chance to test their skills. The Deep Academy Organic Challenge tasked builders with creating organics to fit in with a specific map created by builder "Bestofthelife." The builder had to modify part of the structure to give a realistically organic element, such as a person resting on a bench.

More than anything else, community projects show just how big an impact Minecraft has had on the world and its potential as both a tool and an art form, as well as a game.

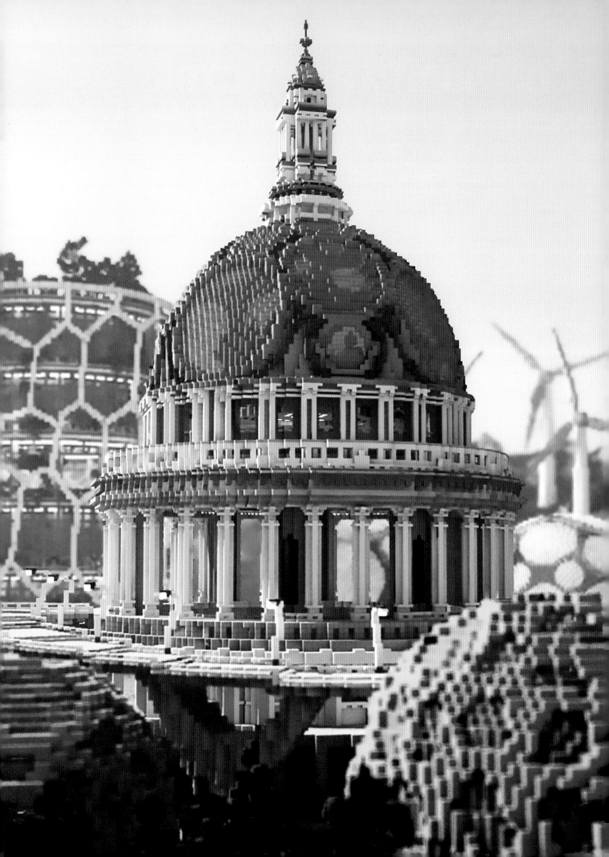

INTERVIEW: BLOCKWORKS PROFESSIONAL BUILDING TEAM

BlockWorks is a team of architects, artists, and designers working within Minecraft®, creating game maps, server spawns, and role-playing worlds for YouTubers, gaming networks, museums, galleries, and film studios around the world. The team's managing director, James, gives some insight into the world of the professional Minecrafter.

WHAT'S IT LIKE LEADING A TEAM OF MINECRAFT BUILDERS? WHAT ARE THEY LIKE? I IMAGINE THEM BEING CREATIVE AND SCATTY AND DIFFICULT TO MANAGE AND MOBILIZE?

It's a unique challenge! Twenty-five builders working from 11 different countries, with an age range of 14 to 26. Communication is absolutely essential, particularly on a build project, and we're lucky enough to have a team that all get on so well together. I think a correlation between eccentricity and creative genius could certainly be made, but the effort it takes to manage them and ensure deadlines are met is absolutely worth it in the end.

WHAT DO YOU THINK THE MIND-SET IS THAT ALLOWS SOMEONE TO MOVE BEYOND BUILDING A HUT AND FEELING OVERWHELMED BY THE GAME? SO MANY PEOPLE TELL ME THEY HAVE DIFFICULTY THINKING BIG. I TEND TO JUST BUILD A GIANT BLOCK OUT OF BLOCKS, THINK, "OH NO, I HAVE NO IMAGINATION," HAVE A CRISIS OF CONFIDENCE, AND THEN GIVE UP.

I think it's largely confidence. No one is able to pick up Minecraft and create epic builds straight away. Most of our builders have been using Minecraft for five years and steadily improving and honing their skills; practice makes perfect, and Minecraft is no exception! So you need a positive mind-set and the confidence that if you keep working at it, you can refine your builds and take on more ambitious projects than you would have ever imagined.

TELL ME ABOUT CLIMATE HOPE CITY.

This was a project commissioned by the Guardian Media Group in the UK, with the brief of engaging young people with climate change. To do this, we created an entire city that showcased a variety of cutting-edge green technologies being used in an urban setting. The great thing about this project was that all the technologies featured are either in use or in development, and so, although it has a very futuristic feel, it certainly isn't fantasy. Furthermore, much of the architecture and design of the city was based on existing architectural projects and concepts. As you explore the map, you come across a variety of green technologies being used and have the opportunity to learn about those with external links to various Internet articles about those technologies. The project was a perfect example of the use of education in Minecraft.

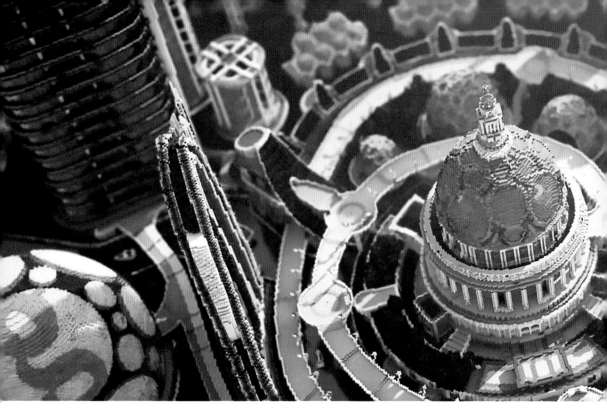

I NOTICE THAT IN THE PRESS MINECRAFT IS OFTEN TALKED ABOUT AS AN ORGANIZATIONAL OR EDUCATIONAL TOOL FOR GOOD, BUT IT'S RARELY TALKED ABOUT AS AN ART FORM. DO YOU THINK IT HAS A PLACE IN ART?

It certainly does! Only recently, an Italian design studio that was putting together an exhibition about Minecraft and its place in design and art contacted us. The studio picked up on a rather interesting link to the Bauhaus School of Design from early-20th-century Germany. The school placed an emphasis on the importance of creative play and produced a range of children's toys, essentially building blocks, designed to encourage creative thinking and design. Currently there is a huge amount of interest in Minecraft in education; however, this largely seems to focus on areas such as physics, maths, and occasionally social subjects like history. What I'd like to see more of is Minecraft being used in education as an artistic tool. From our perspective, Minecraft is not simply a game, but a computer-aided design tool, that is easy to use, interpret, and share designs and creations in.

AN INDEPENDENT INDUSTRY HAS GROWN UP AROUND THE GAME, WHICH BLOCKWORKS IS A GREAT EXAMPLE OF. CAN YOU TELL ME ABOUT THE COMMERCIAL ASPECT OF BEING BUILDERS FOR HIRE? WHAT SORT OF CLIENTS DO YOU GET, AND WHAT SORT OF THINGS DO THEY WANT?

Our clientele varies quite a bit. I would perhaps divide them into the sectors of gaming, media, and education. In gaming, we're often working with Minecraft YouTubers and Minecraft server networks, providing maps and worlds for those servers to use and YouTubers to explore and record themselves using. With the media, companies are now starting to see the publicity potential of Minecraft. We were recently commissioned by Disney to re-create a city from its film *Tomorrowland*. The map was then released as a mini-game, and also played by YouTubers, to raise the profile of the film among the Minecraft audience. As for education, again, it is largely companies and initiatives trying to connect with a younger audience in a language and context they understand. We've undertaken projects from *The Guardian*, Southbank Centre, the Royal Institution of British Architects, and also the London Zoo, all asking us to design and build a project relevant to a cause they'd like young people to engage with.

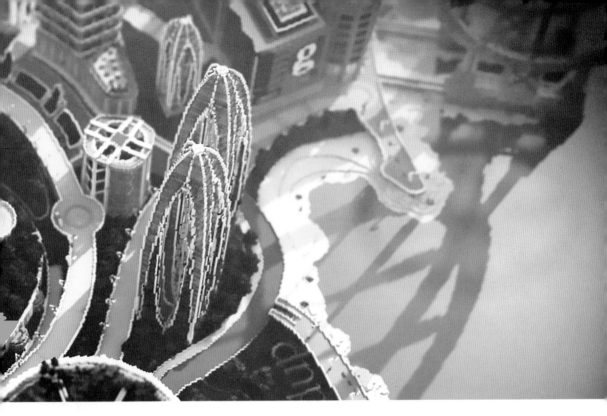

DO YOU THINK THERE'S A LIVING TO BE MADE IN BUILDING? ARE YOUR TEAM MEMBERS ABLE TO BUILD TO A SCHEDULE? HOW DOES THAT STUFF WORK?

There is a living to be made, but it's certainly not easy. I am finally in the position to be managing BlockWorks full time, however most of our other builders are currently at school or university, so are only working in Minecraft® on a part-time basis. I'm only fortunate enough to be in this position because of the four years of unpaid building work I did, prior to the commission basis BlockWorks now operates on. However, I would say that the payments coming in subsequent to that period are essential in giving our builders the opportunity to improve their skills and build on the large scale we often work on.

LOOKING AT THE SORTS OF BUILDS THAT ARE POPULAR IN MINECRAFT, WHAT DO YOU THINK THEY SAY ABOUT THE BUILDERS AND WIDER SOCIETY?

Large, epic builds have always attracted more attention than any other type. I firmly believe that there is an equal level of beauty to be found in smaller works; however, I understand the fascination with larger projects. I think this partly comes from people's admiration and respect for the time and effort required to produce a large project, but also an inherent interest in spectacle and grandeur, something which is just as easily seen in real architectural practice today.

WHAT DO YOU THINK THE FUTURE OF USER-CREATED CONTENT AND GAMES MIGHT BE LIKE?

Perhaps one of the most interesting phenomena of Minecraft has been people using it as a game engine. By that I mean people using Minecraft to create their own, new games; a game within a game. I think people will always try to push the boundaries of Minecraft's natural limitations in new and unexpected ways. That makes predictions of what future content might look like very difficult!

LOTS OF YOUNG PLAYERS, AND PLAYERS NEW TO MINECRAFT, ASK ME FOR ADVICE ON WHERE TO START AND HOW TO PROGRESS AS A BUILDER. WHAT WOULD YOUR TOP ADVICE TO THEM BE?

There are plenty of things worth considering when building; perhaps it might be easiest to try and focus on three separate areas: shaping (the form of your build), detail (the decoration you use on top of that shape), and finally palette (the choice of blocks in a build). All these things need to be considered simultaneously, and work together to produce a coherent and consistent style and overall design. Other than that, always try to finish your builds. One of the best ways to progress is to examine previous projects, try and identify what doesn't work so well and why. You can make a conscious effort to improve on those areas in future projects.

WONDERS GUIDE

P32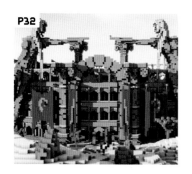

P36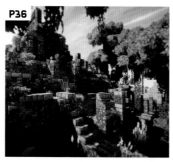

P44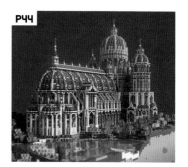

P52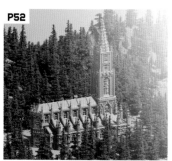

P58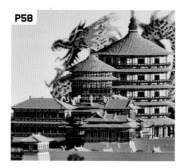

P62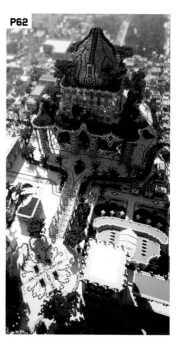

P66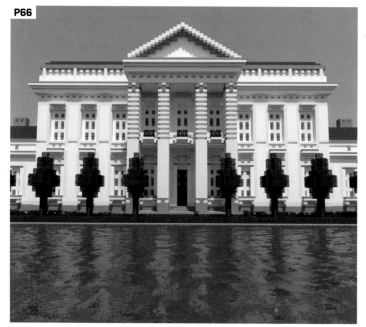

P72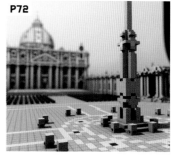

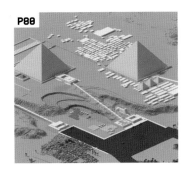
P80

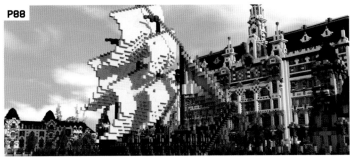
P88

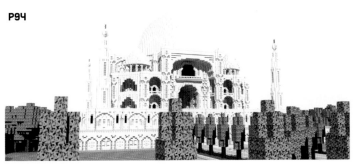
P94

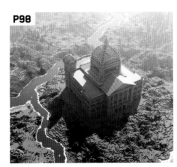
P98

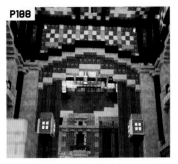
P100

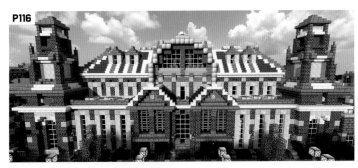
P116

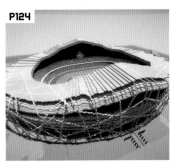
P124

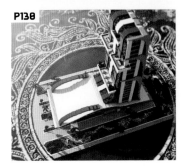
P130

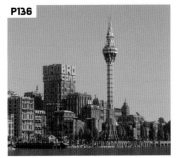
P136

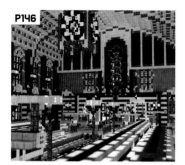

P146

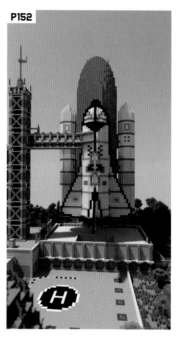

P152

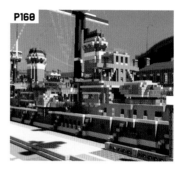

P168

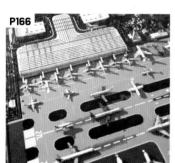

P166

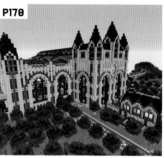

P178

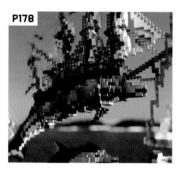

P178

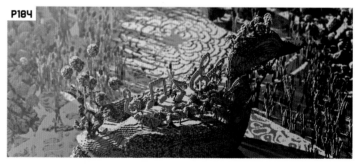

P184

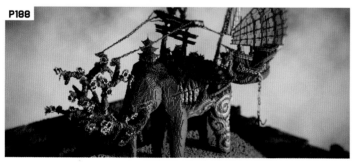

P188

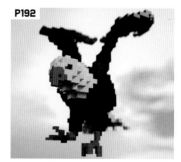

P192

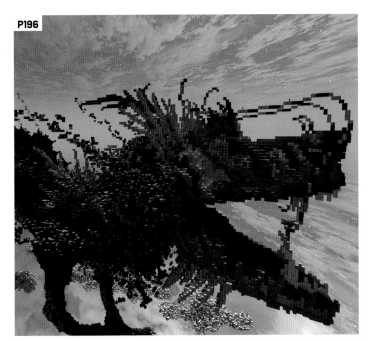
P196

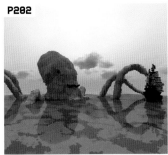
P202

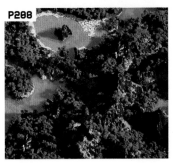
P208

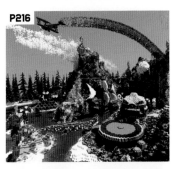
P216

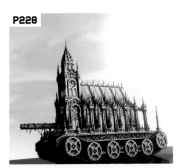
P220

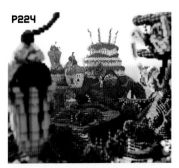
P224

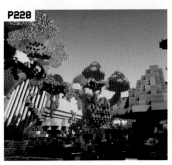
P228

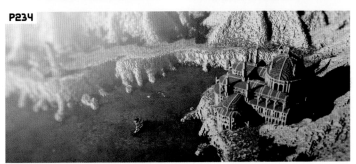
P234

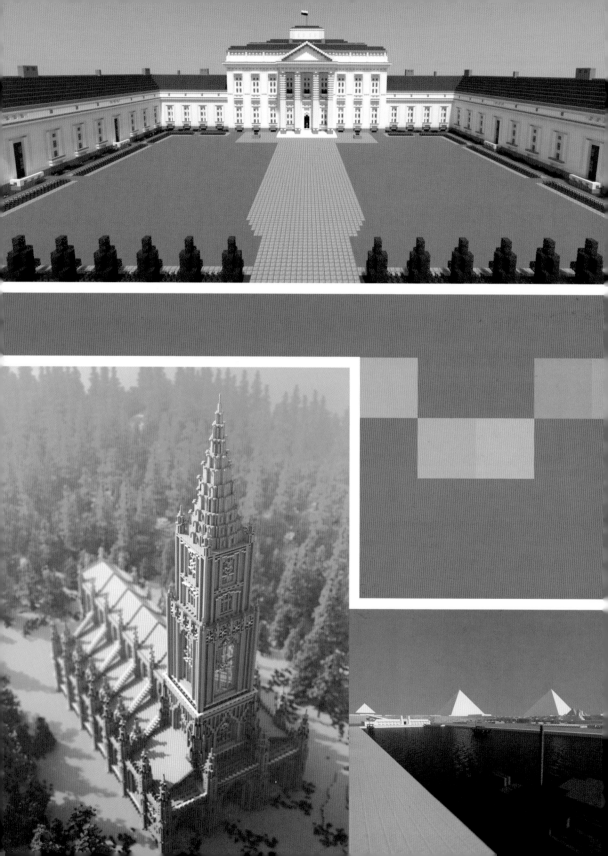

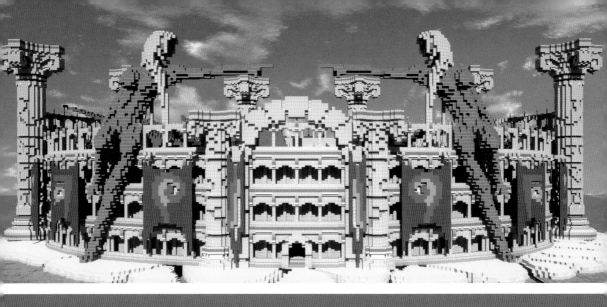

CHAPTER 1

HISTORIC LANDMARKS

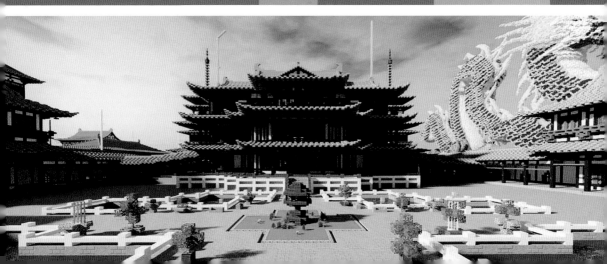

COLISEUM

Shaders and mods: WorldEdit, VoxelSniper
Time to build: 18 days
Blocks used: 2,000,000

THE BUILDER

James is the manager of the professional build team BlockWorks. He is an 18-year-old from London, England and is about to begin a degree in architecture. He has a great deal of interest in architectural history, which influences his designs in Minecraft®. A particular fan of classical architecture, many of his builds have elements of classical design.

The Coliseum built by BlockWorks is a large amphitheater, created as a survival games map for the MultiCube server network. Although it takes inspiration from its classical namesake, the Coliseum in Rome, the build differs in numerous ways. Despite being grand in scale, the map has a less ornate feel to its finish and details. Perhaps the relative lack of ornament is a clue to its more brutal function as an arena of death, albeit the death of Minecraft characters. Stretched canvas awnings provide a partial covering over the arena, most of them an appropriate crimson shade of red.

The structure was built in a logical fashion. Once the shape had been laid out on the ground, the basic structure was put in place starting from the ground up. Only once a skeleton of the structure was in place did the detail get added to the build, in the form of columns, arches, and statues, as well as the banners and awnings found throughout the arena.

James considers one oversight of the build was the fact that the circular structure presents a gameplay issue for players, who inevitably find themselves, quite literally, running around in circles. The team adjusted the design of the arena to add interruptions to this circuit, in addition to a new underground network of tunnels. Once these had been added, he was happy with both the practical and visual aspects of the map.

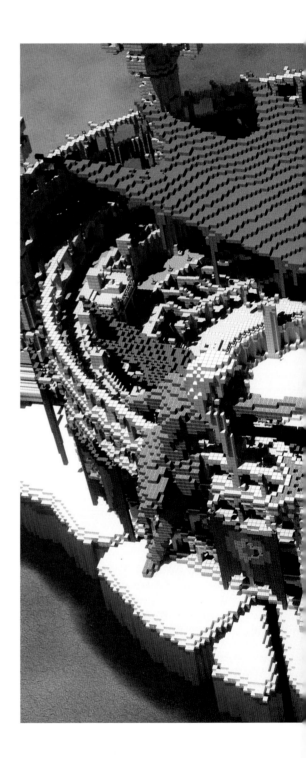

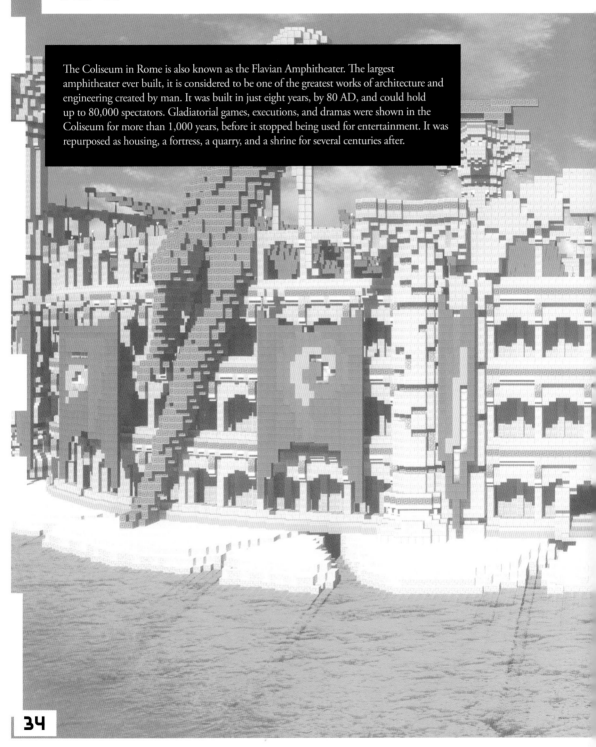

TIPS

The Coliseum in Rome is also known as the Flavian Amphitheater. The largest amphitheater ever built, it is considered to be one of the greatest works of architecture and engineering created by man. It was built in just eight years, by 80 AD, and could hold up to 80,000 spectators. Gladiatorial games, executions, and dramas were shown in the Coliseum for more than 1,000 years, before it stopped being used for entertainment. It was repurposed as housing, a fortress, a quarry, and a shrine for several centuries after.

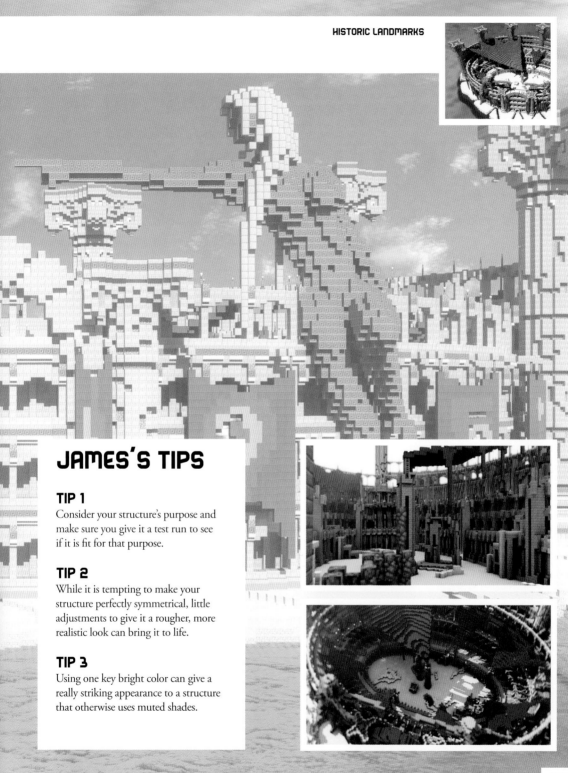

JAMES'S TIPS

TIP 1

Consider your structure's purpose and make sure you give it a test run to see if it is fit for that purpose.

TIP 2

While it is tempting to make your structure perfectly symmetrical, little adjustments to give it a rougher, more realistic look can bring it to life.

TIP 3

Using one key bright color can give a really striking appearance to a structure that otherwise uses muted shades.

MAYAN TEMPLE

Server: www.avand.org (type "/warp c" and then
"/p v patrixcraft 2" to teleport to build)
Shaders and mods: OptiFine, modified Sonic Ether's
Unbelievable Shaders, Better Foliage mod
Time to build: 96 hours

THE BUILDER

Patrix from Taiwan is 22 and loves 3-D modeling and
creating temples in Minecraft®. He is fascinated by the
variety of mods available to use and the diverse community
surrounding the game.

Patrix's love for Mayan temples is actually a fairly pragmatic
interest. He feels that the style really suits the look of
Minecraft, with its rectangular patterns and easy-to-match
colors and textures.

To research the project, Patrix studied many Mayan and Aztec
decorations, paintings, and structures and also viewed
Aztec-themed movies and animations for reference.

Patrix took to his build so much that he created a lore to go
with it, where ancient man stumbles upon a portal that
mysterious tall beings emerge from and bring knowledge to
the people, who form an advanced civilization. They then built
a temple around the portal, to honor the master of the
advanced beings and a legendary beast that dwells on the
other side. Sacrificial offerings were thrown into the portal
daily to please the godly beast, but as the civilization grew, the
land couldn't sustain its population anymore. Famine and
plague ravaged. The ancient people began hosting tournaments
under the temple, where gladiators would fight to the death,
hoping to please the god. Their savagery angers the beast,
causing the annihilation of the civilization. The temple is the
only structure left of the once-great capital. History repeats
itself, as players still fight in the temple arena, not knowing it
will bring their doom!

In fact, the build began with a simple dragonhead statue, which
expanded out to become the full temple. Patrix laid out the
three-step pyramid around the statue and dug out the pool. Once
a full scale was decided, walls and decorations were replaced with a
variety of materials. Weathering, erosion, and overgrown vegetation
was added to give it its distinct abandoned look. The underground
chamber was added last of all, as a player-versus-player arena
for Patrix's friends to play in, complete with a glass-floored
observation room where you can choose teams.

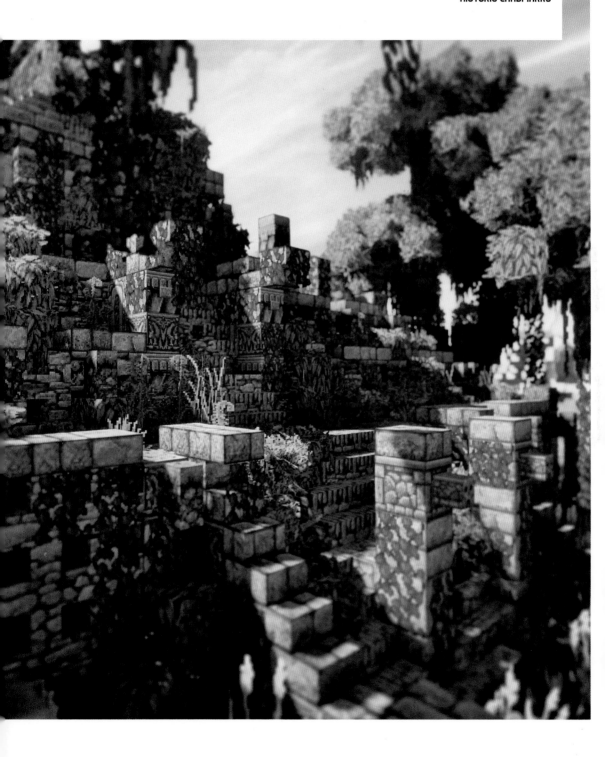

TUTORIAL

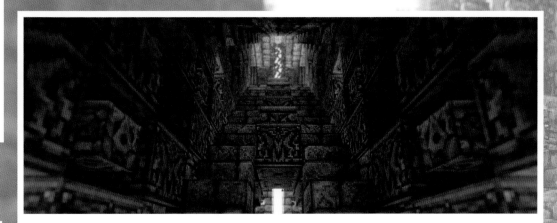

The detailing on Mayan and Aztec structures has a very particular style to it. Adding carvings, interesting flooring, and vegetation to give the look of a long-abandoned ruin is the key to really evoking the look of an ancient wonder.

1

DECORATIONS
Make a variety of decorations using stairs. Use the connective property of the stairs to make the monster-head statue.

2

COMBINATIONS
Utilize the way the stair block connects to make interesting combinations like the smaller quarter block at the bottom.

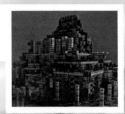

3

LESS SPACE
It takes less space using stairs and half slabs to make the same shape than it does using full blocks. This means you can cram more details into your build.

4

UPPER FANGS AND LOWER JAW
Flip the shape upside down to make the upper fangs. Add the lower jaw using stairs and half slabs.

5

SKULL AND EYE SOCKETS
Add the skull using mossy cobblestones, and eye sockets using upside-down stairs.

6

FINISH HEAD
Finish the rest of the head by adding curly patterns using cobblestone half slabs and stairs to the back and mossy stone wall as ears. Add water to the mouth, and now you have a monster-head water fountain.

TUTORIAL

7

FLOOR CARVINGS

The Aztec calendar-style floor carvings are made using stairs. Start by making the center skull face. See how the various connected stairs are used to make the teeth of the skull.

8

CENTER RING

Next, add a ring of carved stone brick centered around the mouth of the skull.

9

BIGGER RING

Add a bigger ring of carved stone brick with arrow markings at north, east, south, and west to make a calendar.

10

FILL SPACES

Fill the spaces with curly stairs patterns, alternating between cobblestones and stone bricks. This was used as the floor carving for the arena to make sure that there were no dents large enough for players to sink into.

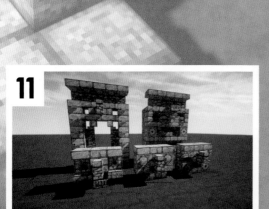

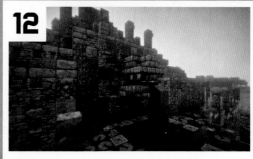

11

FACE PATTERNS

There are lots of ways to make face patterns—using stairs, carved bricks, buttons, stone walls, or even special blocks like piston base. You will need to use WorldEdit or MCEdit for the piston base blocks.

12

WEATHERING AND EROSION EFFECT

Replace full blocks with stairs or slabs to simulate a weathering and erosion effect. Replace normal blocks with mossy blocks, and add leaves, vines, or various plants to simulate vegetation growth. These steps can greatly improve the aesthetic, atmosphere, and realistic aspect of ruin-style builds.

TIPS

The Mayan people were keen astronomers, and many temples have doorways and other features aligning to celestial events. Temples were some of the Mayans' most valued buildings, and some of their pyramids reached heights of 45 meters. Rebuilding and modifying structures was common in Mayan society, with the changing of the political climate or new leaders coming to power. It is even suggested that rebuilding may have taken place as part of a 52-year calendar cycle. Some temples have been noted to have 1,500 years ' worth of architectural modifications recorded.

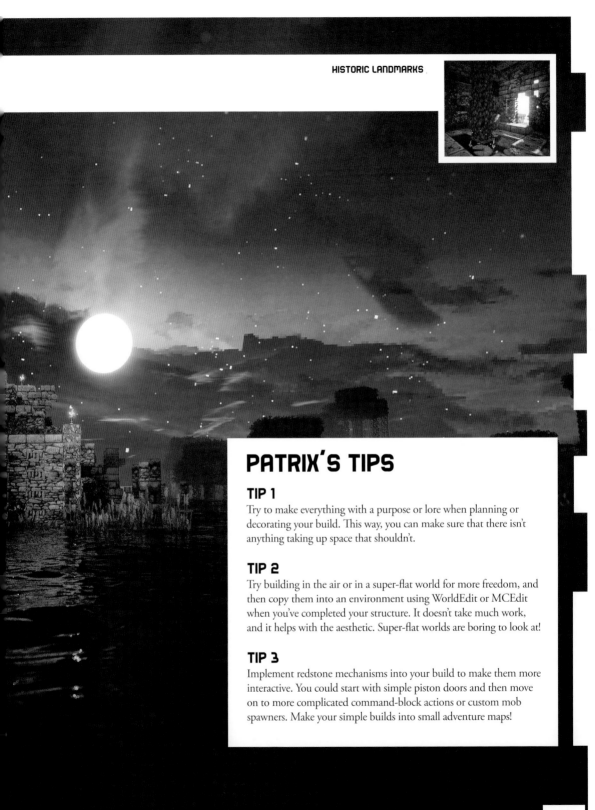

PATRIX'S TIPS

TIP 1

Try to make everything with a purpose or lore when planning or decorating your build. This way, you can make sure that there isn't anything taking up space that shouldn't.

TIP 2

Try building in the air or in a super-flat world for more freedom, and then copy them into an environment using WorldEdit or MCEdit when you've completed your structure. It doesn't take much work, and it helps with the aesthetic. Super-flat worlds are boring to look at!

TIP 3

Implement redstone mechanisms into your build to make them more interactive. You could start with simple piston doors and then move on to more complicated command-block actions or custom mob spawners. Make your simple builds into small adventure maps!

CATHEDRAL

Shaders and mods: OptiFine, modified Sonic Ether's
Unbelievable Shaders
Time to build: 96 hours

THE BUILDER

Patrix isn't just interested in building Mayan temples. As time has gone on, he has
been more and more encouraged by the diversity of the creations the community
continues to produce.

Patrix mostly works alone, but has taken up with a few builders he met when they
watched his Twitch channel. Despite being wildly different people, they have
Minecraft® in common. Patrix feels his Asian background has had little influence
on his style of building, as he prefers Aztec and European buildings. He has spent
most of his building time on temples and cathedrals, improving on each creation as
he goes along.

Despite never having visited a cathedral in his life, Patrix is fascinated by their intricate
details and decorations, as well as the spacious feeling of their interiors. As he puts it,
"Who doesn't love a cathedral?!" For him, they are the ultimate architectural marvel.

Patrix decided to use the iconic dome of the Cathedral of Santa Maria del Fiore as his
main style reference and combine this with lots of elements from other cathedrals, such as
flying buttresses and arches. The cathedral was originally built on a friend's private server
as a personal project. But after he completed the main architecture, Patrix decided to add
a parkour course and a hidden underground chamber for server players to use.

The underground secret chamber uses redstone blocks, so you need to enter the code
"LIMBO" on the buttons on the alphabetical bookshelves to open the gate into the
chamber. The parkour course has a fly-cheat-proof system, and the chamber
mechanism has X-ray protection.

To create perfect symmetry, Patrix made one half section of the hall, then mirrored and
stacked it using the WorldEdit tool to form the halls. He then made one eighth of the
tower and rotate pasted this to form a complete, symmetrical tower. Once the towers
and halls were done, he manually connected the gaps to complete the structure. Since
most of the cathedral is symmetrical, the building took just three days to create.
Adding the parkour course and secret chamber was more time-consuming, as the
mechanisms needed to be debugged and made cheat-proof.

Despite being pleased with the build, Patrix feels it has room for improvement but says
it was a great way to learn how to create symmetrical buildings and command blocks.

TUTORIAL

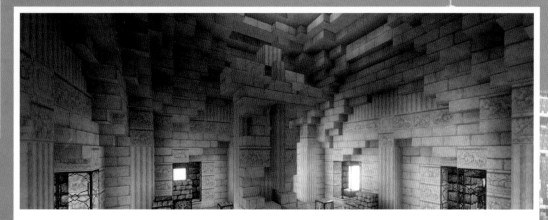

A cathedral is made up of many elements. Getting the arches, domes, smaller arched windows, and large stained-glass-window frames right will make a lot of difference to the look of your final build. Follow these simple steps to create these elements and incorporate them into your own cathedral design.

1

VISUALIZE SLOPES

When making an arch or curve for domes, it is easier to build if you visualize it as different angles of slopes. In this image you can see how the arch gradually bends using the different slopes.

2

SMOOTH

Use stairs or half slabs on the edges to make the slopes smoother. This way, you can make the same slope using smaller spaces as opposed to using full blocks.

3

DETAIL

Use stairs, slabs, and stone walls to make the arch smoother and add more detail at the same time.

4

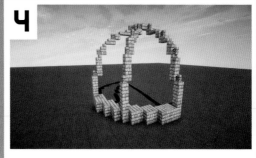

QUARTER DOME

Copy and arrange the arch into a quarter-dome shape as a frame for later.

5

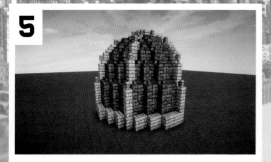

ROOF TILES

Fill out the space using full blocks and stairs to make the roof tiles.

6

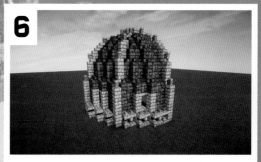

POTS AND ROOF WINDOWS

Add flower pots and replace the base with zigzagging stairs as decorations. Then, add windows to the roof.

TUTORIAL

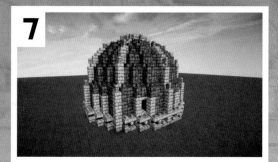

7

FULL DOME
Copy, rotate, and paste the quarter dome into a full dome. Now it is ready to be moved to the top of your build.

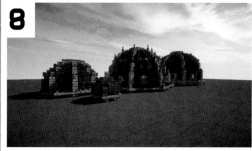

8

DOME STYLE
There are lots of different sizes and styles of domes—you could add decorations and spikes to the dome frames and base, or add windows and buttons to the roof tiles.

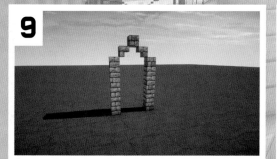

9

BUILDING SHAPE
It's best to make your building out of an odd number of blocks for easier arrangement and layout. Make the arch for windows five blocks wide using stone bricks and stairs to lay down the basic shape.

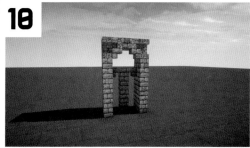

10

FILL
Fill the top with cobblestone stairs to differentiate the arch from the wall. Add a column in the middle to divide the window into two long windows and leave a space for a circular window on top.

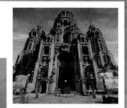

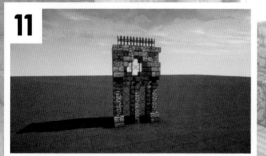

GOTHIC WALL

Add iron fences on top as guard rails. Add a glass block and glass pane for the window. Replace some pillars with stone walls and anvils for decoration. Now you have a Gothic wall section for your cathedral! Copy, paste, and stack them into a row.

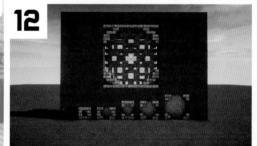

CIRCULAR WINDOWS

There are lots of different sizes of circular windows in a cathedral, from only two blocks wide to nine blocks wide, or even bigger! The trick is using stairs and slabs to make them rounder and to add more detail. You could also replace the normal glass with colored glass.

TIPS

Cattedrale di Santa Maria del Fiore, which Patrix based the dome of his cathedral on, is otherwise known as Florence Cathedral and is the main church of the Italian city. Filippo Brunelleschi engineered the dome in the early 15th century. Its design posed many problems for more than a century, due to its size, even before building began.

PATRIX'S TIPS

TIP 1

Install WorldEdit for server or single player. It is a very useful tool that can greatly increase your efficiency. Make good use of the functions such as copy, paste, rotate, stack, flip, and move when your building is symmetrical or has repetitive parts. The increase in build speed will also make it easier to visualize and to experiment with ideas.

TIP 2

Use the replace function in WorldEdit to randomize materials. Instead of making a wall just of stone bricks, you could replace them with randomized mossy stone brick and cracked stone brick, making it more interesting and realistic. You could also make layers with different percentages of mossy stone bricks so that there is more moss closer to the ground or a water source.

TIP 3

Some texture packs, like Conquest, make use of unused block meta-id or biomes, giving them custom or randomized textures. For example, a mine-cart rail would look like ropes in certain biomes, or some stone fences would look like wooden logs. This method adds a wide range of blocks into vanilla Minecraft® that you might use. Although you need to install MCPatcher or OptiFine and turn on the connected-textures option to see this effect, you can still play the map without them, unlike when using block mods. Without connected textures, you would just see the original textures.

BERN MINSTER

Shaders and mods: KUDA v5 shaders
Time to build: 30 hours
Blocks used: 110,000

THE BUILDER

Julian is 17 and lives in Bern, Switzerland. He is interested in physics, chemistry, soccer, and movies, and he plays the piano. Minecraft® made no real impression on Julian when he first saw it. It was only when his brother bought the game for him in 2011 that he paid more attention and became entranced by the open world and the freedom to create whatever he wanted.

As the game becomes more popular with the younger generation, who are often more interested in the survival aspect of the gameplay, Julian feels his creative community is quieter than before, and would like to see more people working not just on building, but on creating mods and texture packs.

Julian prefers building with his friend Louis more than working in a big team. Longtime friends, they have much in common and an innate understanding of each other, which helps them work together effectively.

Julian loves to create medieval and Gothic constructions and has been obsessed with building castles his whole life, making them in sand on the beach, in LEGO® and Playmobil®, and now in Minecraft.

Bern Minster is a Swiss Reform cathedral located in the old town of Bern and is a great example of Gothic architecture. The cathedral was Julian's first replica of a real-world building, so he had to face the challenges of working out where to start, how big it should be, and what materials to use. He got lucky with his proportions, which, for the most part, despite starting out with a few intuitive decisions, worked out well. The roof had to be rebuilt after a false start, but there was very little refining required. Julian found the build fun and reasonably fast to put together.

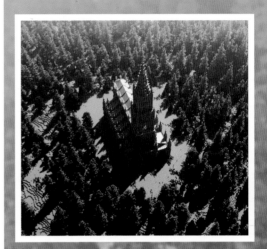

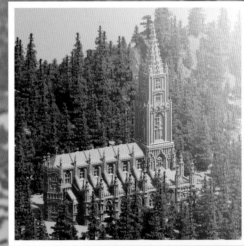

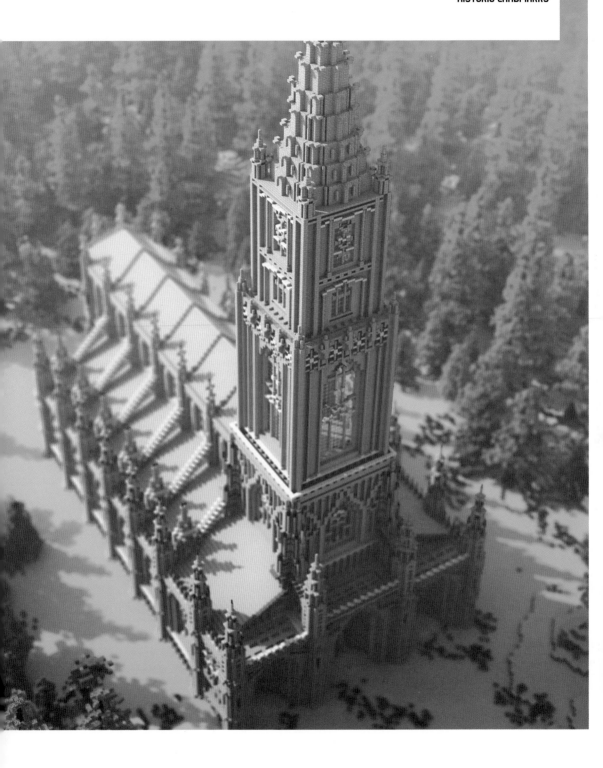

TUTORIAL

If you can make a Gothic-style wall with a stained-glass window, you have an important piece of any cathedral design that you can use for your own fantasy creations, or use the basics here for re-creating existing buildings.

1

LAYOUT
Build the basic layout first. Build 13 stone brick blocks, followed by a layer of cobblestone behind it, and a 5x5 stone brick square to the left and the right, replacing the inner and the corner blocks with chiseled stone bricks.

2

STACK
Stack up the wall to a height of 25 blocks, replacing all the corner blocks of the squares—now cuboids—with cobblestone walls, except the bottom ones. For WorldEdit users: select the blocks, then type "//stack 24 up".

3

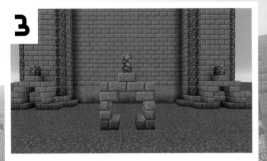

DECORATE PILLARS

To decorate the pillars (cuboid to the left and right), add the structure shown in the image to the sides of both pillars. Also, place a slab to the sides of each chiseled cobblestone.

4

STAIRS

Next, add the stairs as shown in the image and connect them with a line of stone brick slabs. Now, fill the created section by adding cobblestone walls, always leaving a one-block gap. Make sure you replace the background of this section with pure stone.

5

GOTHIC STYLE

In order to give the pillars a Gothic look, remove most of the center blocks so the chiseled stone bricks are visible. You can add several slabs or stairs to fill the gap, but make sure you don't use them too often.

6

WINDOW

The most important part of this section is the window. You can experiment with this by trying out a variety of shapes and going with the one you like best. Adding cobblestone walls to the edges will create a smoother transition to the cobblestone background.

TUTORIAL

7

GLASS
Now remove all the cobblestone, except the blocks on the sides, and add glass or glass panes one layer behind the cobblestone. This will create a nice Gothic effect and allow you to add detail to it.

8

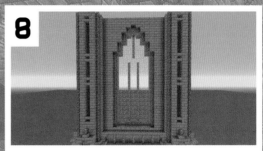

EXTRA FEATURES
Because the glass is one block farther away from the cobblestone frame, there are tons of possibilities to add walls, slabs, or stairs.

9

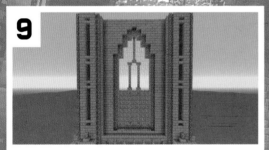

CONNECT
Next, connect the two cobblestone wall poles by adding slabs to the end of the cobblestone walls. To break up the long-and-straight, rather plain part, add a full block somewhere in the middle.

10

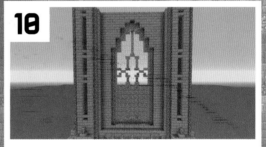

WALLS AND STAIRS
Add walls and stairs to your build as shown in the image and you'll end up with a typical, simple, yet pleasing Gothic window decoration.

11

DECORATION
Add an interesting detail to the space surrounding the windows by arranging the stairs and slabs as shown in the image, removing any gaps between the blocks.

12

WALL AND TORCH
To finish, add a cobblestone wall and place torches on either side of the windows. This is a nice little extra that will come to life at night.

TIPS

Construction of Bern Minster began in 1421. The tower was finally completed in 1893. There has been a church of one kind or another on the site since the 12th century. It is the tallest cathedral in Switzerland and is in the old city, which is the medieval center of Bern, built on a narrow hill surrounded on three sides by the Aare river.

JULIAN'S TIPS

TIP 1
When building large-scale buildings, download and install WorldEdit. Structures like Bern Minster would be very difficult to create without it.

TIP 2
For the main material, choose one that includes slabs and stairs of the same type. This way, it will be much easier to create smooth, rounded shapes and patterns.

TIP 3
Making a basic layout of what you want your build to look like in the end can help a lot. Using WorldEdit, you can make a quick 3-D model of your build with flat walls, to see whether or not your ideas are feasible and pleasing.

LUOYANG

Server: mycraft.chinacraft.cc
Time to build: 164 days
Blocks used: 8,557,319

THE BUILDER

EpicWork is a China-based team founded by "Paddymama" and "Jessefxm" in 2012. Most of the members are Chinese, and they specialize in performing their builds as time-lapse creations which are then shown as videos. Their main inspiration is traditional Chinese architecture.

The ambition of the team is to become the best construction team in Minecraft®, and they have worked toward innovating new building methods and unique skills. The historical accuracy of their builds, along with their construction skills and extensive pre-production planning, makes their structures some of the most striking and unusual ever seen in the game.

Luoyang was an ancient capital in the east of China during the Tang dynasty; however, there have been settlements there since the Neolithic era, and Luoyang is still a city today. At its height in the 7th century, it was one of the largest cities in the world, and this is the period the build reflects.

The structures featured are: the Hall of Light, the Buddhist Temple Tian Hall, the Imperial Palace, and YingTian Gate, and the team included their own giant traditional Chinese dragon statue.

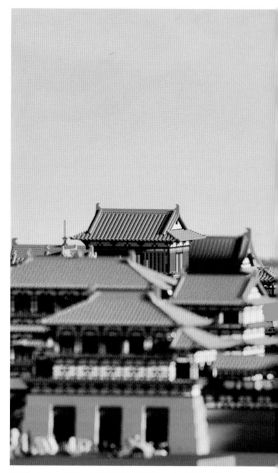

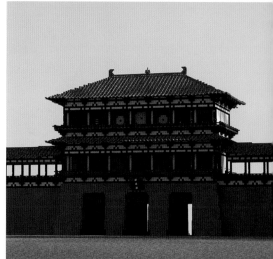

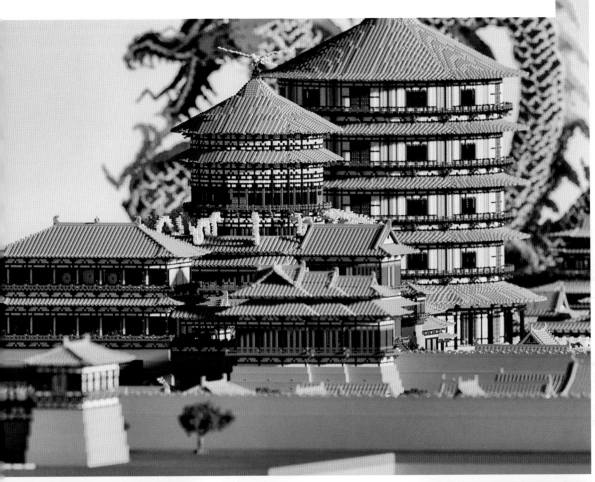

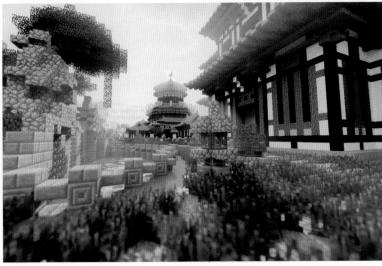

TIPS

Luoyang is one of the cradles of Chinese civilization, representing one of the Four Ancient Capitals of China. The Buddhist Temple that features in the build has existed for 2,000 years and is still there today, although its architecture has changed through the centuries. In the period depicted, the wider city, outside of the imperial section shown, housed more than a million citizens.

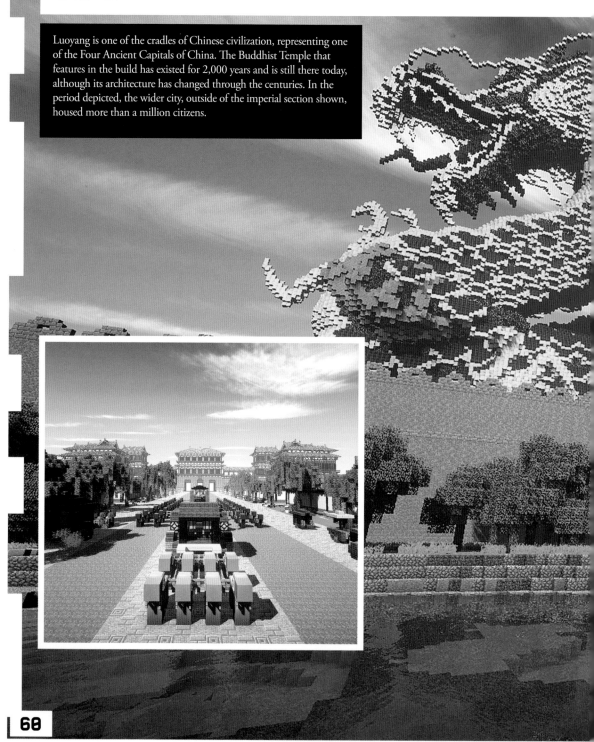

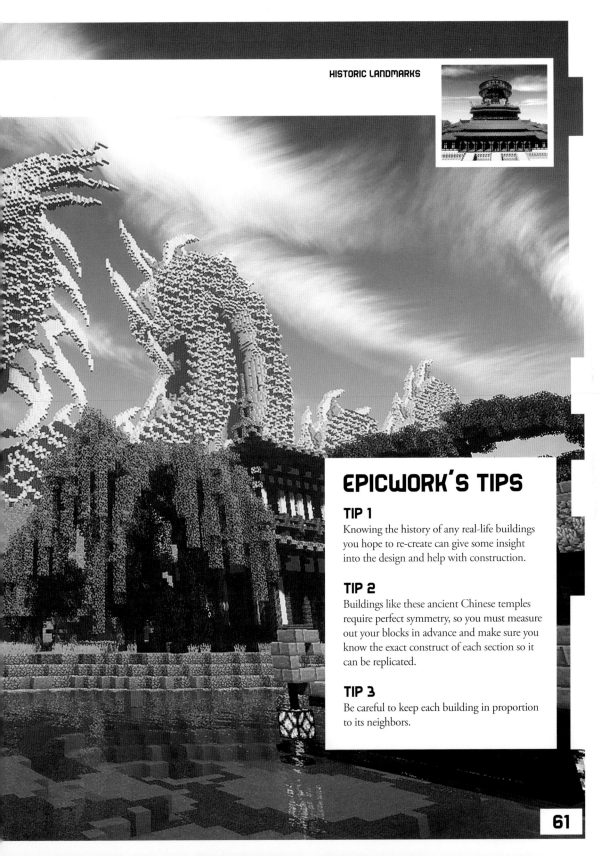

EPICWORK'S TIPS

TIP 1

Knowing the history of any real-life buildings you hope to re-create can give some insight into the design and help with construction.

TIP 2

Buildings like these ancient Chinese temples require perfect symmetry, so you must measure out your blocks in advance and make sure you know the exact construct of each section so it can be replicated.

TIP 3

Be careful to keep each building in proportion to its neighbors.

LA MOMIE

Shaders and mods: OptiFine
Time to build: Three months

THE BUILDER

La Momie's builder is a 21-year-old French physiotherapy student who goes by the name "Rastammole" and lives in Madrid. Rasta loves outdoor sports, playing basketball, running, and surfing, but his outdoor life doesn't deter him from his great love of playing video games.

Amazingly, considering the incredible builds he creates, Rasta only started playing Minecraft® in 2014. Even more incredibly, he mostly works alone. Although a member of a few Minecrafting communities—including one with friends, Les Cailles, and another international community, Deep Academy—Rasta has developed his own style and is able to create amazing structures by himself.

He considers himself to have quite strange taste in subjects, enjoying building rather surreal structures of ponies and toilets and unicorns! The freedom to be weird is one of the most fun things about Minecraft and lots of fun for those exploring the weird builds of other players too.

For La Momie, Rasta researched Egyptian structures and cities extensively. The Babylon garden that is the crowning jewel of the city is surrounded by hundreds of houses in several different districts. The entire map is built for adventure and has enough realism to use for survival games. It is also filled with historic elements.

Rasta began building the map by terraforming a desert environment using the VoxelSniper tool. He then moved on to create the incredible Babylon garden featured here before working on the wider city elements. Although happy with the look of the map, Rasta feels there could be more life within the streets up close.

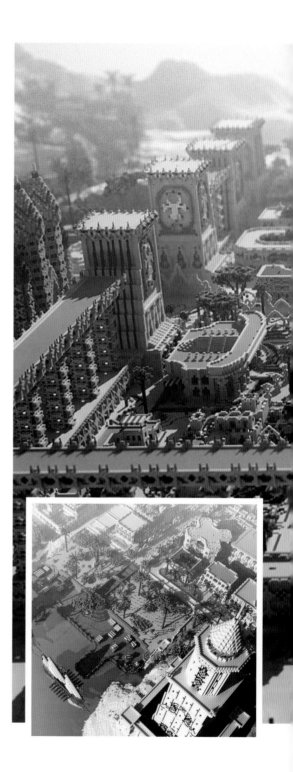

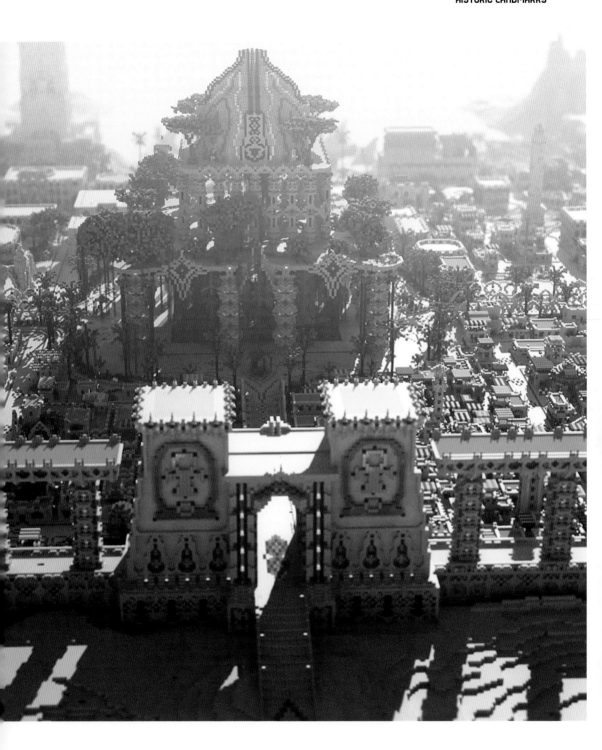

TIPS

La Momie means "The Mummy" in English, and references the movie of the same name. The ancient city of Thebes features in the film and looks a little like the city created by Rastammole; however, the Minecraft® city is actually a far more accurate depiction of many elements of ancient Egyptian cities and life. The fabulous Babylonian-style stepped-garden structure, described as one of the wonders of the ancient world, comes from the neighboring ancient land of Assyria. It having ever existed is in dispute, but this structure incorporates design elements from several interpretations of the lore surrounding the wonder.

RASTAMMOLE'S TIPS

TIP 1
Building in the desert has its own challenges. Remember to include water sources and features for city builds in this type of environment.

TIP 2
While structures in the desert often blend in when colors similar to the sandy surroundings are used for building, greenery used judiciously can look great and stands out beautifully against the harsh, pale landscape.

TIP 3
Remember, it is your creation. Not everything has to be historically accurate or all from the one place. Mixing in elements from other regions or even eras might be fun. Filmmakers often mess things up and use anachronistic features in structures used for movies.

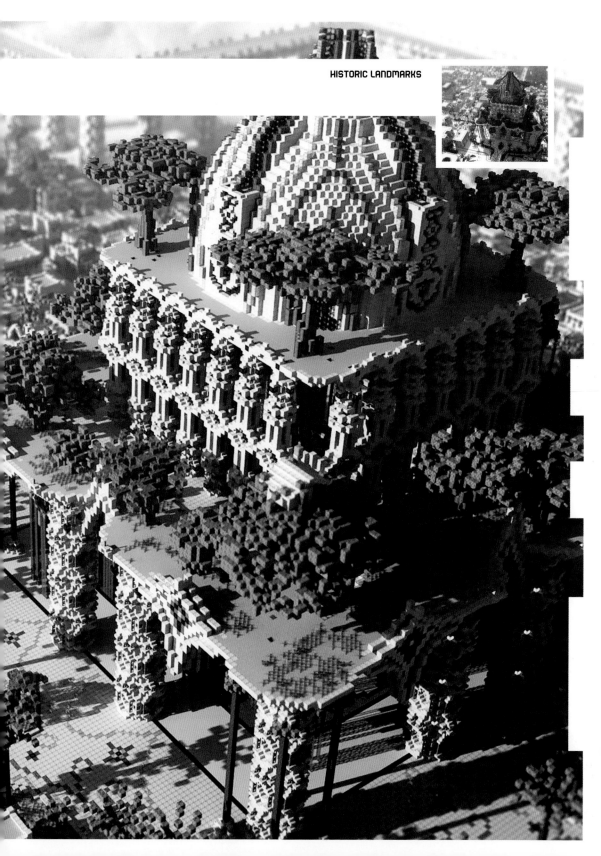

BELWEDER PALACE

Server: Aliquam.org:25573
Shaders and mods: Pamplemouse texture pack
Time to build: 700 hours

THE BUILDER

Jan "Gigeno" Pasznik is a 16-year-old Polish schoolboy. When he's not snowed under with homework, he unwinds by gaming and listening to classical music, especially Beethoven, Mozart, and Chopin.

An avid LEGO® builder in childhood, Jan has been interested in Minecraft® since videos of the game first started to appear on YouTube five years ago. He has used one particular creative server for four years and feels he can relax while playing away from the wider community.

Usually preferring to build alone, Jan sometimes helps others out if they need it and has recently joined a new group, Aliquam Build Team. He's excited to see how being part of the group unfolds and also to begin work on a group project.

Jan specializes in creating real-life palaces and town halls. While looking around online for the perfect palace to show his artistry and challenge his craftsmanship, he came upon Belweder Palace and discovered that it was coincidentally very close to his home. While not finished yet, Jan has poured hundreds of hours into the building. He is satisfied with the outer building, but may look to his new team to help him with the interior.

While Jan has learned a few things during the creation of Belweder Palace, he says he's keeping them to himself! He plans to begin a new build soon, which will either be another palace or possibly tenement housing.

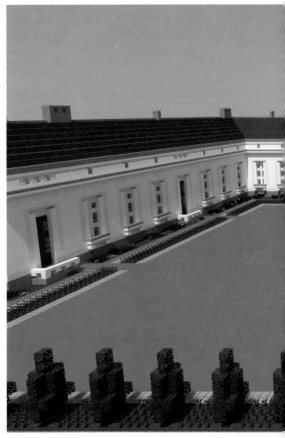

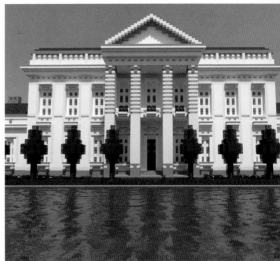

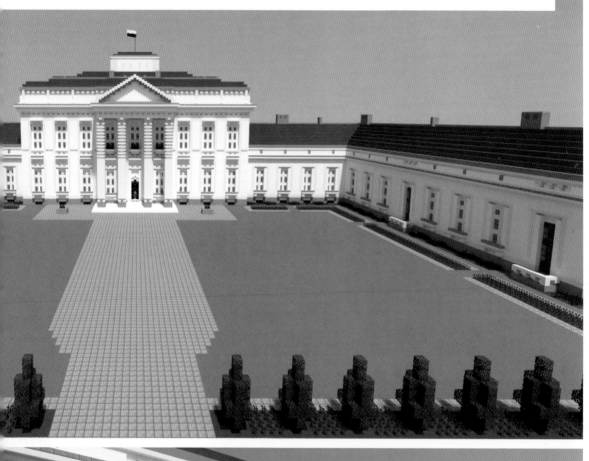

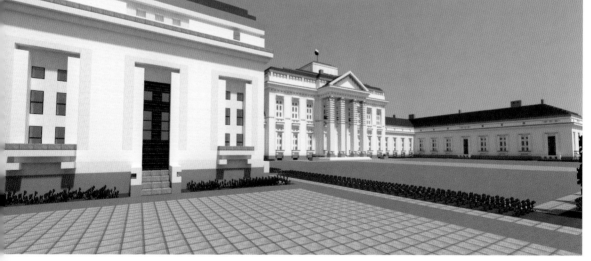

TUTORIAL

Belweder's Polish name is Pałac Belwederski. It is in Warsaw and is the residence of the president, Bronisław Komorowski. It was completed in the early 19th century and is one of the few original buildings in Warsaw to survive the Second World War. There are plans to have the palace converted into a museum dedicated to Marshal Józef Piłsudski—a former resident of the building and the man considered to be the father of the modern Polish nation.

1

OUTLINE
First, create a contour outline of Belweder. Divide it into three squares, one with parameters 38x93 blocks, and two with 13x33 blocks.

2

MARK
Mark the location of the windows using quartz and snow blocks.

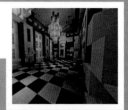

3

WINDOWS

Next, create your windows adding windowsills and details.

4

FIRST-FLOOR WINDOWS

Make similar windows and details for the first floor, again using quartz and snow.

5

ENTRANCE

The entrance should be made from dark wood, and you can add some stairs for more detail.

6

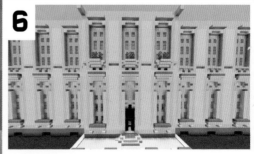

COMPLETE WINDOWS

Create the rest of the windows on the front and back walls. The design is the same for every wall, but side walls can be left blank.

TUTORIAL

7

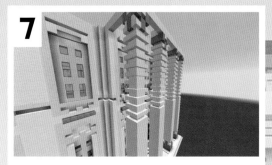

PILLARS
Make pillars on the front wall and use the same scheme on the back wall.

8

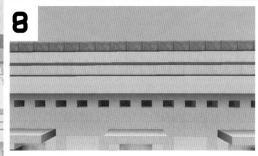

ROOF AREA
Begin the roof area using quartz stairs, snow, quartz, and stone slabs.

9

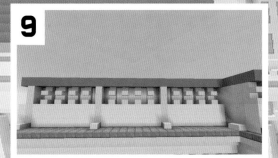

TOP OF ROOF
The very top of the roof is more elaborate and uses quartz stairs, snow, quartz, and gray hardened clay.

10

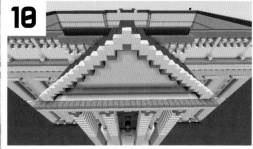

ROOF CENTER
Create a triangle on pillars for the central part of the roof.

11

MARK OUT
In the image, the distance between blocks is marked out with red wool, but you can use any kind of hardened clay.

12

CUBE AND FLAG
To finish, build the distinctive small cube on the roof with the Polish flag.

TIPS

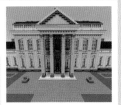

JAN'S TIPS

TIP 1

To make a fancy-looking palace, you should start with a good selection of materials. In the game you have many blocks, but only a couple of them look nice when combined with others. Jan prefers the sandstone blocks and hardened clay. For windows you can use colored full blocks of glass, and flat glass for window frames.

TIP 2

Re-creating something from the real world is a great way to learn about building methods that you can apply to structures you make in the future.

TIP 3

Try working with a team if you can, or start your own. Building alone will take much longer, but it can produce more spectacular and cohesive structures with just one person's vision depicted.

ST. PETER'S BASILICA

Server: s.minecraft.name / s.worldofminecraft.de
Time to build: Five weeks
Blocks used: 300,000

THE BUILDERS

The large German community of Brauhaus der Hoffnung is known for its epic builds, created by a core team of 100 original members and 10,000 gamers who have taken part in their projects since their formation in 2010. *Brauhaus der Hoffnung* literally means "Brewery of Hope," and their aim is to build structures that most people would think were impossible within Minecraft®. They are focused on nonprofit activities, and aim to give every player the opportunity to enjoy the game with them for free, and keep their activities non-commercial.

The team was founded by happenstance, having originally been a group of fans of the game Half-Life. Their at first small Minecraft server very quickly grew from just a few friends trying out the game, into a much larger community, with some of the members even going on to work in the games industry, based on the skills they learned in gaming.

Their normal way of working is to create cities that individual members can contribute buildings to, expanding on the overall project. Each city has a theme, with some early examples set in place for other gamers to come along and grow the city from.

No one on the team had seen St. Peter's Basilica in real life, so it was a great challenge. Others had tried to re-create the building in Minecraft but had never managed such an exact re-creation as Brauhaus der Hoffnung intended to produce.

The team learned a great deal about Renaissance-themed buildings and used that knowledge to go on to build a full Renaissance city on a later project. St. Peter's Basilica has been modified often to correct mistakes and refine the details. The team now feels no additional changes are needed.

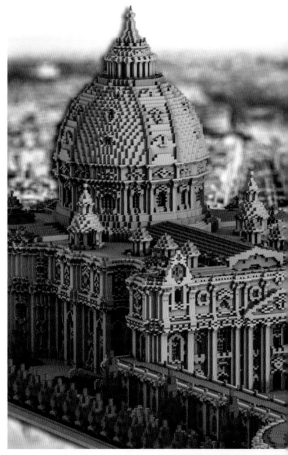

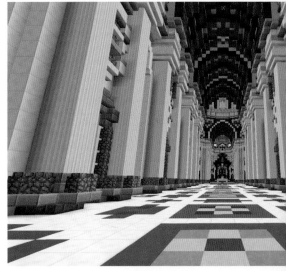

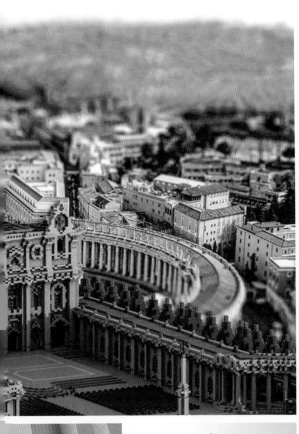

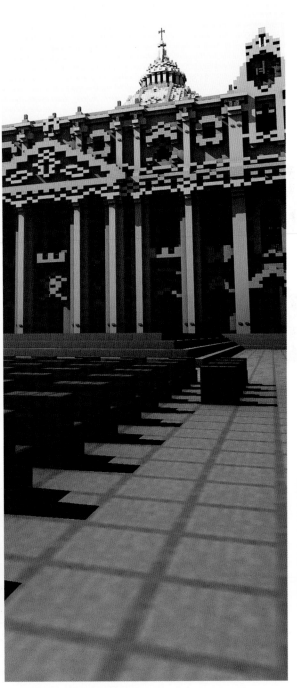

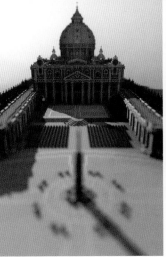

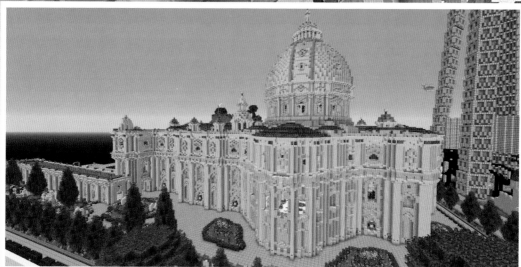

The full title of the basilica is the Papal Basilica of St. Peter in the Vatican. It is located in Vatican City and had several architects involved in its design, including Michelangelo. Said to be the burial site of St. Peter, his tomb is believed to be below the high altar in the church. Building began in 1506, and the church was completed 120 years later.

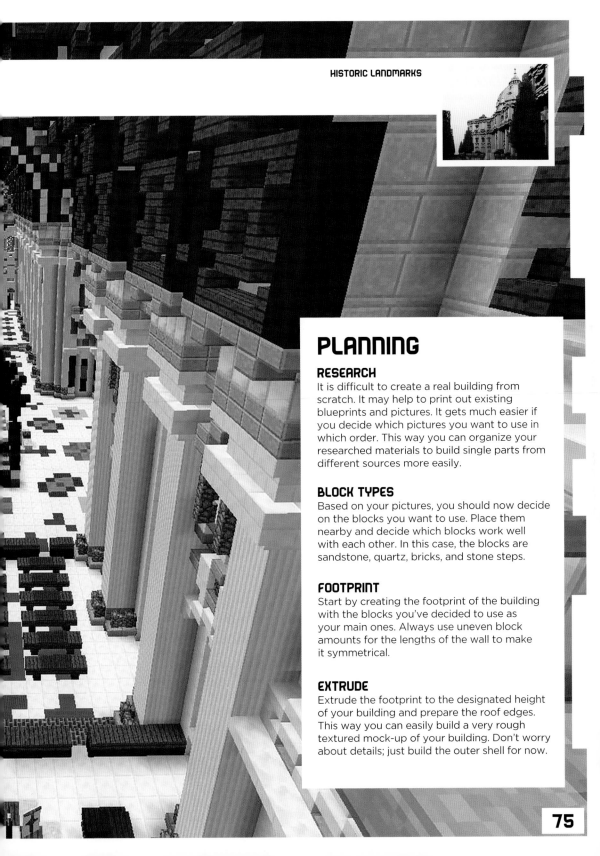

PLANNING

RESEARCH

It is difficult to create a real building from scratch. It may help to print out existing blueprints and pictures. It gets much easier if you decide which pictures you want to use in which order. This way you can organize your researched materials to build single parts from different sources more easily.

BLOCK TYPES

Based on your pictures, you should now decide on the blocks you want to use. Place them nearby and decide which blocks work well with each other. In this case, the blocks are sandstone, quartz, bricks, and stone steps.

FOOTPRINT

Start by creating the footprint of the building with the blocks you've decided to use as your main ones. Always use uneven block amounts for the lengths of the wall to make it symmetrical.

EXTRUDE

Extrude the footprint to the designated height of your building and prepare the roof edges. This way you can easily build a very rough textured mock-up of your building. Don't worry about details; just build the outer shell for now.

TUTORIAL

1

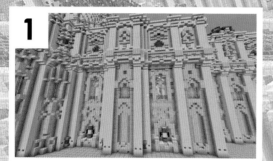

FILL

When you're happy with your outer shell, fill in the materials designated for the walls. Keep an eye on the shape of your building and optimize it if needed. With solid walls in place, the building can begin to look very different.

2

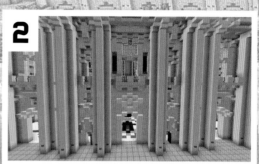

DOORS AND WINDOWS

Break through the walls to add doors and windows. You should start thinking about the structure of the interior while doing this.

3

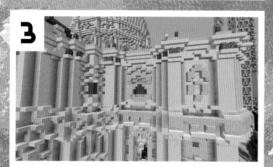

DETAILING

Once you're happy with the shape, start working on the details. Add borders to the windows, pillars, vertical elements, clocks, towers, and more. Refer back to the material you've researched while creating your details.

4

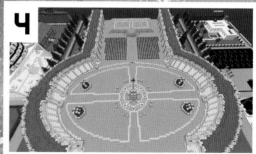

ENVIRONMENT AND LEVELS

Build the floors and place roads, grasslands, and other outdoor-related designs next. Also consider adding more levels to the interior of your building.

5

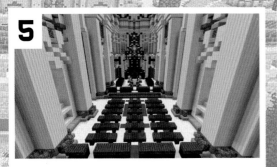

INTERIOR

Deciding which interior elements are achievable in Minecraft® can be difficult, so focus on a few ideas and dismiss the rest. Build the walls and decorate the ceilings with arches.

6

FURNISH

Fill out your rooms with appropriate furniture. You don't want your building to be impressive on the outside but dull on the inside.

7

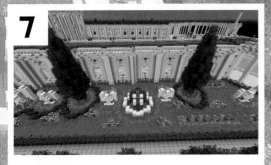

SURROUNDINGS

To complete your structure, you have to work on the surroundings to make it look good. Build hills, streets, trees, bridges, and more.

8

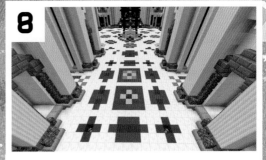

NAP TIME!

Take a nap. Don't finish your building the same day you started it. Take a look at your research materials and compare them with your structure. You'll naturally find many parts that require additional work. Maybe you could work on your build every other day until your structure eventually looks "alive." Then, it's ready.

TIPS

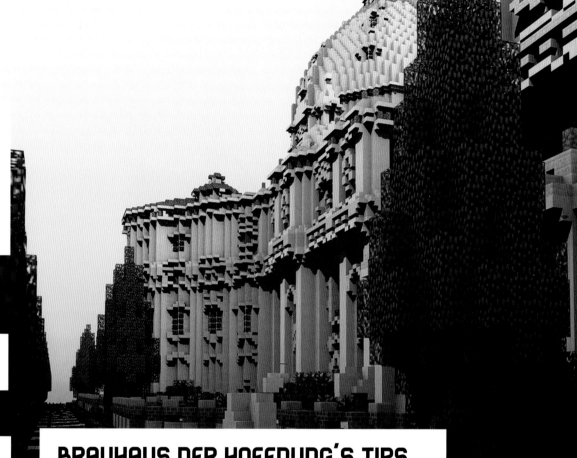

BRAUHAUS DER HOFFNUNG'S TIPS

TIP 1

Draw a blueprint on graph paper before you start. It will help you to get a feeling for the dimensions of the building and will make it easier to transfer it into Minecraft®.

TIP 2

Take your time. If you're stuck, a break does wonders for your creativity. Not only will you be refreshed, but stepping away also helps to give you a new perspective.

TIP 3

Never forget that Minecraft isn't about getting every detail right. And never try to build perfectly. The charm of the game often lies in the imperfections of a build, and these can make a building look much better than a perfect one.

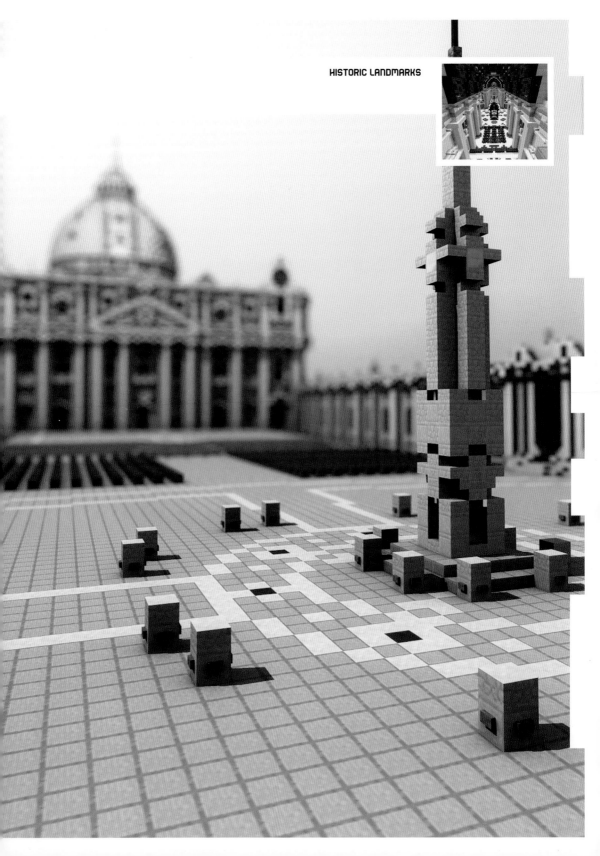

THE GIZA PLATEAU

Server: play.reawakens.net
Shaders and mods: Isabella_II_1.8b.zip texture pack
(http://resourcepack.net/isabella-ii-resource-pack/)
Time to build: 500 hours
Blocks used:
Khufu Pyramid
Smooth Sandstone: 2,114,752
Block of Quartz: 121,556

Khafre Pyramid
Smooth Sandstone: 2,465,784
Block of Quartz: 135,060

Menkaure Pyramid
Smooth Sandstone: 196,260
Block of Quartz: 13,596
Red Stained Clay: 11,203

The Sphinx
Block of Quartz: 23,525

The City of Workers
Mixed blocks: 91,098

THE BUILDER

Niclas is a 24-year-old IT technician from Sweden. He plans on working toward his master's degree soon. Niclas believes that one day everything around us will be represented by computer code in some way or another. Minecraft® is a great example of this.

Niclas enjoys finding ways to connect history and classic art with the modern world and its people. Although Minecraft has proven an ideal tool for him to express himself, he didn't feel that way when he first laid eyes on the game back in its early stages, and in its pre-alpha condition. He couldn't see any real future for it and certainly didn't predict the impact it would have on his life.

Feeling a kinship with Persson, the developer of the game, who is also from Sweden, Niclas bought Minecraft and was quickly hooked, once the lack of limitations the gameplay offers became clear to him. Although Niclas hasn't interacted as much with the community as he'd like, the feedback and expectations of other Minecrafters regarding his project have driven and directed how it has developed over time.

Niclas likes to work on historical projects. In the case of The Giza Plateau, he wanted to do more than just produce an accurate depiction of the ancient complex found at the Giza pyramids. The project explores the engineering behind The Giza Plateau and details the Jean-Pierre Houdin theory, which is currently the most plausible theory on how the pyramids were built.

Niclas's ambition to translate this ancient feat of engineering into a digital world where anyone can walk around, explore, and understand ancient Egyptian building methods is a noble one. It is not a finished project as long as there is more to discover in the sands of Giza, so he continues to refine and add to it, along with the developing archeological understanding of the site.

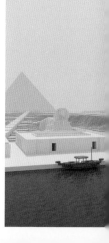

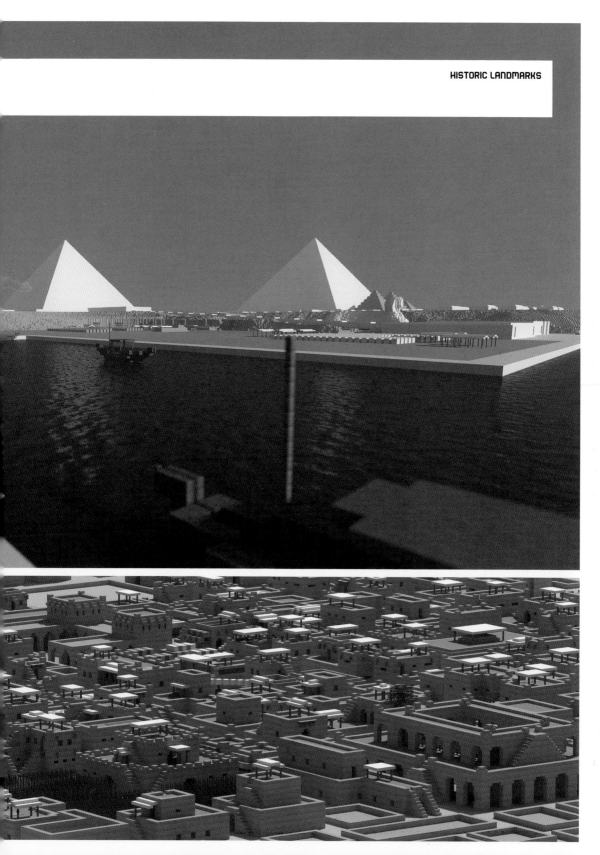

TUTORIAL

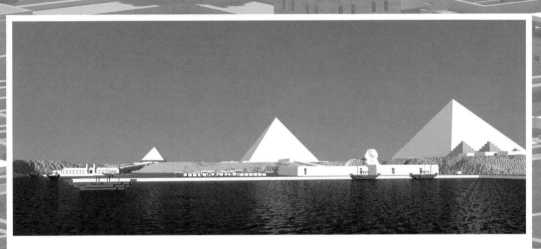

This tutorial will show you how to build a satellite pyramid, usually found near bigger pyramids. They were designed for Egyptian queens and princesses. It uses 45-degree angles, smooth sandstone, and a quartz stair casing. It should be 24x24x12 blocks and will have a small queen's chamber at the bottom.

1

LOCATION

Pick a suitable location for your build. Map out the size. Keep in mind that you'll have to use even numbers, as you'll be working with stairs. They have to add up when you reach the top.

2

BASE

Construct the base. Mark the location for the entry to the queen's chamber on it. Empty out a four-block-deep ditch, where you will later put the roofing and the pyramid.

3

ROOM
Make a large enough room with a 6x4 block area four blocks deep.

4

INNER CHAMBER ROOF
Place the base of the pyramid with smooth sandstone with an area of 6x4. This will also act as a roof for the inner chamber.

5

STAIRS
Place quartz stone stairs around the first level of the pyramid base.

6

ADDING BASES
The next steps will be pretty straightforward. You should keep adding a base, which decreases by one block for each level on all sides.

TUTORIAL

7

SIZE
The bigger the base of your pyramid is, the longer this part will take.

8

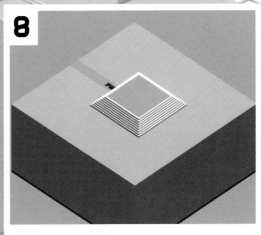

HALF THE HEIGHT
Once half the entire height of the pyramid has been built, two-thirds of the blocks you will use have now been placed. The areas will get smaller and smaller from here.

9

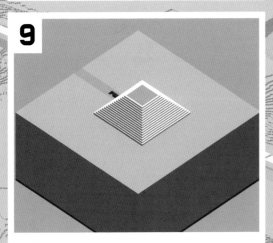

MATH
If you didn't do your math correctly at the beginning, it is at this stage that you will begin to realize you've made a mistake.

10

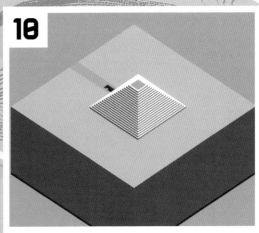

REPEAT PROCESS
The repetitive process here can be somewhat tedious and time-consuming, but it's reasonably simple, so you could combine it with watching a relevant documentary about the particular site you are re-creating.

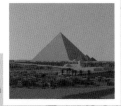

11

TUNNELS, CHAMBERS AND TOMBS
Now that you've created your first solid pyramid, you need to add mystery and excitement. That's where tunnels, chambers, and tombs come in to play.

12

FINISH
Since this is a fairly small pyramid, chambers, tombs, and tunnels can be added at the end, rather than planned from the start.

TIPS

The three pyramids dominate the plateau, running in a southwest diagonal line through the site. These are the tombs of the pharaohs: Khufu, Khafre, and Menkaure. The largest at the northernmost point is Khufu's. This is the Great Pyramid of Giza and the only remaining seventh wonder of the ancient world. The site also features the Great Sphinx, a workers' village, an industrial complex, and several cemeteries.

NICLAS'S TIPS

TIP 1

Use pen and paper to create a draft of your structure before proceeding to the building phase.

TIP 2

Try to get a hold of GIS data, which will provide special geographical information about the place you are trying to replicate. You can scale and apply this using height maps in programs such as WorldPainter.

TIP 3

If something looks wrong up close, step back and look at it from a distance. Minecraft® is a low-detail game, so some things might not look great at close range but look amazing from a distance.

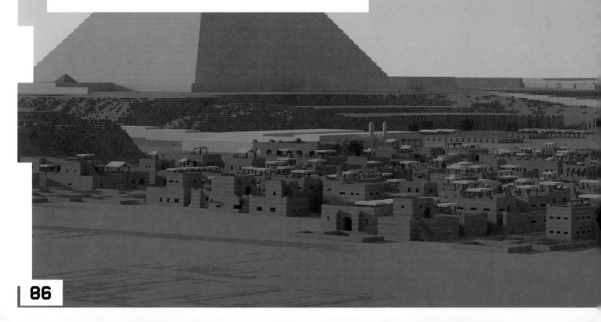

JEAN-PIERRE HOUDIN THEORY

While most people think of Minecraft as a video game, for many of the mega builders featured in this book, it is a 3-D modeling tool. It has the ability, unlike any other 3-D modeling program, to allow a designer to visualize and manipulate any model or structure. Some of the builders you have read about here have used the game to work out complex architectural and structural ideas.

Niclas used Minecraft and his build to explore the Jean-Pierre Houdin theory, which poses the idea that the pyramids were actually built from the inside. Houdin noted a construction anomaly in the pyramids that resembled a spiral structure on the interior and looked like a ramp. The theory suggests that the first third of the pyramid was built with external ramps and the rest with the internal spiral-ramp process, where the stones were hauled up through the pyramid at a seven-degree angle. As yet, the theory remains unproven.

Niclas was fascinated by this theory as so few plausible theories are available on how the pyramids were built. Although his project was already an enormous undertaking, he decided to incorporate Houdin's theory and portray it as accurately as possible within his build.

HUNGARIAN PARLIAMENT

Server: s.minecraft.name / s.worldofminecraft.de
Time to build: Three months
Blocks used: 550,000

THE BUILDERS

Many of the Brauhaus der Hoffnung staff members have come and gone, but the community as a whole has hosted 100,000 gamers, visiting and helping out in creating their enormous cities.

With so many team members, they find it hard to describe themselves, but the one thing they agree about is that everyone on the team is awesome!

They take inspiration from many different things for their themes, often re-creating or basing structures on movie and video game franchises, such as *The Lord of the Rings* and *Elder Scrolls V: Skyrim*. However, some of their real-world re-creations are just as spectacular as any fantasy creation.

This building is inspired by the real Hungarian Parliament but was extended to build out and into an entire city. For a long time, it was the first building anyone who joined the Brauhaus der Hoffnung server would see.

The team started without using a plan and didn't restrict the use of dimensions, style, or even color. As with any building with imaginary elements, many mistakes were made, and some of those have survived refinement. The team feels it is more authentic not to smooth out every little mistake. Brauhaus der Hoffnung only ever publishes buildings they are really happy with. They learned a lot from creating this incredible structure and only quibble with the density of the final product, which they think looks better from a distance than it does close up.

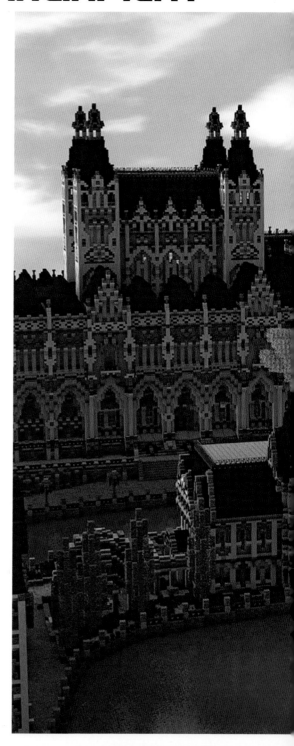

TUTORIAL

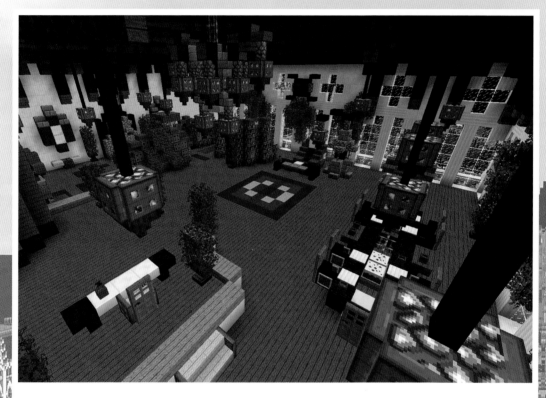

To create a building that is inspired by real life but is completely unique, search for images of several different buildings that you can combine elements of. You should check which blocks work together by placing them side by side. Nether brick and quartz are used here. When creating your outline, decide where to place courtyards.

1

FILL HEIGHT
Decide the height of the structure and fill it up to create a good base.

2

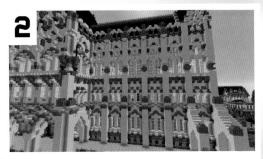

EXTRUDE WALLS
Extrude the walls to the build height. Use odd numbers for the length and the height to make sure the building will be symmetrical.

3

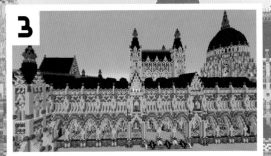

ROOF
This building requires a proper roof, not a flat one, so keep in mind the additional height for it. Decide the position of the dome on top of the building.

4

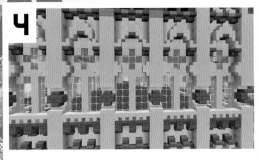

WINDOWS
Decide on the positioning and the shape of your windows. Rather than making big windows, go for multiple smaller ones. A wall made of glass doesn't look as good as smaller framed sections.

TUTORIAL

5

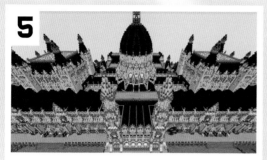

DOME
The best way to build a dome for such a big building is to mix half slabs and stairs together. You can also use glass as one of the materials for an attractive look.

6

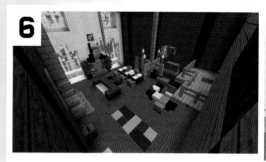

INNER WALLS
Place the inner walls of the rooms. These should be rather small. A parliament is a public-service building, and they usually don't have big offices. Small rooms are also much easier to decorate than big ones.

7

INTERIOR
Every room needs a proper interior. You need bathrooms, conference rooms, bureaus, waiting rooms, floors, and other little details to bring the structure to life.

8

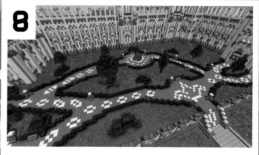

EXTERIOR
Place gardens and flower nurseries around your building, but don't build outdoor decorations that dwarf it.

9

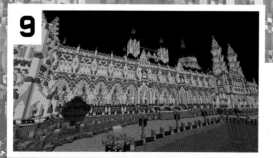

COMPARE
Compare your finished structure to the various resource images you used and see how closely they match, or how much you changed elements to fit with your own ideas.

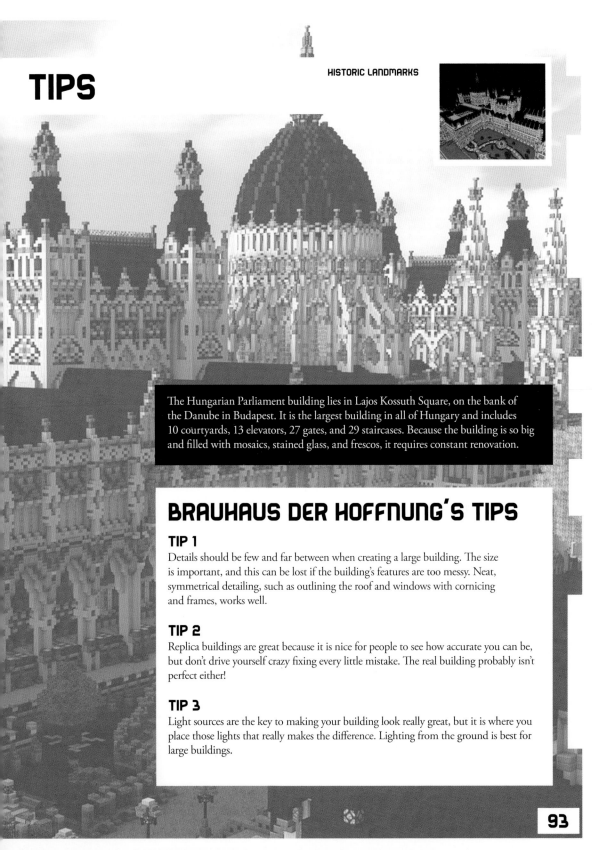

TIPS

The Hungarian Parliament building lies in Lajos Kossuth Square, on the bank of the Danube in Budapest. It is the largest building in all of Hungary and includes 10 courtyards, 13 elevators, 27 gates, and 29 staircases. Because the building is so big and filled with mosaics, stained glass, and frescos, it requires constant renovation.

BRAUHAUS DER HOFFNUNG'S TIPS

TIP 1
Details should be few and far between when creating a large building. The size is important, and this can be lost if the building's features are too messy. Neat, symmetrical detailing, such as outlining the roof and windows with cornicing and frames, works well.

TIP 2
Replica buildings are great because it is nice for people to see how accurate you can be, but don't drive yourself crazy fixing every little mistake. The real building probably isn't perfect either!

TIP 3
Light sources are the key to making your building look really great, but it is where you place those lights that really makes the difference. Lighting from the ground is best for large buildings.

TAJ MAHAL

Server: hub.worldofkeralis.net
Shaders and mods: WorldEdit
Time to build: 18 hours
Blocks used: 100,000,000

THE BUILDER

"Ellowat" is a 17-year-old student from England. When not studying for his A levels, he works at a theme park. He is also one of a small group who hold the land-speed record for model rocket cars, at a speed of 533.1 mph. Ellowat plans to be a renewable-energy engineer and shape the world for the better. In his spare time, he works in an outreach STEM education program for young people and does technical theater work.

Most of Ellowat's interests and hobbies involve engineering in some way, so it's no surprise that he took to Minecraft® quickly. As a mega builder, he's quite a late adopter, having started playing in 2012. After playing on a few different servers, he joined a build team, Team Calabrus, who he helped manage for some time before going on to be a solo builder. He has created structures for major Minecraft events and features his work on his YouTube channel "Ellowat."

Ellowat always thinks in terms of function and doesn't tend to just stand back and admire beautiful structures. He wants to understand the engineering involved. Using information found online, Ellowat learned about the architecture of the Taj Mahal in detail before intensively working on his re-creation in 18 hours over two days.

As the builder, Ellowat sees many faults with the structure and says he would like to change just about everything; however, he admits that, to anyone else's eyes, it looks great. He figures he shouldn't waste time worrying about the faults he sees, and just move on to building another great wonder.

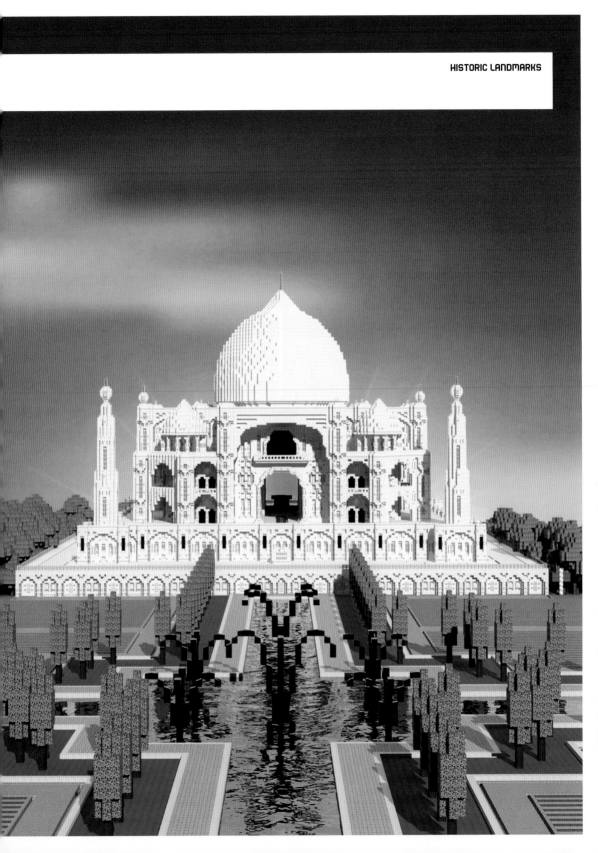

TIPS

Taj Mahal means "Crown of Palaces." Many people don't realize that it is in fact a mausoleum. Constructed in 1632 to be the tomb of the Mughal emperor's favorite wife, it was built from white marble by 20,000 artisans and took 21 years to complete. It appears to be a perfect, solid structure, but there is much concern about the falling groundwater levels, some tilting in the structure, and cracks that have appeared, suggesting it could possibly collapse within the next five years.

ELLOWAT'S TIPS

TIP 1

Have a plan, but never stick to it! Use it as an idea, not an instruction manual.

TIP 2

Too much detail is too much detail. Don't overdo it, but don't leave walls plain either. Add elements for texture and depth, as well as color where needed.

TIP 3

If you don't like it, don't do it. Use mods for the boring bits. Placing a 500x500 square of grass takes hours and ruins your fun—use WorldEdit.

FEDERAL PALACE

Shaders and mods: KUDA v5 shaders
Time to build: 30 hours
Blocks used: 80,000

THE BUILDER

Julian from Bern is very close to his family, especially his two brothers, who he swears he's hardly ever had a cross word with! He doesn't take them for granted, nor does he the lovely life he has in a beautiful environment and country.

Julian plays Minecraft® on a private server with his friend of 12 years, "LouisZ." They have their own survival world in the game and created a custom player-versus-player system.

Julian's fascination with the Middle Ages started with castles, medieval weapons, and armor. This, along with an interest in Gothic architecture, has made his building style in Minecraft distinctive and highly elaborate.

The Federal Palace is an important building in Switzerland and is in Julian's hometown. Julian used an exacting method to re-create this symmetrical building. Although he used some reference material, he is very familiar with the building. For the basis of the build, Julian used a ground plan of the real-life structure and scaled it down to use in-game Minecraft blocks. However, later he had to rework some vertical elements of the structure, as some calculations were incorrect.

When Julian looks at the finished building now, the only thing he would change would be to reduce the number of cobblestones, particularly on the front, in favor of more sandstone, which is closer to the real building's materials.

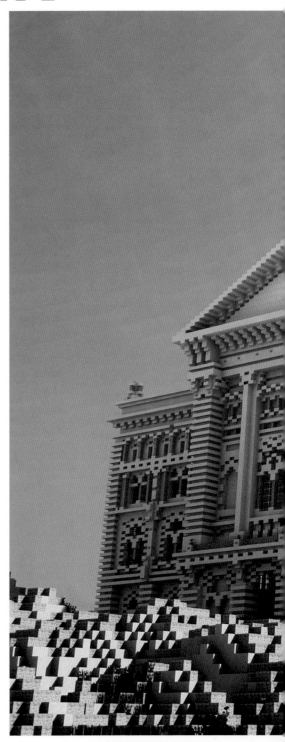

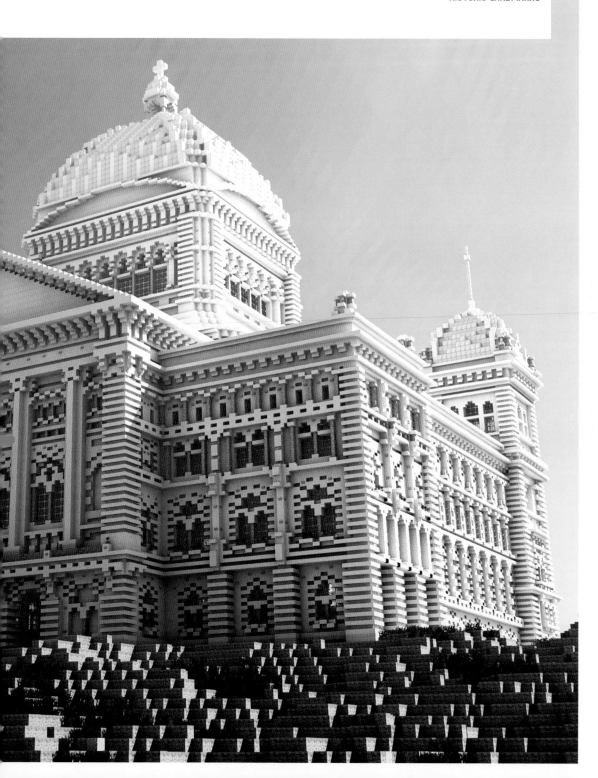

TUTORIAL

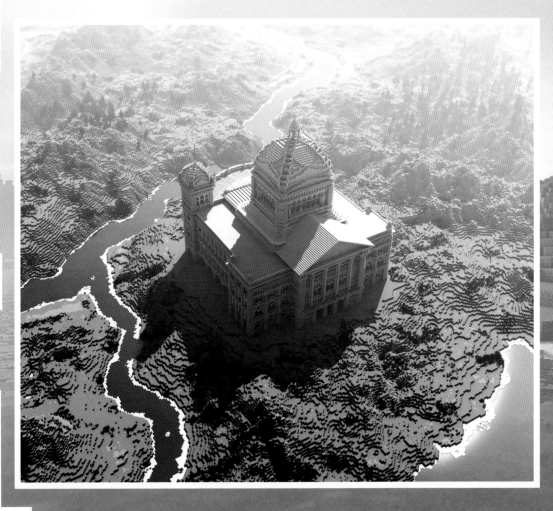

1

LAYOUT
Build the basic layout on the ground with a two-block-thick, 15x15 smooth sandstone square. Build five stairs around each corner.

2

STACK
Stack the blocks 11 high, reaching a maximum height of 12 blocks. WorldEdit users select the blocks and type "//stack 11 up" in the chat.

3

STRAIGHT LINES
Add a three-high layer of regular sandstone on top and connect the highest stairs using sandstone slabs. These straight lines are typical for this particular style.

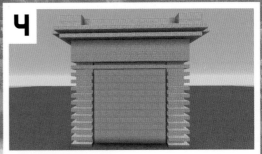

4

SANDSTONE SQUARES
Add a 19x19 sandstone square on top. Build a 17x17 smooth sandstone square on top of that, bringing out the five blocks at each corner by one block. Add the slabs as shown.

TUTORIAL

5

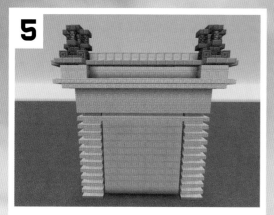

DECORATE
Place stone slabs around the smooth sandstone to add some color variation, and then add these decorative structures to each corner. Finally, lay out the shape of the dome with diamond blocks.

6

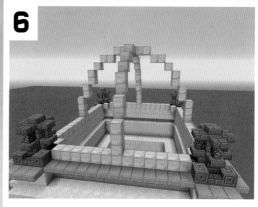

DOME
To build an attractive dome, begin by placing the center lines on every side. This grid technique is an easy way to create the shape correctly. It is now easier to picture the connecting blocks between these.

7

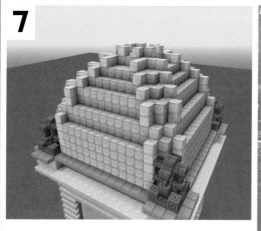

FILL
Now, fill up the empty space with diamond blocks and add veins of gold to it, which will give it a lovely touch and make it look more spectacular.

8

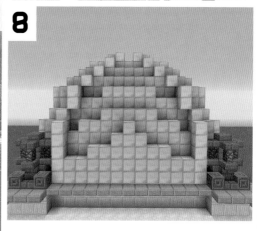

SMOOTH
Smooth the area between the gold blocks. There are several ways to do this. Here, the round shapes become more and more even toward the top.

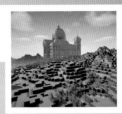

9

POLE AND FLAG
Add a simple pole, and maybe attempt an interesting flag too!

10

WALLS
With the dome completed, work on connecting the bottom walls and the top. Add stairs with the slabs below to give it a realistic look. Also, make sure you don't forget the line slabs around the whole area.

11

WALL DECORATION
To decorate the walls, remove a 7x9 rectangle of sandstone and place glass panes behind it. Add slabs to separate it from the newly built stair pattern beneath them.

12

CONNECT
Finally, divide the glass into three windows, with two sandstone pillars separating them and sandstone slabs to connect the pillars. Placing a stair on the bottom of the pillars is a good idea too.

TIPS

As well as being where the Swiss Federal Assembly meets, the Federal Palace houses several government departments, the Federal Council, and a library. The two main chambers in the building are separated by the 64-meter-high dome.

JULIAN'S TIPS

TIP 1

Sandstone is a great material to build with; there are slab and stair variants for it, and you can also use smooth or chiseled sandstone, allowing you to experiment with different shapes, materials, and colors.

TIP 2

Building a small model of the structure you plan to create can be helpful. It should be simple and clean with no details, as it's just there to help you keep the schema and an overall view of your structure.

TIP 3

Pay attention when adding detail to your build, especially when building in the baroque style. Try not to throw stairs and slabs everywhere. You will develop a sense for what looks good where over time. It all comes with practice!

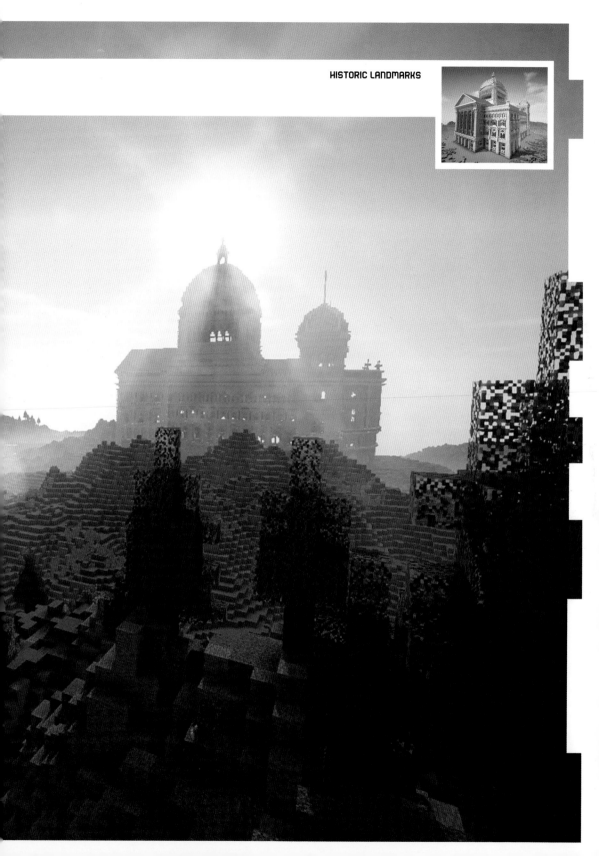

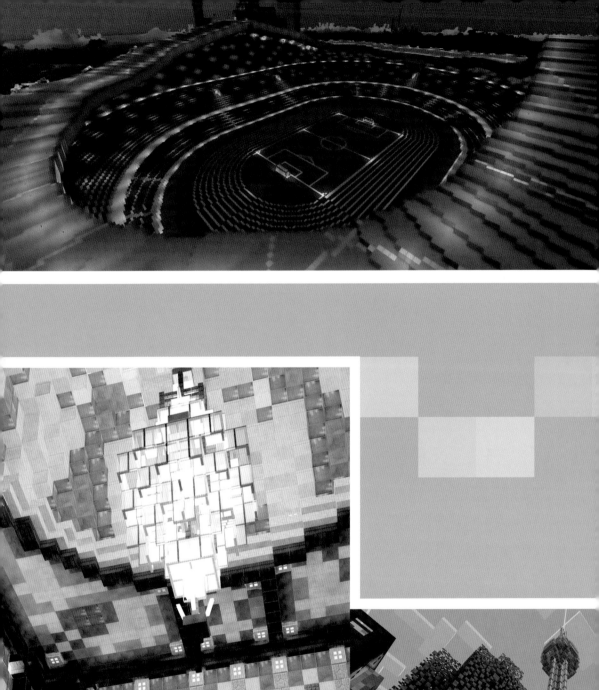

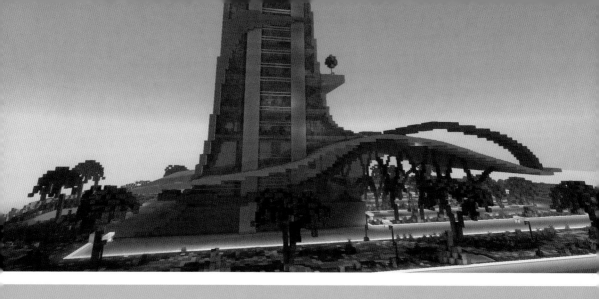

CHAPTER 2

MODERN STRUCTURES

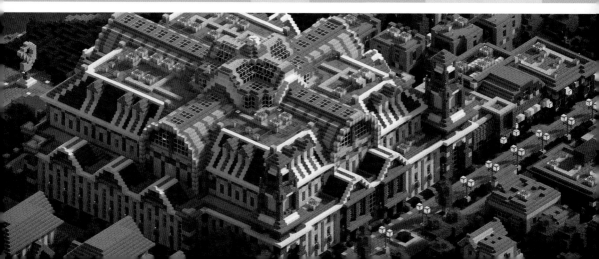

OPERA HOUSE

Server: play.keralis.net
Shaders and mods: WorldEdit, WorldEdit CUI
Time to build: 120 hours

THE BUILDER

Ofri is 18 years old and lives in Israel. He started playing Minecraft® four years ago and hasn't stopped since. Ofri loves painting and drawing, and Minecraft is just another creative platform for him to express himself and showcase his abilities.

As an aspiring architect, Ofri uses Minecraft to practice working with different styles. He feels the game has helped him develop as an artist, and with each new addition to the game, his love for it grows. Ofri finds the way the game brings builders together in pursuit of creativity quite mind-blowing.

While he often works alone on his structures, Ofri has built friendships that have really enriched and inspired his creations. For the Opera House, he worked with his friend "Scherox" on the interiors, which he says he could not have done without him.

Ofri is mesmerized by Parisian architecture and often re-creates famous French landmarks, although he always likes to make changes and additions to his builds to personalize them in some way. He first fell in love with Paris after seeing the animated movie *Ratatouille*. Then, after a visit to the city, he became completely fascinated by it and tried to recapture that magic in Minecraft.

Ofri starts with pen and paper and sketches out realistic pictures of buildings he is interested in. After researching examples online, he works out how to put something spectacular together.

With the Opera House, Ofri followed his sketched-out plan. Often he would get stuck on a section he wasn't happy with and would go back to working on paper to come up with alternatives. This isn't a stage he finds frustrating though—it's all just a part of the building process and helps him produce a structure to match his ambitions for it. In this case, the process worked perfectly. Ofri exceeded his own expectations for the Opera House and feels a great sense of accomplishment and personal achievement with the final result.

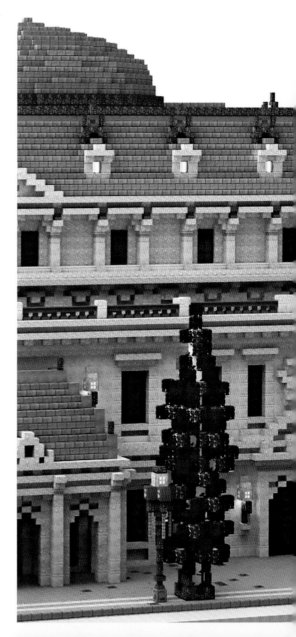

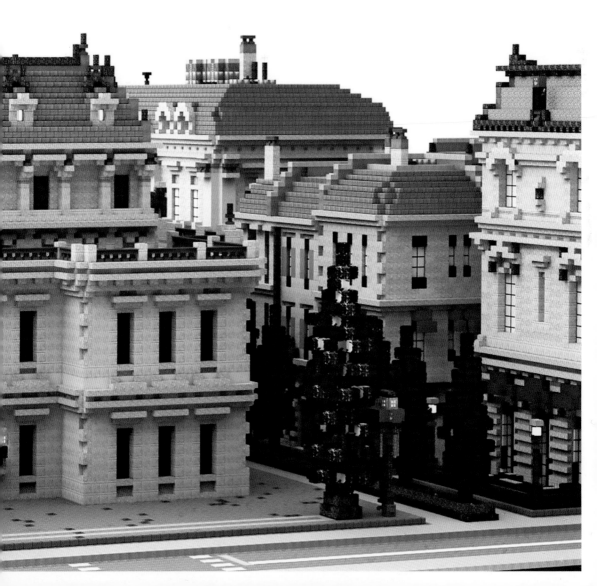

TUTORIAL

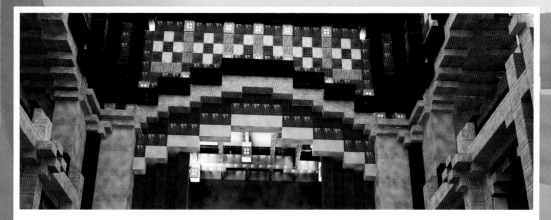

Townhouses are common in Paris and often share features like roof shape and building materials. With a basic understanding of French style, it is quite straightforward to create a nice townhouse. Make sure you research your perfect house for inspiration, and grab a pen and paper to sketch a general idea of what you want to build.

1

MATERIALS

Choose the materials for the building; roof, window glass, window trim, exterior, and exterior detail.

2

BASE

Lay the base of your building and the floor plan. Begin laying out the rooms you planned and start putting in floor tiles and placeholders for future features.

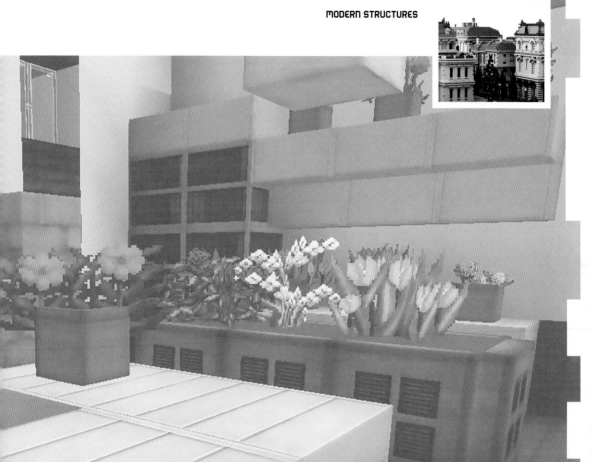

3

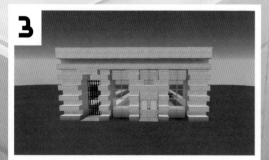

GROUND FLOOR FACADE

Start building up your ground-floor facade. This could be a storefront and the entrance to the staircase.

4

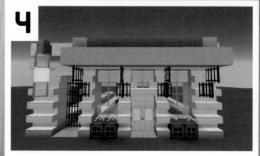

FACADE DETAIL

Add detail to your facade. This is going to be a flower store, so plant boxes and a green awning have been added.

TUTORIAL

5

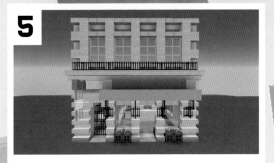

NEXT FLOOR
Start building the next floor. Add windows, railings, and details.

6

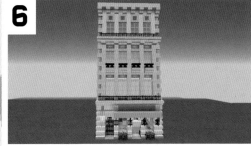

OTHER FLOORS
Build up your remaining floors and the desired details. The details really bring a building like this together.

7

BACK AND SIDES
Build up the back and sides of the building. This one has back access, so it needs windows.

8

ROOF DIVIDER
Place the roof divider. The curved shape is very typical of French style. This will help it stand out from other roofs.

ROOF
Add the roof, windows, skylights, and chimneys. Follow your roof divider and create that curved roof shape.

ROOF DETAIL
Add some detailing to the roof area. This really helps the richness of the building and brings it to life.

FURNISH INTERIOR
Now furnish the interior, starting with the flower store.

FURNISH APARTMENTS
Finally, furnish the apartments! Looking back to step 2, make a similar layout and fill the rooms with furniture.

TIPS

The most famous opera house in the world is the Palais Garnier in Paris. It was the setting for *The Phantom of the Opera*, and the auditorium has the largest stage in Europe, accommodating up to 450 artists. It also holds a seven-ton bronze-and-crystal chandelier.

OFRI'S TIPS

TIP 1

For French buildings, use sandstone blocks, as these are the closest Minecraft® equivalent to the real materials used in French architecture.

TIP 2

It's important to use shapes that reflect the style you've chosen. If you are working in a French style, use arches, specific window designs, and roof shapes like the "mansard" sloped roof. This will make your build instantly recognizable.

TIP 3

Landscaping can make or break your build, and it's important to spend time on it. Try to use vegetation that is typical of your building's surroundings. A Mediterranean house might have palm trees or a cypress tree, for example.

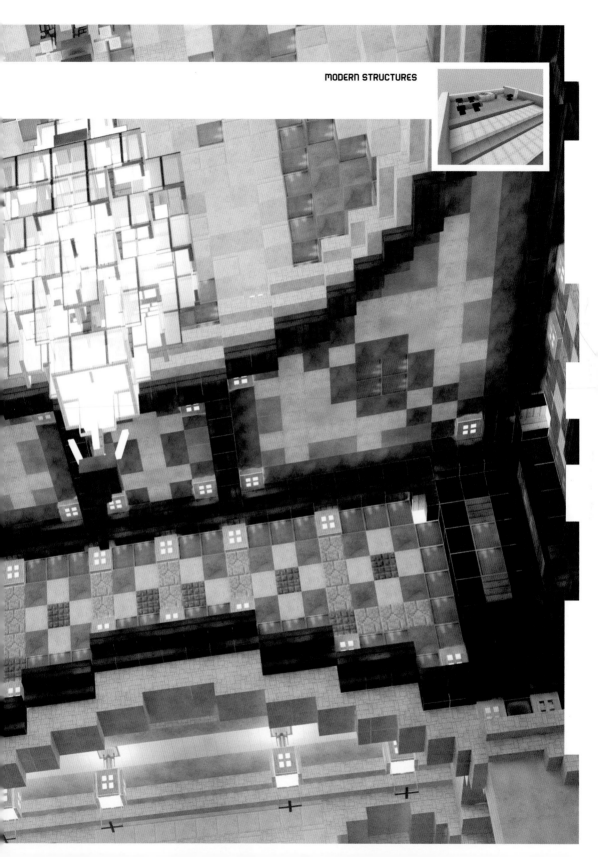

MUSEUM OF NATURAL HISTORY

Shaders and mods: Chunky renders,
CoterieCraft texture pack
Time to build: Two weeks
Blocks used: 12,000

THE BUILDER

Golonka has been living in Sweden for 20 years
and studies graphic design. He was coaxed into
trying Minecraft® in 2010 by a friend and was
instantly hooked. He loves the way the community
has continued to grow and how different pockets of
interest keep appearing. The new groups and teams
emerging and building greater and greater structures
raise the bar for everyone.

Golonka likes to make a wide variety of structures,
plucked at random from his head. He has turned his
hand to dungeons, space stations, barnyards, and even
skyscrapers. He thinks it is important to build a fantastic
central structure that defines the style of what's around it
and for everything to build up and out from a central
point. As a child, Golonka grew up with assembly toys
and scale models and likes to draw top-down city
layouts. Minecraft was the perfect home for his talents.

The Museum of Natural History was built over a period
of two years by Golonka and his friends "Moneybob,"
"Darkfox118," "Descole," "Bickerteeth," "Sburc009,"
"Apricot," "Vayeate OZ," and "Mokrithorr," along with
"CrispKreme," who made the screenshots seen here.
Located in the wealthiest part of the Broville City map,
its design was based on two different museum buildings
using marble pillars, high windows, and a glass dome roof.
Every exhibit in the museum features an info button that
gives you a description of the exhibit.

The T. rex skeleton was ready to be placed inside
before the museum was even built. That way, the
building could be constructed around it, creating a
360-degree display, with exhibit floors looking down
over it. Golonka and the team are very happy with the
final look of the museum. As a building, it can be
seen from far away in their city map, and once inside,
there are many things to discover.

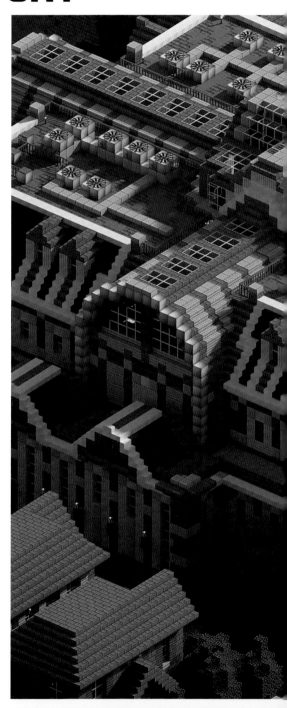

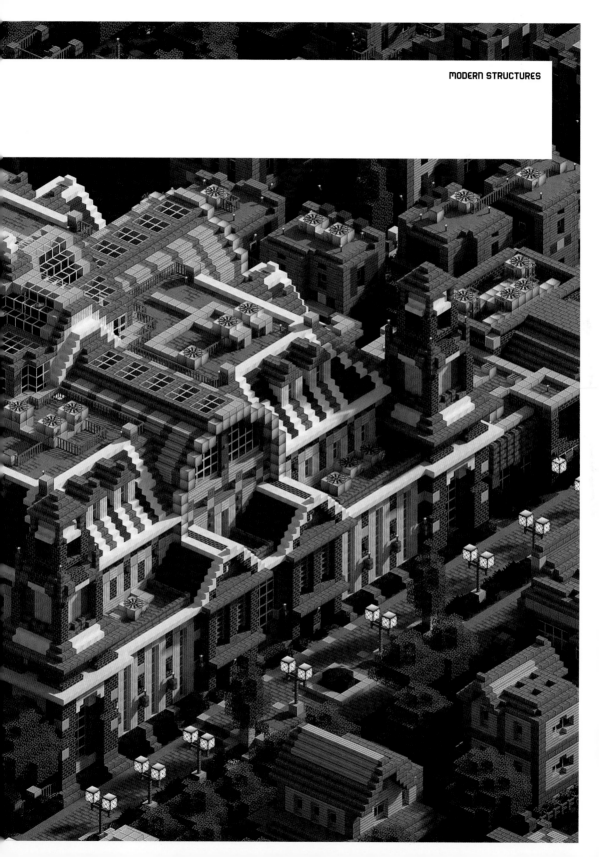

TUTORIAL

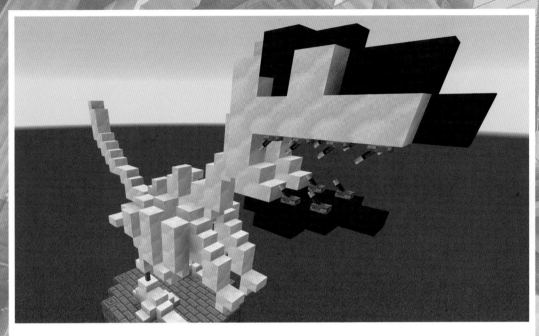

A T. rex skeleton is a perfect addition to any museum, gallery, mansion, or ancient ruin. To create the skeleton, use a combination of regular and inverted quartz blocks, stairs, and slabs. Alternating between orientations in the stairs and slabs allows you to create a realistic skeleton.

BASE
Start with a base that is 7x7 blocks in area. Place two full blocks, with four stairs on the sides and one slab in the front.

FENCE
Add two blocks on top of the rear blocks and a slab in front. On one leg, put an inverted stair facing backward. Since skeletons aren't always complete, add a fence to the second foot.

3

STAIRS

On top of the fence, place a backward stair, then add a backward inverted stair above. On the other leg, add a backward stair and a backward inverted stair.

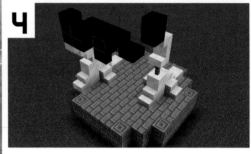

4

PELVIS

On the fence foot, add a block with a slab on top, one space behind the stairs. Add three full blocks in an "L" shape to the other. For the pelvis, make a "T" shape from slabs, one block, and one forward inverted stair.

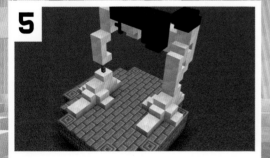

5

LEG

Add one block and an inverted stair facing forward from the pelvis, with three blocks horizontally above. Add one block on one side below. On one leg, add a backward stair and forward inverted stair. Put two fences underneath for support.

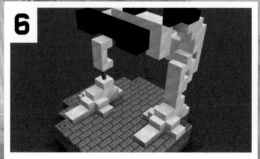

6

STAIRS

Leaving one space, add two blocks three spaces apart in front of the pelvis. Add three inverted stairs between them to create the first rib. On the pelvis, add one backward stair with one backward and inverted outward-facing stair in front.

TUTORIAL

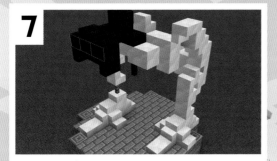

7

SPINE
On the first rib, add a block with a backward stair on top in the middle and two slabs on each side. Make another rib in front with three blocks, with one on top in the middle, and two slabs on each side. Add two inward-facing inverted stairs underneath, with a slab in the middle. Place one slab in between the ribs as a spine.

8

FRONT RIB
On the back rib, add one block on each side with an inverted stair facing outward below. Add three blocks and an inverted stair to the front rib. Put one inverted stair facing outward between each rib one space below them. Add one slab on top of the front rib.

9

TAIL
For the tail, starting at the pelvis, add one forward-facing stair with two blocks behind it. Add a forward stair with an inverted stair and slab behind. Add two sets of alternating forward-facing stairs and inverted rear-facing stairs, then a block and one stair as the tip.

10

ARMS
For the arms, add two stairs with one block below. Place two inverted stairs in front as hands. The neck is made of two sets of one block, with a rear-facing stair on top and forward-facing stair below.

HEAD

To create the head, add two sets of a sideways "T" shape of blocks, three across the back and five forward. On the bottom, add an inverted rear-facing stair and forward-facing stair. Place three blocks across the back of the head with a slab on top. Leaving one space, add two blocks on top.

FACIAL FEATURES

In the gap of blocks on top, add two rear-facing stairs for eyes. Down the middle of the skull, add four blocks. Add one in front as a nose. Place four slabs covering the top of the skull. For the lower jaw, make two sets of a rear-facing stair, a block, and a slab. Place two slabs in the middle of the jaw. Use redstone levers for tooth detailing.

TIPS

It's not uncommon for natural history museums around the world to feature a dinosaur skeleton in the main lobby. A Diplodocus took center stage in the Natural History Museum in London for 35 years, while the American Museum of Natural History in New York features a Barosaurus skeleton rearing to defend its young from an enormous Allosaurus.

GOLONKA'S TIPS

TIP 1

When making large-footprint buildings, you might end up with a big empty rooftop. Try making height variations on the roof instead of having it all at the same level. Adding details like ventilation units and shafts is a good way to spice it up too.

TIP 2

The museum is symmetric from front to back, which makes sense for this kind of building, but remember that asymmetry is generally more interesting when making cities. That could mean adding a ground-level wing to your high-rise office or making variations on different walls of a structure.

TIP 3

Facades and walls are rarely just flat in real life, so adding depth to them will guarantee you a boost in detail. This can be done by replacing some regular blocks with stairs of similar material, and facing them forward, sideways, or upside down. Stairs under and over windows create a window-frame look.

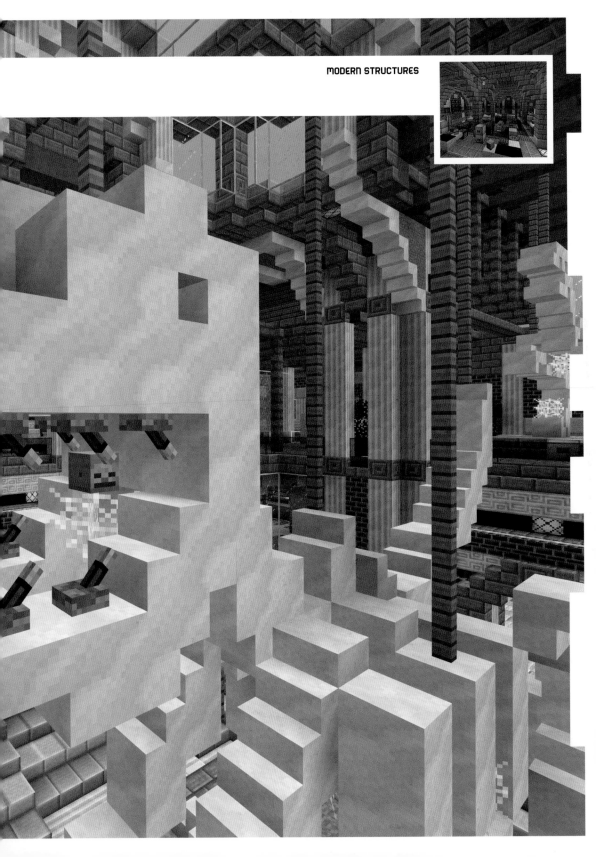

BEIJING NATIONAL STADIUM

Server: mc.mcamsterdam.net
Time to build: 120 hours
Blocks used: 631,000

THE BUILDER

Robbert is a 23-year-old mechanical-engineering student living in Delft in the Netherlands. When not building in Minecraft® or studying, he can be found sailing, surfing, or playing the piano.

Robbert began playing Minecraft four years ago, with four of his friends on their own server. He quickly learned how to use 3-D-modeling programs, which he could combine with his Minecraft builds.

Normally, Robbert dedicates his building time to creating old buildings and churches and likes to visit real-life historical sites for inspiration and research. It was during the London Olympic Games in 2012 that Robbert developed a particular interest in stadiums. He found the shape of Beijing's stadium, built for the 2008 Olympics, to be one of the most interesting.

Robbert and his friends used a 1:1 scale 3-D model of the stadium online as their reference material for their own build. Following the design, their Minecraft version is also a 1:1 scale, with each block representing $1m^3$. Later, the team began to use a program called Binvox to import 3-D models into Minecraft. If they had the right shapes, all they needed was to import them and add color and details, but Beijing's stadium has a unique set of shapes, so the structure had to be built piece by piece.

TUTORIAL

1

STUDY
Download a 3-D modeler and study photos and drawings of the building you want to re-create.

2

SCALE
Decide on your scale. Do you want to build it on a 1:1 scale or bigger? Working without a specific scale will cause problems. Don't forget you can't build higher then 256 blocks in Minecraft®—calculate the scale so that your building will not exceed this.

3

LAND
Measure your land. Make enough space, measure the outer lines, and put some fences on the land.

4

OUTER CIRCLE
Build the outer circle. Make sure the shape is correct and symmetric.

5

INNER CIRCLE
Build the inner circle between the arena field and the bleachers.

6

FRAME
Build the construction frame, creating a skeleton for your structure, and build to the highest point.

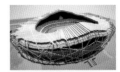

7

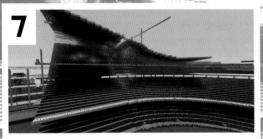

ROOF
If the roof has an unusual shape, concentrate on the inner circle to define it.

8

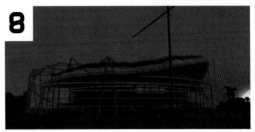

POLES
The next step is to build the slanting iron poles.

9

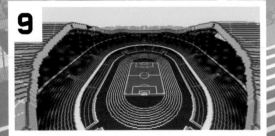

BLEACHERS
Now build the bleachers.

10

FIELD
To build the soccer field, first search the Internet for the official sizes. You can also build other types of sports fields.

11

COPY
You can use WorldEdit to copy and paste the other three-quarters of the shape. Here, one-quarter has been built and the rest copied. This keeps the building perfectly symmetrical and prevents mistakes from creeping in, and it saves time too.

12

INTERIOR
Make your interior. You could add stores and elevators to make it more realistic.

TIPS

The Beijing National Stadium is also known as the Bird's Nest. The design grew out of the architecture team's study of Chinese ceramics—they wanted the building to evoke a sense of a porous vessel. The plans were originally drawn to include a retractable roof within the building, however this particular feature was eliminated from the final design. During the most intense phases of construction, the structure had 17,000 builders working on it.

ROBBERT'S TIPS

TIP 1
Use a 3-D model in SketchUp modeling software, and measure it. Measure your building in-game, so you can match all your shapes to your model.

TIP 2
Always check your builds as you go along, looking for any mistakes. It's easier to correct earlier rather than once you've built more elements, which might create a knock-on effect.

TIP 3
For difficult details when re-creating real-world buildings, use photos taken from different angles.

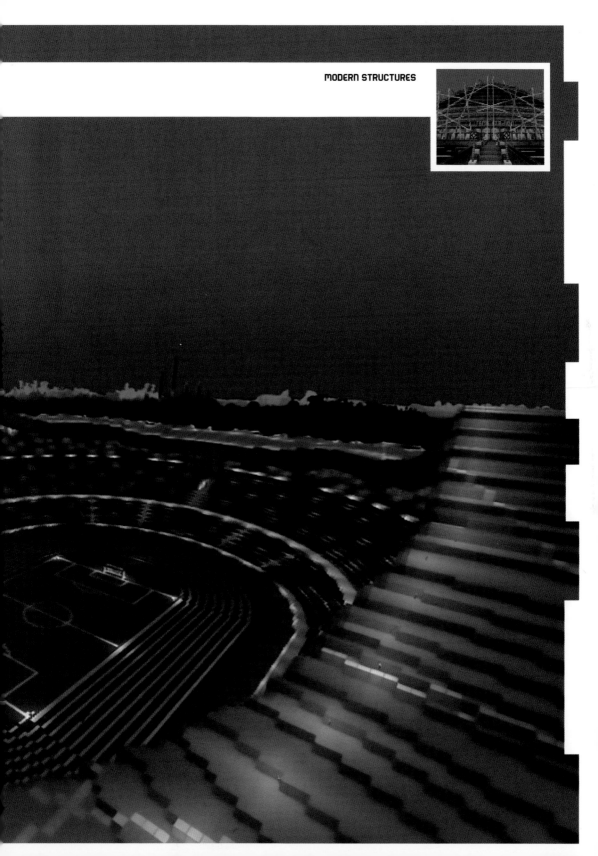

OASIS CASINO

Time to build: 100 hours

THE BUILDER

Marie's friend described Minecraft® to him as a game where you could build anything you want with cubes! He was immediately interested. The constant exchanging of tips and skill building within the community is what keeps Marie coming back.

Although not currently part of a building team, Marie is part of a small community of five players they call "Les Cailles." They met through fellow builder "Rastammole," who introduced himself after seeing Marie's builds and being impressed by his work.

Marie likes building in contemporary architectural styles but does not have one particular type of structure that he sticks to. He's willing to turn his hand to whatever ideas come to mind.

The Oasis Casino has no basis in the real world and doesn't serve any particular purpose in the game other than to look interesting. First, Marie sketched out some designs, and then worked in the game, creating the curves that define the building. The curves were not quite right to start with and had to be reworked, with Marie taking advice from other players on how to get them just right. Marie never stops work on a build until he is completely happy with every aspect of it, inside and out.

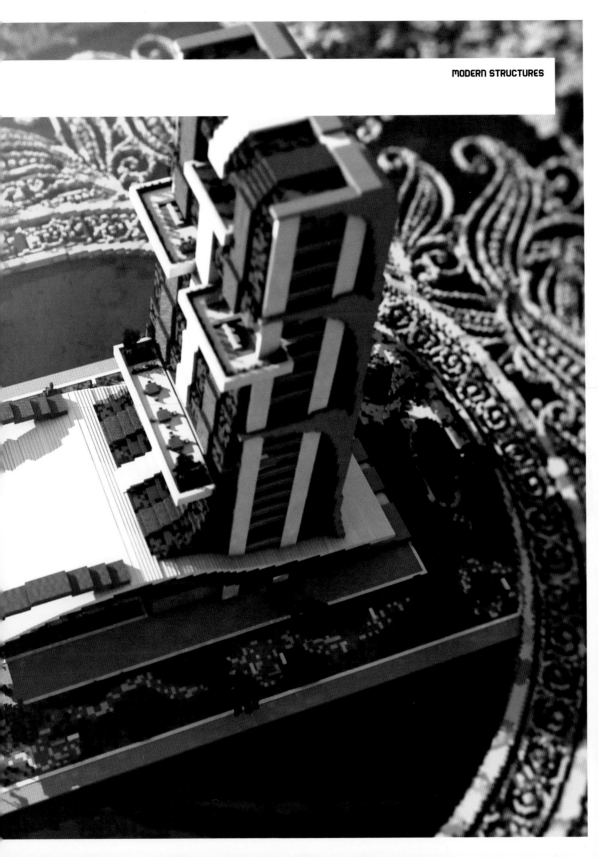

TUTORIAL

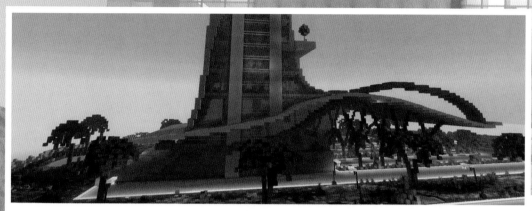

An important detail in the Oasis Casino is the base of it. It's a big building, but the bottom of it is vital, because it features the signature curves that define the look.

1

WALL
Make a wall and it will help you draw the curve. It doesn't matter which blocks it is made from.

2

CURVE
Build the shape of the curve against the wall. Count every block. If you use 7x7 blocks, the curve will be less rounded than with 2x2 blocks.

3

DEMOLISH
Remove the white wall. You can break the blocks with your hand or use WorldEdit.

4

LENGTHEN
Lengthen your curve. You can choose the breadth of your build, but don't go too small, because this is a big structure.

5

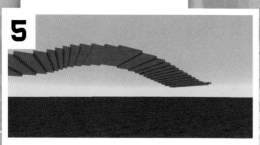

SECOND CURVE
Now it's time to make a second curve, repeating steps 1 and 2.

6

FIT
Remake the second curve, or paste it if you are using WorldEdit. The second curve has to fit the first one. Put them next to each other.

7

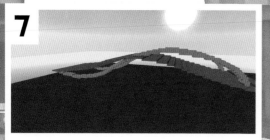

STICK
You may want the second curve to be big. In this image you can see how to stick it to the first one.

8

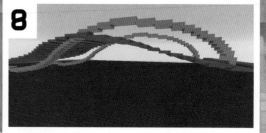

REPEAT
Repeat for the other side of the build.

9

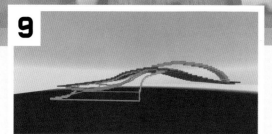

PATTERNS
Add the patterns of the walls. Try to follow the gray curve so they fit perfectly. Add them on one side, and then the other.

10

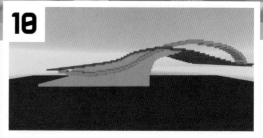

WALLS
Next, add the walls. Don't worry about the colors too much. These are bright to make them stand out. Just focus on the shape.

TUTORIAL

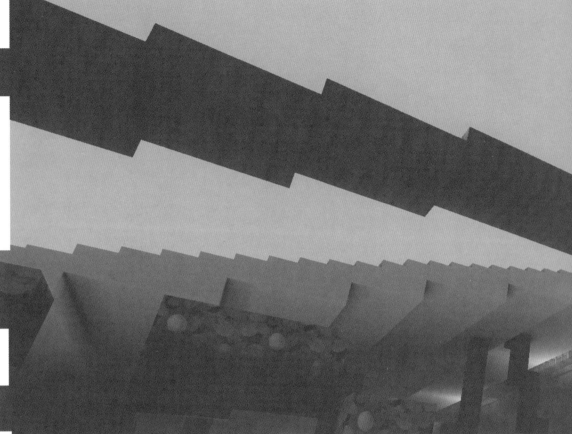

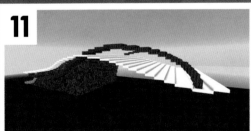

11

COLORS
Now add the colors. In this build you'll want snow blocks, black glass, cyan glass, light-gray glass, and some wood. You can choose any wood you want, but we've used the acacia log here. Don't forget to mix the glass colors together.

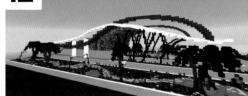

12

DETAILS
Add some details, like columns, beams, etc. It's up to you, but remember not to add too many!

TIPS

While the casino featured in Marie's build is not based on a real-life structure, it evokes the large curved skyscrapers in Dubai. The city is synonymous with innovative, large-scale construction and has the world's tallest building, the Burj Khalifa.

MARIE'S TIPS

TIP 1
Patterns are very important when you start building. They define the shape of your build. The Oasis Casino uses curves. Start by making these shapes and ensure they fit with each other, but try not to add too many of them.

TIP 2
Select the colors, but don't add too many or your build may start to look messy. In this build, the main blocks are snow, clay, and glass. Try to not add more than three main colors.

TIP 3
With modern structures, it is important not to overwhelm them with too many details. The Oasis Casino has some white columns and balconies. There are not many of them, but they work if put in the right place.

BN TOWER

Shaders and mods: Chunky renders,
CoterieCraft texture pack
Time to build: Six hours
Blocks used: 3,000

THE BUILDER

Jake is 25 years old and works in a photography studio
in British Columbia, Canada. He lives with his wife
and two cats. In the Minecraft® community he's known
as "Oldshoes" and has been involved since its early
days in 2010. The game's infinitely huge maps and the
ability to shape them immediately captivated him.
Jake has watched the community grow from a small
fan base to an enormous world of players.

Jake works with his team of 15 regular builders and 30 or
so contributors from all over the world. They all have one
thing in common: the vision and ability to create huge
maps filled with fabulous buildings and structures that
share a cohesive look.

While Jake's maps contain buildings and city structures,
his favorite elements to work on are the natural
formations: terraforming the landscapes and adding
flowers, trees, and city infrastructure. Minecraft is
known as a "sandbox" game, and this idea has always
appealed to Jake. As a child, he would play for hours in a
real sandbox, making tiny cities from rocks, plants, and
fish tank toys, and use a garden hose to make little rivers.

Jake built the BN Tower with friends "Matalus" and
"Golonka" and some help from "Crispkreme" for
the screenshots. It is modeled on a number of tall,
freestanding towers around the world, but most closely
resembles the CN Tower in Toronto. It's the tallest
structure in the team's city of Broville, at 182 blocks
high. It helps balance the other skyscrapers in the city
and provides a visually striking feature to the skyline.

When building, it was important to create a base that
a viewer could imagine would realistically support the
long, thin tower section and observation deck at the top.
It was a good exercise for the team in structural detailing,
and they've never felt a need to embellish it further. It
remains a major landmark in their city.

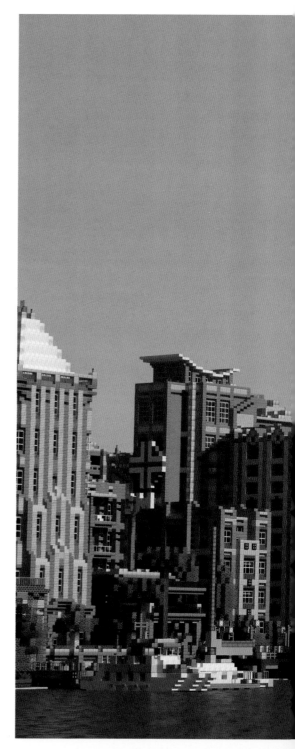

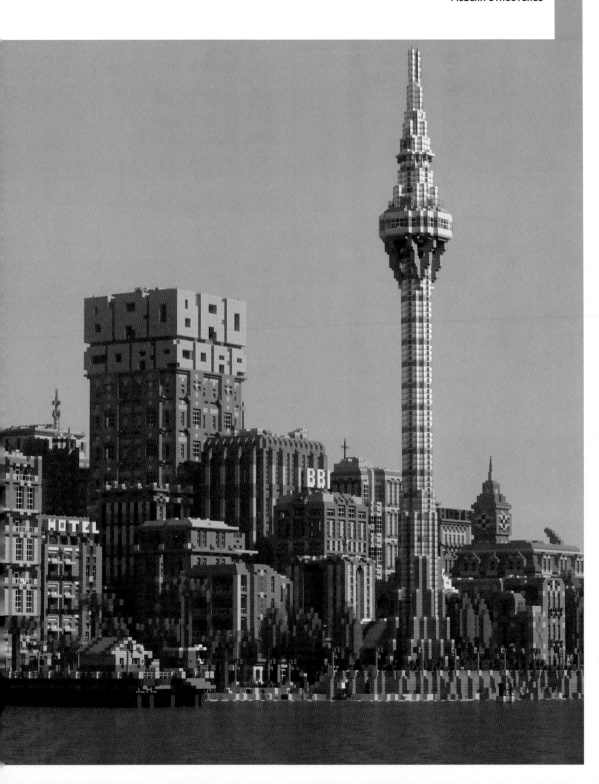

TUTORIAL

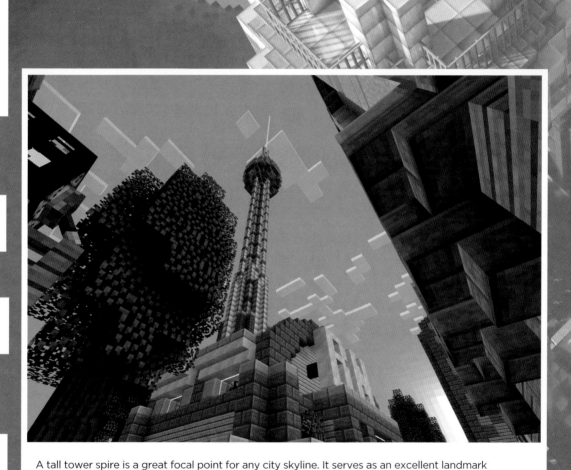

A tall tower spire is a great focal point for any city skyline. It serves as an excellent landmark that can be used for navigation, and the view from the top is always spectacular. Spires such as these should generally be taller than any of the other buildings and skyscrapers in the area. In this tutorial we use iron blocks, stone brick, slabs, and a little polished diorite.

1

FOUNDATION
To begin, create the foundation using a small ring of iron blocks surrounded by a larger ring of stone bricks. Add two four-block-long sections sticking out three blocks apart on each side.

2

STACK
Next, starting from the outside of the four block sections, add two stone bricks, leaving one space free at the end. Then add another stack of five stone bricks, followed by another stack of nine, then finally a stack of 14. Place a stone slab on the top of each stack. Repeat this three more times, one on each side.

3

BALANCE
To balance the structure of the foundation, add one nine-block-tall stack of stone bricks diagonally between the two tallest stacks, then two five-block-tall stacks of stone brick. Cap with a slab and repeat around the base three more times.

4

BUILD UP
Add two more stacks of stone brick behind the two taller stacks for a total of 20 blocks in height. Add chiseled stone brick to the top. Leave three stone bricks below, and then add another chiseled block. Cap with a slab and repeat three times around the foundation.

TUTORIAL

5

BASE

To create the base of the central tower shaft, add two stacks of iron blocks 28 blocks high. Then, behind, add two 2x1-wide stacks of iron blocks, 32 blocks high. Add two chiseled stone bricks to the middle and cap the rest with slabs. Fill the gap with glass blocks and repeat three more times around the base.

6

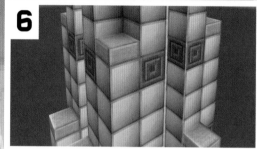

TOWER SHAFT

Next, add two sections of three iron blocks, topped with a chiseled stone brick, to create the beginning of the tower shaft. Repeat this section 11 more times, for a total of 12 sections, to create the tower shaft.

7

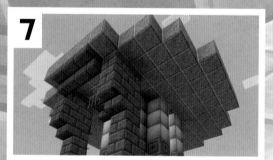

OBSERVATION DECK PLATFORM

Create the platform for the observation deck by making a circle of polished diorite that is 14 blocks in diameter. Add support underneath using stone bricks, and alternate normal and inverted stone brick stairs with a slab cap on the bottom.

8

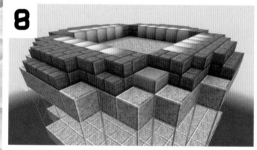

ENCLOSED OBSERVATION DECK

Create the enclosed observation deck by adding a stack of three glass blocks around the perimeter of the platform. Cap it with a layer of polished diorite, and then add stone blocks or stairs around the edge. The iron blocks around the inside will be for the topmost section of the tower, and the slabs on the corners for detailing.

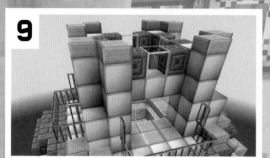

9 — TOP OF LAST SECTION

Start the top of the last section of the tower by adding two iron blocks in the corner, then four stacks of iron blocks on the inside of the two-stack. Span the stacks with three iron blocks, adding chiseled stone bricks and a glass block on top. Throw in some iron bars and slab caps on the stacks of four to create the detailing.

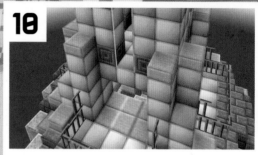

10 — MIDDLE OF LAST SECTION

Add the next section of the tower with more iron blocks and use chiseled stone brick detailing. Put in a stack of glass blocks between the middle sections. Add a ring of slabs around the top of the section with cobble fences underneath for support.

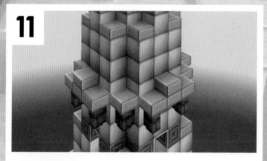

11 — TOP SPIRES

The final section of the tower is all iron blocks with slab caps. The two top spires are 19 blocks tall. Add some iron bars and redstone torches for extra detailing.

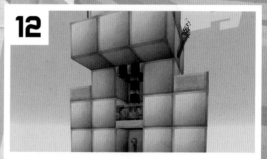

12 — BEACON

To top off the tower add a beacon block to the middle of the two topmost sections. Inside the top section, add a block with a lever on the side and a redstone torch on top. Add another block above the torch, with another redstone torch. Above the torch place a sticky piston with an iron block attached. Flip the switch to push the iron block up below the beacon block to activate it.

TIPS

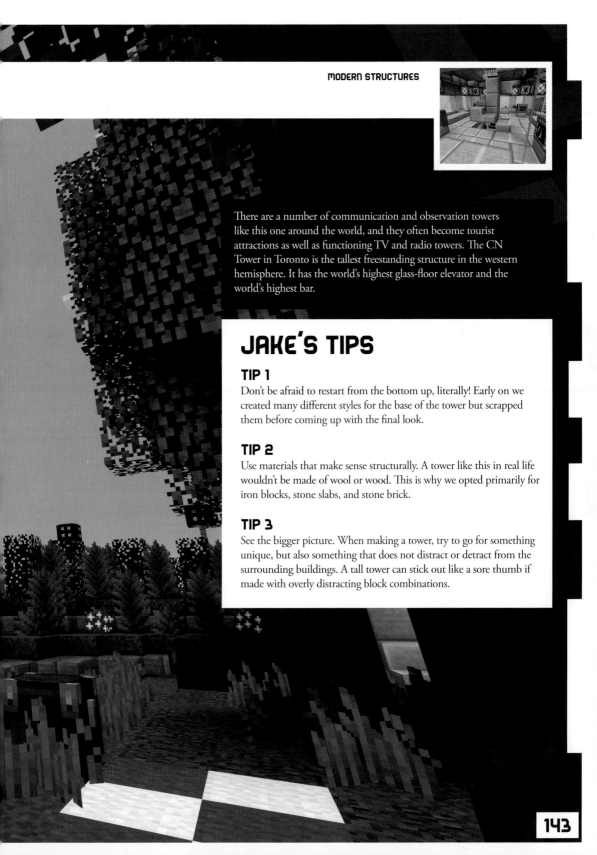

There are a number of communication and observation towers like this one around the world, and they often become tourist attractions as well as functioning TV and radio towers. The CN Tower in Toronto is the tallest freestanding structure in the western hemisphere. It has the world's highest glass-floor elevator and the world's highest bar.

JAKE'S TIPS

TIP 1

Don't be afraid to restart from the bottom up, literally! Early on we created many different styles for the base of the tower but scrapped them before coming up with the final look.

TIP 2

Use materials that make sense structurally. A tower like this in real life wouldn't be made of wool or wood. This is why we opted primarily for iron blocks, stone slabs, and stone brick.

TIP 3

See the bigger picture. When making a tower, try to go for something unique, but also something that does not distract or detract from the surrounding buildings. A tall tower can stick out like a sore thumb if made with overly distracting block combinations.

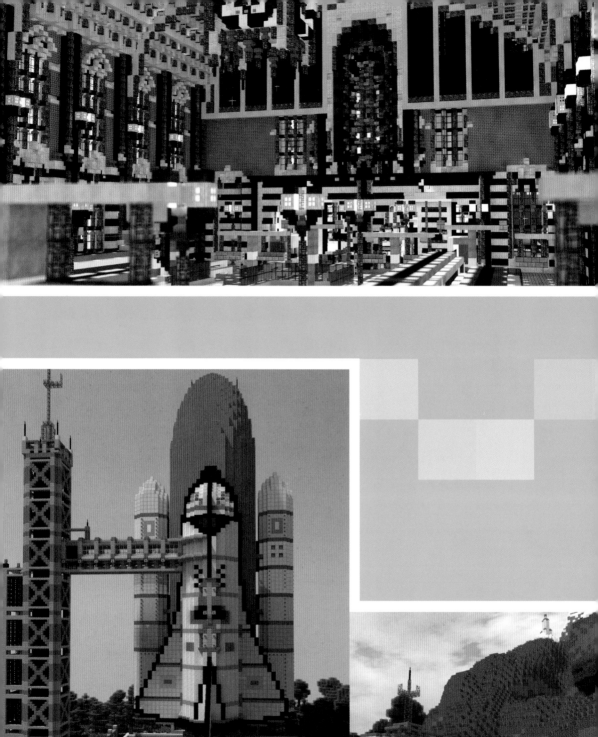

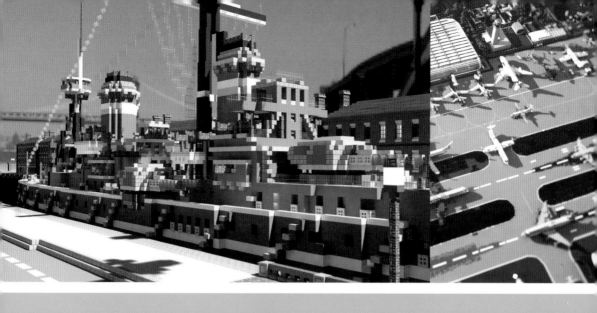

CHAPTER 3

TRANSPORTATION

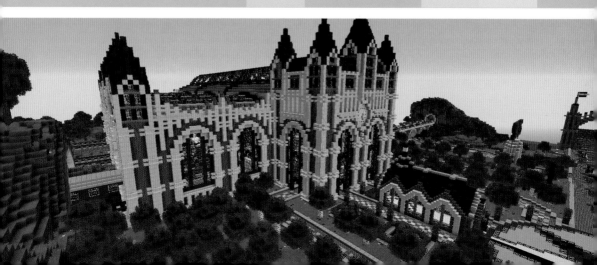

BERTLEY TRAIN STATION

Server: play.keralis.net
Shaders and mods: WorldEdit, Sonic Ether's
Unbelievable Shaders
Time to build: 21 hours

THE BUILDER

Daniel Davies is 21 years old and spends his days constructing and caring for pipe organs. His job allows him a great deal of creativity, and he feels it is his duty, as one of the few young organ builders around, to make sure the craft survives and is taught to future generations. Unsurprisingly, he has a keen interest in Gothic architecture and history and spends much of his time on Minecraft® creating Gothic cathedrals.

Daniel builds in partnership with his friend Cameron, who shares his passion for history and architecture. They have the most fun in-game building replicas. The satisfaction of successfully re-creating something people can easily recognize, gives them the most enjoyment. Daniel likes to build structures from buildings he likes in real life.

While the train station is part replica, it combines portions of structures from different sources. Some artistic adjustments and original features were included, with the challenge being to make sure they were feasible and realistic and that they fit in with the replica sections.

Starting with a floor plan, Daniel created a frame to get the correct shapes and proportions for the building first, and he made continual refinements along the way to get everything exactly how he wanted it to look. Then, the focus was finding the best ways to translate real-world shapes and details into blocks. In the end, Daniel was happy with the station, but would have preferred the building to be on a slightly smaller scale.

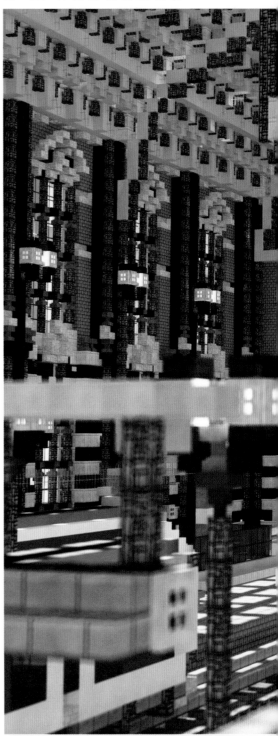

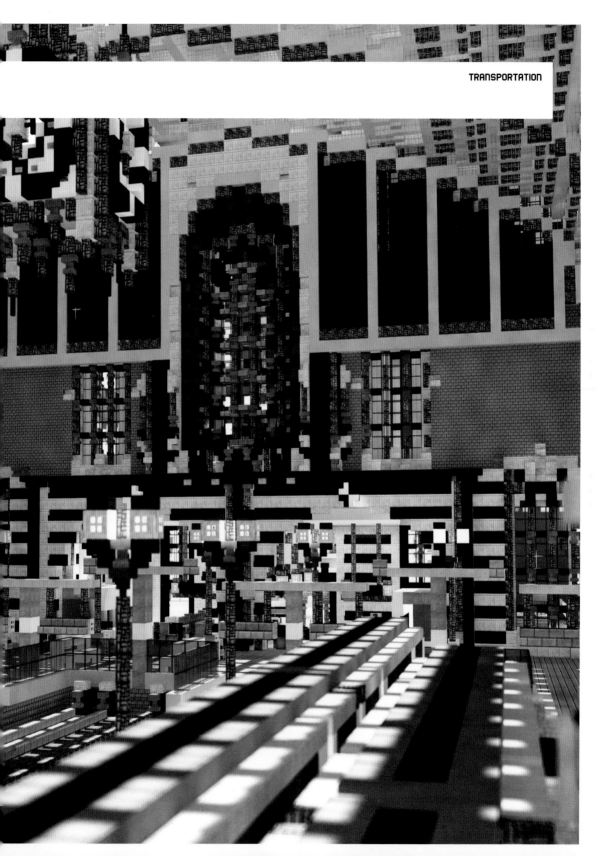

TUTORIAL

If you can make a Gothic-style wall with a stained-glass window, you'll have an important part of any cathedral design that you can use for your own fantasy creations, or use the basics here to re-create existing buildings.

1
FLOOR PLAN
Start by creating a basic floor plan, which can be laid out before building begins, or have a real-life floor plan to hand. These can be easily obtained by searching the Internet.

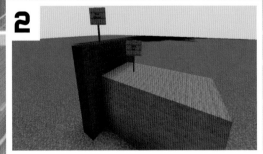

2
MODEL
Create a model to work from, using your floor plan, so you have a clear idea of the scale and proportion.

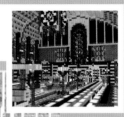

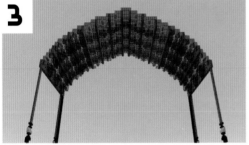

3

MODULES

You can construct your building in modules or bays. This allows you to save time later on.

4

PASTE

Once you have your module constructed, paste it over your floor plan. In this example, the train station's engine shed is being placed.

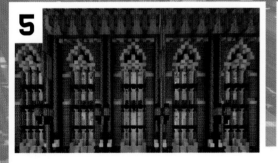

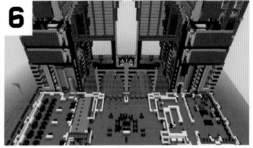

5

BLEND

Take any steps needed to ensure the bays are blended together correctly, and check if any part of the bay should be adjusted. It will be harder to fix later on.

6

HOTEL PLAN

Next, lay out the plan for a hotel at the front of the station. This part of the building serves as the primary entrance and exit for the platforms in the engine shed.

TUTORIAL

7

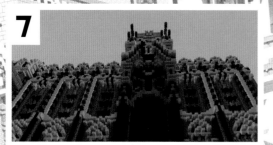

PROPORTION
Make sure your hotel looks balanced and is in proportion with the engine shed. There are a large number of material combinations you could experiment with when doing this.

8

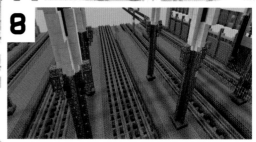

FURNISH
Furnish your engine shed with platforms, tracks, and other objects to bring the station to life.

9

DECORATE INTERIOR
Decorate the interior of your hotel at the front of the station. You can include stores, offices, and ticket booths.

10

FEATURES
Add features like lighting, and carefully place them to give the building extra depth and atmosphere.

11

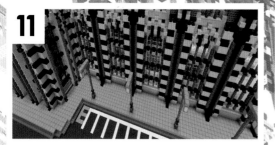

PARKING
The outside of the station should have parking spaces and taxi stands to give it a sense of modern realism.

12

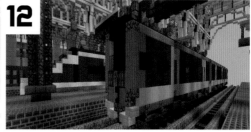

TRAINS
Finally, add the trains themselves. Play with train designs that fit your tracks. Carriages around five blocks in width and 25 blocks in length should work well.

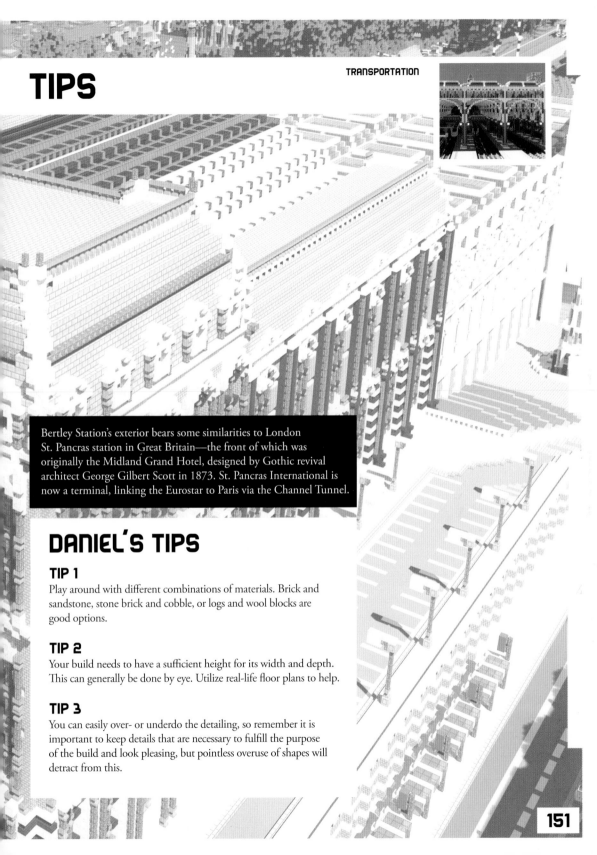

TIPS

Bertley Station's exterior bears some similarities to London St. Pancras station in Great Britain—the front of which was originally the Midland Grand Hotel, designed by Gothic revival architect George Gilbert Scott in 1873. St. Pancras International is now a terminal, linking the Eurostar to Paris via the Channel Tunnel.

DANIEL'S TIPS

TIP 1

Play around with different combinations of materials. Brick and sandstone, stone brick and cobble, or logs and wool blocks are good options.

TIP 2

Your build needs to have a sufficient height for its width and depth. This can generally be done by eye. Utilize real-life floor plans to help.

TIP 3

You can easily over- or underdo the detailing, so remember it is important to keep details that are necessary to fulfill the purpose of the build and look pleasing, but pointless overuse of shapes will detract from this.

SPACE SHUTTLE

Shaders and mods: WorldEdit, VoxelSniper, Forge,
Shaders Mod, OptiFine, Bukkit Server, MCEdit,
Sonic Ether's Unbelievable Shaders
Time to build: Eight hours

THE BUILDER

Felix is a 24-year-old student from western Sweden. Living
in a country full of lakes, mountains, the midnight sun,
archipelagos, and pine forests, it's not surprising that he
has an interest in environment design. Felix loves creating
3-D designs using the 3-D program Blender and, of
course, Minecraft®. His ambition is to be a game-level
designer, and he's working on landing a spot in this area in
a very competitive market.

Minecraft is a great tool for creating game levels. They can
be built, modified, published, and tested by the enormous
user base. Just by playing the game, Felix feels he's learned
a lot about how players move in 3-D environments, and he
puts that knowledge to use in his designs.

Felix first played Minecraft after reading about it on
a gaming website. At that time, the game was played
in a simple web browser, and he could immediately see
its huge potential. The community plays a big role in his
love for Minecraft.

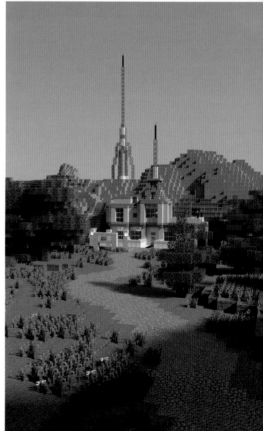

While a fan of building in the fantasy genre, Felix wants
to give every style a shot. He insists it's impossible to know
just how fun it is to build a space-themed structure until
you've tried it for yourself!

Originally, the design was to be entered into a competition
that got canceled. Felix's entry was about a huge meteorite
on a collision course with the Earth. The shuttle was for
taking seeds and other vital objects into space, to later
replenish the planet's surface.

Felix designed the main shuttle structure by googling a
simple image for reference. It was his first modern-style
map, and he learned a great deal about building from its
creation. As a result though, he was left with a number
of elements he'd like to refine and he has even considered
remaking the whole build.

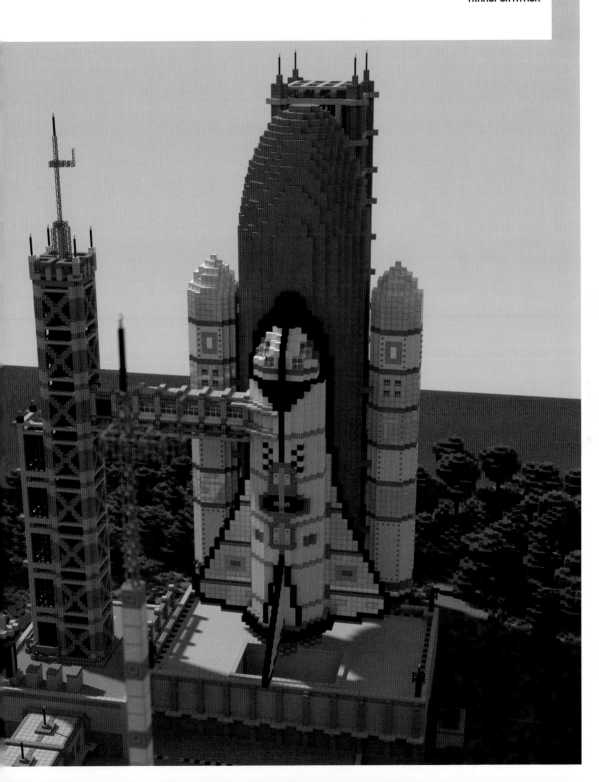

TUTORIAL

The entrance tower for the rocket is in a style you can use in modern builds or in a build set in the space age. The tower might look complicated to make, but in this tutorial you will see that it's quite straightforward. You can change the pattern and size of the tower to make something completely different. It's a useful structure.

1

BASE

The base structure is a simple "X" pattern. The "X" is made out of stone brick stairs. Notice that the middle two are one upside-down stair (bottom) and a normal one (top).

2

CORE

The core of the tower is made out of 5x5 black wool and hollow. The reason it is black is because the black wool contrasts very well with the light-gray support structure.

3

REPEAT
This is a fairly simple build when you get the hang of it. It's a case of repeat and stack. Repeat the base "X" structure around the black core.

4

STACK
This can take a while if you do not use a building tool like MCEdit or WorldEdit. It's a case of stacking the base structure you have made seven times.

5

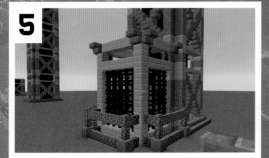

STABILIZER
To make the stabilizer, build a 10-high and 5x5x7 structure using double slabs. Fill the empty space with nether brick fence.

6

STACK
Stack the basic core of the structure four times and add the top. Build a base sticking out of the tower on the sixth floor.

TUTORIAL

7

ROOF

Add a roof and fill the inside with black wool, leaving a 2x1 walkway inside. Fill the outside with nether brick fence.

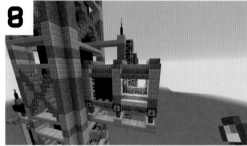

8

LIGHT

Build a similar stack, but now replace the nether brick fence with glass panes and a sandstone stair. Do not add any black wool. Top it with the signal light.

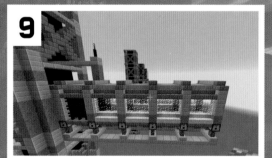

9

REPEAT STACK

Stack this three more times horizontally.

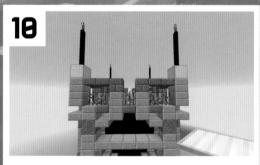

10

ANTENNA

Time to finish the top with the antenna. Repeat it on each side. The top should now be a square, with the iron blocks in each corner, instead of being eight-sided.

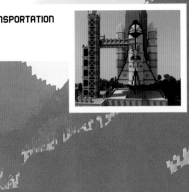

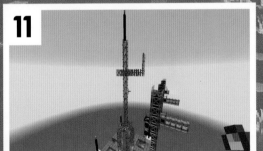

11

PILLAR

Build a five-block-high pillar with half slabs and use iron bars in a 3x3 square around it. Build 15 high with iron bars and put another antenna on the 10th.

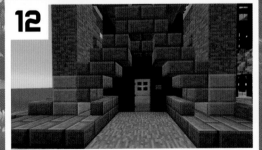

12

DOOR AND INTERIOR

Add a door on the side you prefer. On the inside, you can put in your own stairs and a ladder or use command blocks.

TIPS

A space shuttle is a reusable low-Earth orbital spacecraft. Shuttles were used on 135 missions, to help build the Hubble Space Telescope and the International Space Station. The design was retired in 2011. Until another manned spacecraft is ready in the United States, crews travel to and from the International Space Station aboard the Russian Soyuz spacecraft.

FELIX'S TIPS

TIP 1

Picture the whole map in your head. Use your imagination to tour it in your mind. This can give you a good idea about where to place buildings and how to scale them properly.

TIP 2

Why build huge terrain and buildings by hand when you can use building mod tools, which make the same job much faster? Have you ever seen a construction worker banging a nail with his bare hand? Of course not—he uses a tool to aid him. Mods can be intimidating at first, but there are plenty of guides out there to help you, and once you have learned how to use them, you will never look back.

TIP 3

Don't be afraid to tear down structures that you are not happy with. This is how you become a better builder.

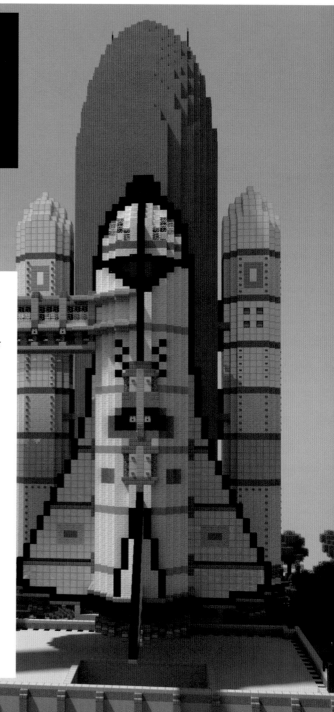

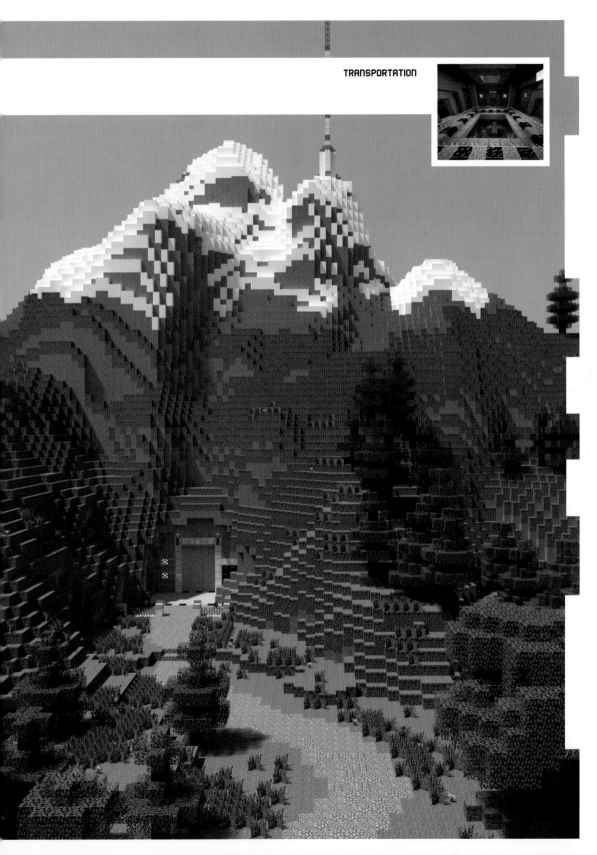

DREADNOUGHT BATTLESHIP

Server: play.keralis.net
Shaders and mods: WorldEdit, VoxelSniper
Time to build: 15 hours

THE BUILDER

Cameron Stebbing is 17 and from Birmingham in Great Britain. He is currently studying for A levels at school and spends his spare time drawing and painting. One of Cameron's great loves is architecture, which he channels into his Minecraft® creations. Old navy ships also fascinate him. He likes painting seascapes and visiting historical buildings and vessels. Two of his favorite visits have been to see HMS *Victory* and the SS *Great Britain*.

Cameron began building as soon as he discovered Minecraft back when it was in Beta and before there were blocks such as stairs and upside-down slabs, which have become so integral to the building process today. For Cameron, there is so much more to Minecraft than just 3-D blocks. A member of the World of Keralis server since 2012, Cameron and the whole group are focused on creating realistic cities.

His love of Gothic cathedrals and old ships has led Cameron to build more and more ambitious structures over time. Along with his friend, Daniel who lives close by in Shropshire, Cameron works on architecturally realistic structures and creates replicas of old merchant sailing ships, modern warships, and every type of ship in between! Daniel also worked extensively on World of Keralis' Bertley City, the train station on page 146.

After reading an old book on the First World War dreadnoughts, Cameron went on an Internet hunt for some navy ship plans. Getting started is always the hardest part of building ships for Cameron. Getting the hull and cross-section shapes right is imperative. He prefers not to use too much ribbing down the hull because, although it is a good way to get a realistic curve, it stops opportunities to experiment. Without this skeleton, it took Cameron a few attempts to get the dreadnought shape he wanted. He's most proud of the superstructure and the main guns. Cameron is currently working on a Canopus-class pre-dreadnought.

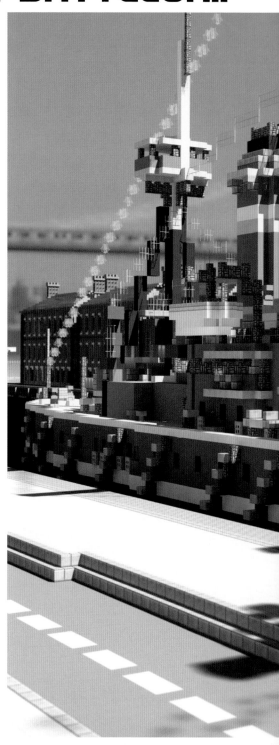

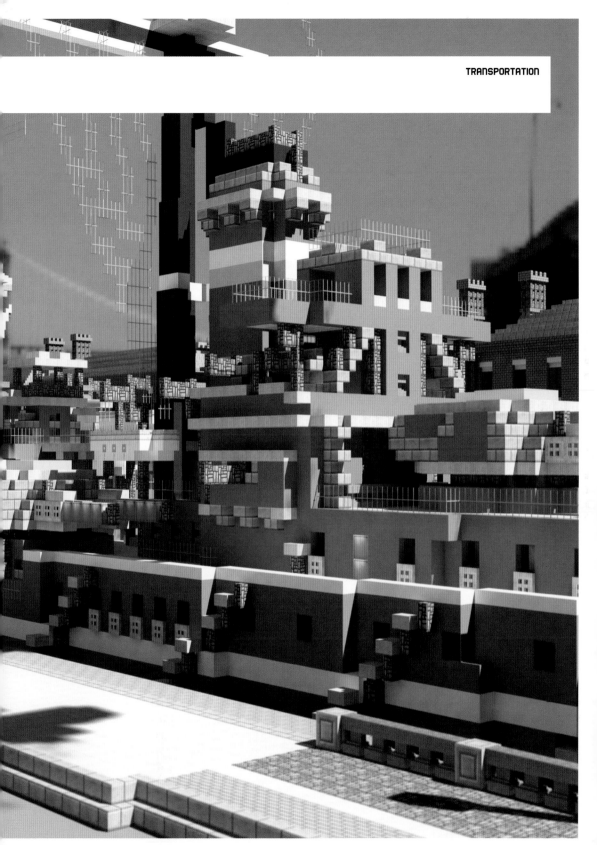

TUTORIAL

MARK

First, mark out the best lines you can. Shape the deck layout from above, then from the side and the cross section from the front. The front of the hull curves out in a point, and the back is raised up over the propellers and rudder. The shape from above should be trim and sharp.

HULL

Fill in the shape of the hull. Try to make pointed shapes pushing toward the front, but as the ship moves back, they should curve toward the middle. Remember to link it up with the cross section in the middle.

BACK

Place blocks on the back of the ship in a more curved way and less sharp than on the front. The most difficult part is to get it to arch over where the rudder will sit, but this can be achieved if you stick to the lines that you laid out.

PROPELLERS

Add the rudder to the back in a fin shape and add simple propellers made of yellow stained clay projecting from the back of the hull. Use gray wool to make the hull more colorful, but keep the red below the waterline on the ship. Make portholes out of glass along the side.

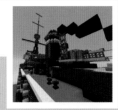

5

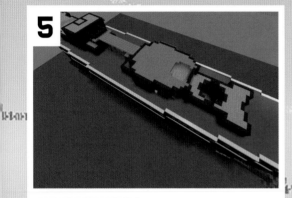

SUPERSTRUCTURE
The structure on the top is called the superstructure and is where the masts, funnels, bridge, and big guns will sit. Raise the front of the ship and leave holes for the main guns. Make the deck green with wood parts higher up.

6

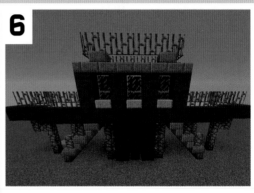

BRIDGE
Now you can begin work on the bridge. This can be made using more gray wool in a "T" shape by punching some windows along the top. Use iron fences to mark out the walkways and stone walls, and make more supports on the side.

7

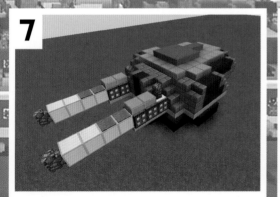

BIG GUNS
With the superstructure laid out, start working on the big guns. Make a circle shape and place another curved shape with a wide front on top to replicate the turret. Use iron blocks for the barrels of the 12-inch guns, along with pressure plates and trapdoors to make them menacing!

8

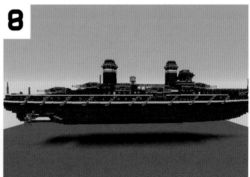

TORPEDO NETS AND FUNNELS
Position the bridge at the front and place the guns in the holes of the superstructure. Add diagonal lines to the side of the ship to act as torpedo nets, and make the funnels as cylinders, with some white bands around them.

TUTORIAL

9

MASTS

This ship doesn't have sails, but masts should be made very tall to house a lookout and range finder. Make them wider toward the bottom. At the top, add perpendicular arms to hang signal flags from.

10

SMALL BOATS

Make small boats to hang off the side of the ship—this can be done by placing quartz blocks with upside-down quartz stairs in front of them. Birch slabs on top finish them off nicely. Stone walls are good for the arms from which to hang the boats.

11

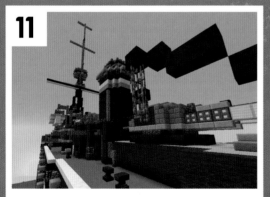

DECK DETAILING

Add details to make the deck look livelier. Trapdoors can be placed below the windows, black stained clay makes simple cranes used for loading, and anvils make good points to tie ropes around for the rigging.

12

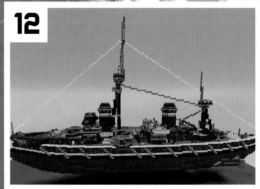

RIGGING

Use cobwebs for the main parts of the rigging and iron fences for smaller parts. Color in the top of your masts yellow.

TIPS

During the First World War, dreadnoughts were the most powerful ships in the world. The British Royal Navy had the largest fleet. The layout of this ship is unique, but Cameron based it on HMS *Dreadnought*. It has a similar length and armament. At the time of completion in 1906, HMS *Dreadnought* was the fastest battleship in the world.

CAMERON'S TIPS

TIP 1

Be sure to mark out the shape of your ship from the topside, and from as many cross sections as you have, so that the shapes work realistically. Spend time making sure the proportions look correct, and if you are re-creating, use the real proportions of a vessel.

TIP 2

Don't be lazy and not include the parts below the water, as these make the rest of your ship look so much nicer and make it easier to work on. Play around with the shapes of your hull until it all works together. Try to use sharp and defined shapes on the bow. Toward the middle section, use some curves and slight ellipses to make it mold well.

TIP 3

Materials are very important to get the right look for your ships. Black and white with yellow funnels and masts achieve a smart look, but for battleships a gray is effective with some white quartz bands on certain areas. Make sure you use the right colored half slabs on the superstructures.

AIRPORT

Server: mc.worldofkeralis.com
Time to build: 60 hours

THE BUILDER

The 18-year-old Belgian architecture student who created the Airport build goes by "Xumial" in Minecraft®. He has been a member of the Keralis creative server for three years. In that time, being part of the group has opened up a whole world of different people and cultures for him. As well as gaming, Xumial likes drawing, painting, and playing basketball.

Alongside his own projects, Xumial has worked on larger group projects like the server edition map created for one of the MineCon conventions. His favorite things to build are real-world structures with multiple elements, such as train stations, malls, and of course, airports.

Xumial's airport, based on Doha in Qatar, is the international airport of the large-biomes map in the World of Keralis. He was asked to create the structure, as he's an experienced airport builder and had impressed the team's admins with his previous work. His favorite thing about the building is the fact that many of the airplanes, cars, and stores were created by members of the community—it was a real team effort.

Xumial didn't do a great deal of research, but the hard work came in the practical planning of the different areas and building the finer details like check-in counters, bathrooms, and parking facilities—all the things that go into making the airport feel real. Built over three weeks, Xumial felt this was a quick process, with a few breaks worked in to renew his energy and inspiration.

He can't help but walk through his airport and spot things he'd like to make better, but Xumial says that at some point you have to be satisfied with the structure and move on to something new. He feels he's learned a lot about planning from this build and will incorporate his new knowledge into his next project—another airport!

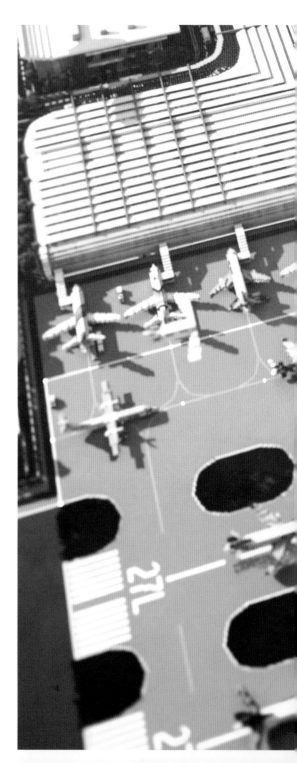

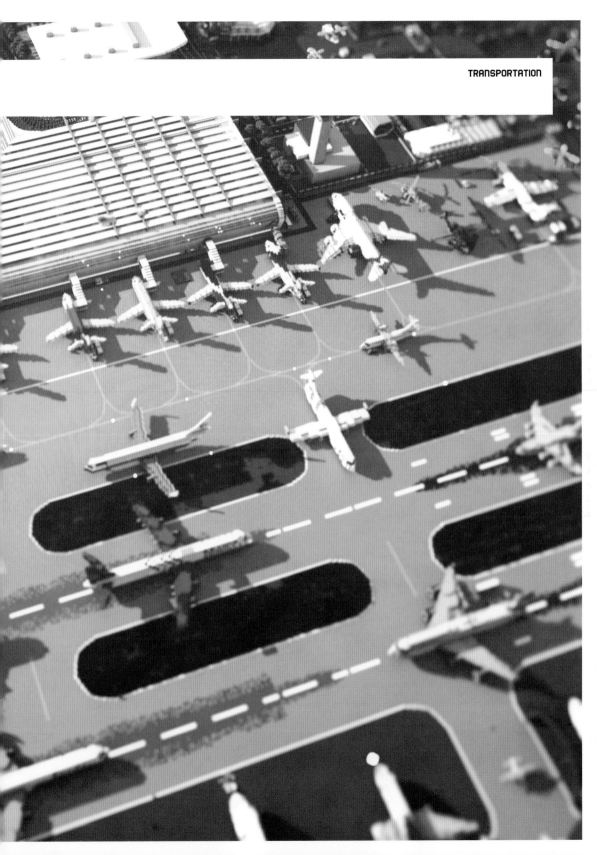

TIPS

Doha International Airport, which this build is based on, was, until recently, the main Qatar airport. It was expanded several times to service the 12 million passengers a year that used it. It had one of the longest runways in civil aviation and was mostly used by vacationers. The new Hamad International Airport was built nearby, and Doha will be demolished soon and replaced by the Al Sahan Airport City project.

XUMIAL'S TIPS

TIP 1

Planning should always be the first step of a successful build. Whether it's a big or small project, always plan your layout.

TIP 2

Make custom furniture for your build, but try to balance how much you use in each room and keep the style consistent.

TIP 3

Take criticism. You can make a structure that has many problems without being aware of it. Take ideas from other people seriously, and find a suitable solution. The ability to take constructive criticism is the best tool for becoming a better builder!

RAILWAY STATION

Server: s.minecraft.name / s.worldofminecraft.de
Time to build: Three weeks
Blocks used: 125,000

THE BUILDERS

Brauhaus der Hoffnung is known for its enormous projects, usually built as cities on one particular theme.

The Railway Station was a build that came about through necessity. The team wanted a way to connect the various theme-based cities on their server. The design of the station would define the theme of their capital city, and give them somewhere to start when planning.

The railroads were built first, and the station fit to the rail lines. Although some calculations were done to decide the size of the station, it was not built to replicate an existing structure. This had both advantages and disadvantages. Without a plan to build from, many mistakes were made during construction that had to be fixed later. However, since the station was created entirely from the imaginations of the builders, some mistakes could be turned into design elements to become integral parts of the building's plan, giving it a greater sense of character.

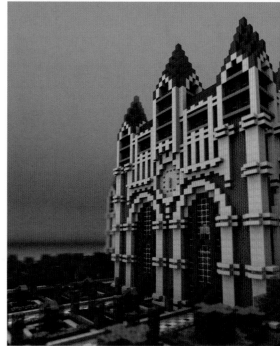

The Railway Station went on to be used as a meeting point for hundreds of gamers before they began their adventures throughout the world, visiting different cities—very much as it would be in the real world.

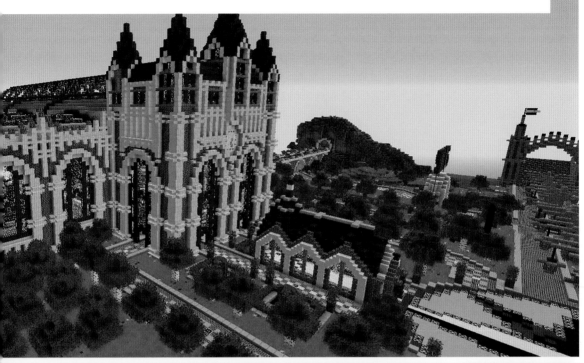

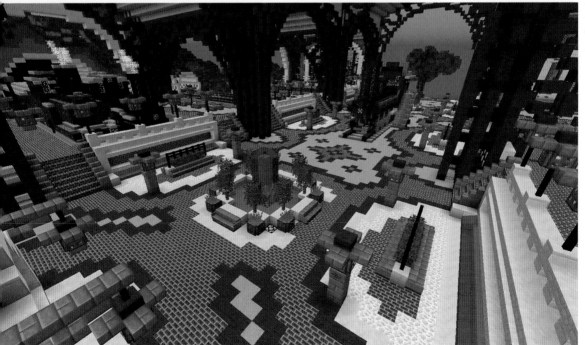

TUTORIAL

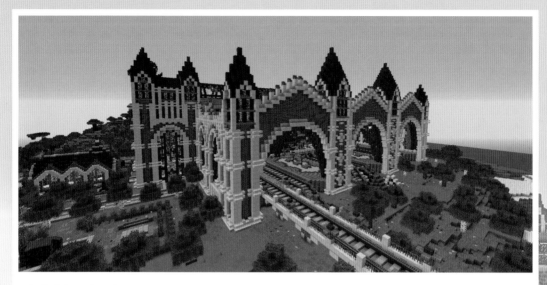

To build a railroad station, start by thinking about the number of rail lines that will need access. It's better to have one too many than one too few. If you're using classical architecture, bricks should be your primary block with sandstone offsets. Use dark-gray wool for your roof and stone slabs for highlights.

Don't forget, you'll need platforms on each side of the tracks. Build the footprint of the main structure using bricks. Expand the building, creating a wireframe to the designated height.

1
STRUCTURE SKELETON AND WALLS
Once your structure skeleton looks good, fill up the walls with bricks, leaving space for very big doors and windows.

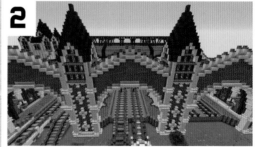

2
TOWERS AND TURRETS
This station has towers and turrets. Once you decide where they will fit best, build their shells. Always orientate them to the rails and merge the shells with the rest of the building.

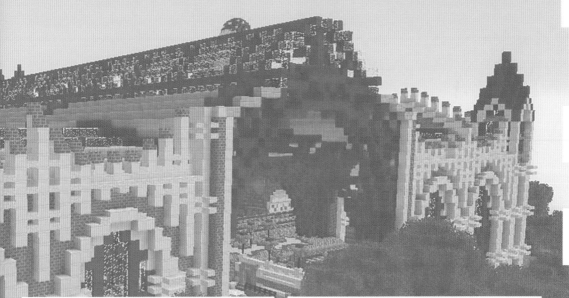

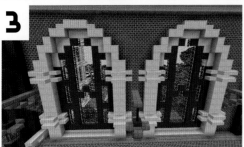

DETAILS

Add random squiggles in sandstone to both the windows and tower walls. Prepare the roof by adding the dark-gray wool. Keep looking at the building from a distance to see how it adds to the look.

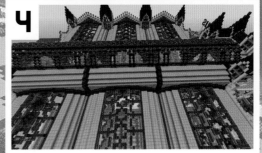

ROOFS

Build flattened dome-shaped roofs above each rail line, highlighted with stone slabs. Add glass to the middle of the building for lighting. Pattern the glass with the wool.

TUTORIAL

5

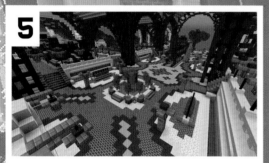

MAIN HALL

Elevate the rail lines above the main entrance and the main hall. If necessary, lower the main entrance to achieve this. Add steps from the main hall to each platform. Add some pillars in the main hall and strut them to the ceiling with gray wool.

6

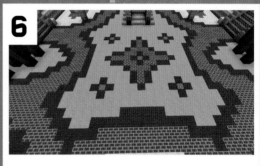

FLOOR

Place the floor using brick and highlight it with pattern using sandstone, dark-gray wool, unburned clay and other design blocks. Add lanterns, floor lights, and redstone lamps. You can also add furnaces for passive lighting in the floor. Finish the interior with banks, indoor fountains, and signs.

7

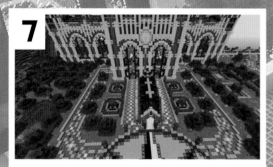

LANDSCAPE

Add roads, trees, grasslands, flowers, and parks outside the station. These frame the whole structure, without distracting from the main building. Don't forget the entrance from the main road of your city to your station.

8

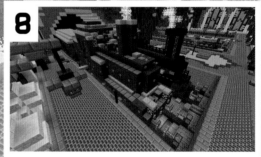

TRAINS

Finally, build locomotives on a few lines to make your station really spectacular.

TIPS

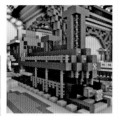

The beautiful steam locomotives featured in this station are great examples of the early-20th-century trains that dominated travel until the middle of the century. In some countries, due to political and economic difficulties, electric trains did not replace steam trains until as late as the 1980s.

BRAUHAUS DER HOFFNUNG'S TIPS

TIP 1

By doing an Internet search for "train station gothic" you can find a lot of inspiration for creating a structure like this. Keep the surrounding landscape or existing buildings in mind while planning your building.

TIP 2

Use a blueprint, and then create a framework for your walls. Make sure you leave spaces for windows. If you build by starting at one corner and then build the outer shell from block to block, you may run into difficulties with the interior. With a framework, you can consider the inner rooms beforehand.

TIP 3

A station is a practical place with architectural grandeur. You can evoke this by making patterned floors, oversize lights, and elaborate support work for a domed glass ceiling. Practical things like signs, walls, stairs, and start tracks all add to the feel. Don't forget water features, plants, and flowers around the exterior.

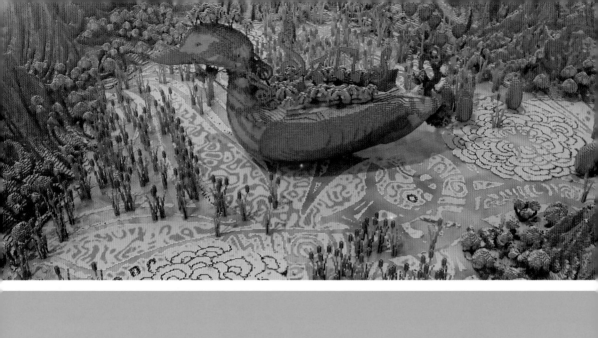

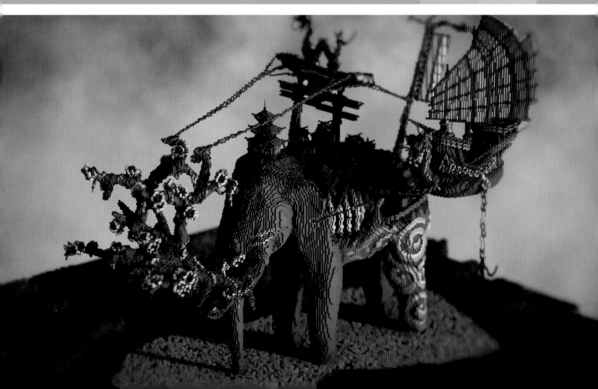

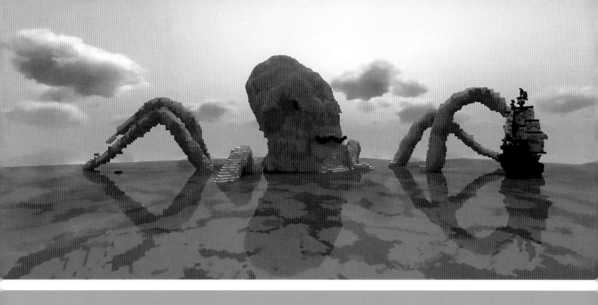

CHAPTER 4

CREATURES

DIDAPPER DOLPHIN CONVOY

Server: US.Shotbow.net: Qubion Creative
Shaders and mods: WorldEdit, Sonic Ether's
Unbelievable Shaders
Time to build: 21 hours

THE BUILDER

Canadian 17-year-old "Jimjabway" is at the end of his high school career and about to go to university. He has a penchant for playing the video games of his childhood and enjoys the nostalgia they bring. It's no surprise then that Minecraft® caught his attention two years ago, with its simplistic format and blocky graphics. He quickly became interested by the creative possibilities the game provided.

Jimjabway's fascination with architecture, engineering, and physics is clear to see in his Minecraft creations, but he also likes to get out and about, enjoying badminton and swimming in his spare time away from schoolwork.

Like many Minecrafters, Jimjabway avidly watched YouTube videos of other people making incredible creations in the game before deciding to try it out for himself. He found the community very supportive and willing to help him improve his skills. He started working with the Qubion build team and met players from around the world who share the same passion and are always there with advice and a pair of virtual hands.

His first love is building structures, and Jimjabway spends most of his time working on these, but his friend "DaKing" introduced him to the world of shipbuilding and taught him all about the concepts and processes involved. It is this teamwork, and learning from one another, that keeps Jimjabway so closely involved with the game and community.

There was no way to create the vision Jimjabway had for this build without researching dolphins, since the key to the build was a foundation in marine biology. The dolphin is a cross between the bottlenose and Pacific white-sided breeds. The concept he wanted to convey was of a world where ships attach themselves to giant dolphins for speed and as a means of defense. The most difficult part of the build was creating the organic shape of the dolphin, which Jimjabway had less experience with. Now, long after the project was completed, he feels particularly pleased with the dolphin and its uniqueness. However, he has honed his shipbuilding skills even more since, and is moving forward with new projects.

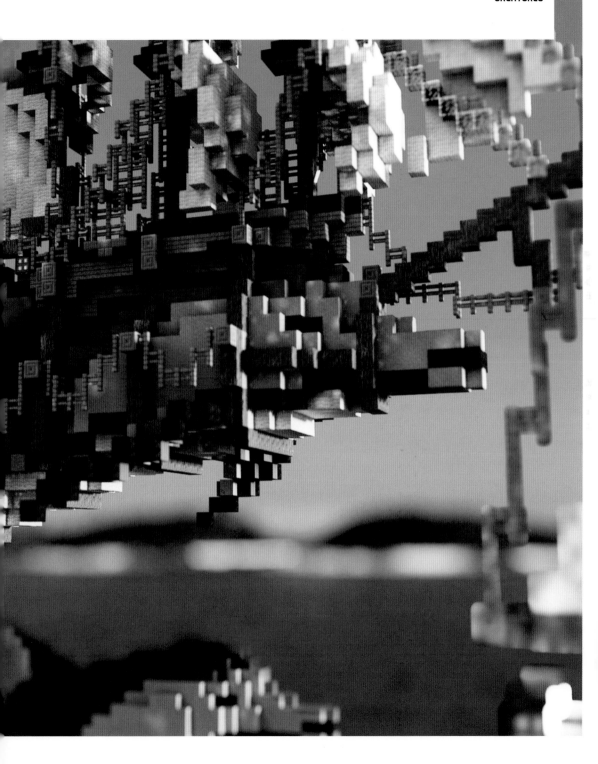

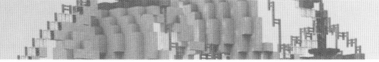

TUTORIAL

Here is a quick tutorial for making a small, two-mast ship. Use smooth curves for the hull and the sails, as they are organic elements. This is a more modern style of ship than a galleon, but will fit well in many different settings. These steps can be applied to any ship, and serve as solid, basic guidelines. Three types of sail are used, based on the most basic sails used on the majority of ships. On larger ships, add windows and more decks.

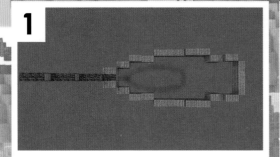

1
OUTLINE
Make an outline of the ship from a bird's-eye view. Use some logs to create a bowsprit at the front of the ship.

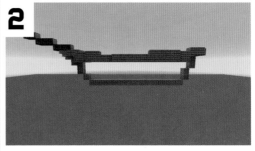

2
CURVES
Make an outline of the bottom of the ship. Use slabs and stairs to create smooth curves. Look at a reference image to help you with the shape.

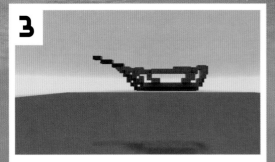

3
HULL DESIGN
Outline a series of recessing ovals on the side to design the shape of the hull. Avoid straight lines, as they detract from the organic look.

4
COLOR HULL
Fill the curved shapes to make a general hull. Color the hull using blocks of your choice.

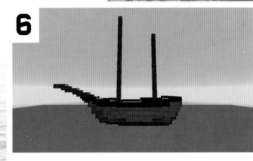

5

FILL TOP LAYER
Fill the top layer of the hull with slabs. Try to keep the hull higher than the deck.

6

MASTS
Add masts to your ship. The masts should be roughly as tall as the hull is long. Make the mast in the front taller than the one behind.

7

YARDS
On the front mast, add horizontal yards to hold the sails. Try having these at an angle to help make the sails. Don't add a yard at the very bottom.

8

SAIL
Between each pair of yards, make a sail. Use smooth curves to give it an organic look. At the lowest yard, the sail should come in toward the hull.

TUTORIAL

9

SUPPORTS AND SAIL
On the back mast, add two supports for a sail. Try to angle these out toward one side slightly. Add a sail between the supports.

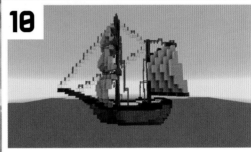

10

RIGGING
Add rigging to your ship. Connect the front mast to the bowsprit and the back mast. Add rigging between the yards and from the top of each mast to the hull.

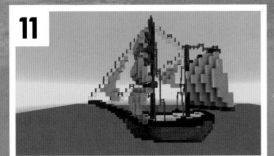

11

TRIANGULAR SAILS
On the rigging from the bowsprit to the front mast, and the back mast to the front mast, add sails that are parallel to the hull. Give them a triangular shape.

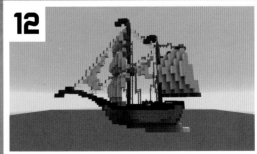

12

FLAGS AND DETAILING
Add flags to your ship as well as any final details. Be sure to have the flags blowing in the same direction as the sails! Chests on the deck, as well as lights, are nice options.

TIPS

While the curvature of the dolphins depicted in this Minecraft®
build is morphologically most similar to the gray bottlenose
dolphins, the coloring is that of Pacific white-sided dolphins,
which tend to have sleeker bodies. Both species have close
relationships with humans. The Pacific white-sided dolphin often
rides alongside boats, while the highly intelligent bottlenose
dolphin works symbiotically with fishermen to share catch.

JIMJABWAY'S TIPS

TIP 1

Practice makes perfect. Don't give up after your first attempt at
building something. The more you build, the better you will get.
Looking at builds others have created is a great way to be inspired.

TIP 2

Start any projects that you work on with the part that you
enjoy the least. This will ensure that you don't lose enthusiasm
for the build.

TIP 3

When making organic shapes, always use smooth curves to create
a better effect. Even though Minecraft uses cubes, when working
on a large enough scale, you can create nice curves. Think of them
as pixels on your computer screen.

WHAT THE DUCK?

Shaders and mods: OptiFine
Time to build: Six hours

THE BUILDER

Solo builder "Rastammole" has been creating
his amazing and wonderfully weird structures
in Minecraft® since 2014. This may account for
how unique his work is. He doesn't isolate himself
from the community, however, as he is part of a
few different large groups, while still spending a
lot of time working on his own amazing builds.
He feels it's a great way to express himself.

Although it is a particularly strange structure,
Rasta did have to do some considerable research
to get his duck just right. In many ways, the more
fantastical and strange the build, the more research
needs to be done to anchor the structure in
something relatable. The duck is adorned with
trees, balloons, and music notes.

The biggest challenge was that Rastammole
only used three types of blocks, and this made
the work quite difficult. Although this is something
he would consider changing, he is really pleased
with the final look.

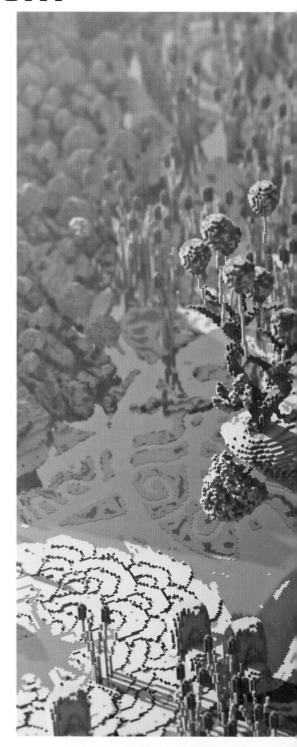

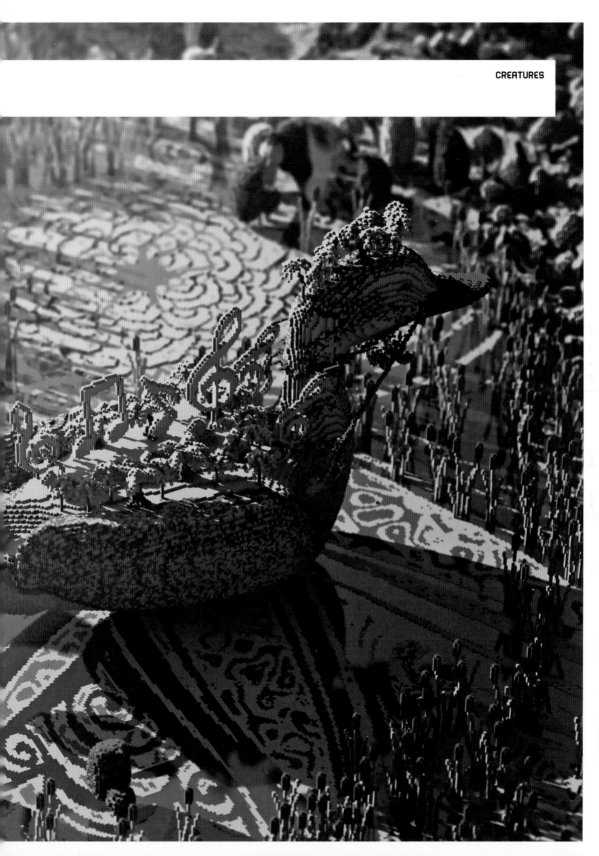

TIPS

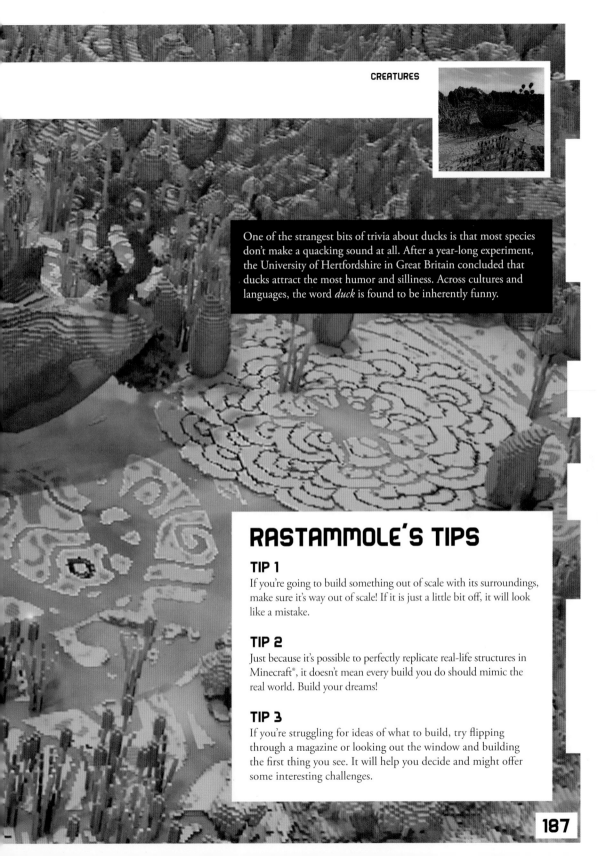

One of the strangest bits of trivia about ducks is that most species don't make a quacking sound at all. After a year-long experiment, the University of Hertfordshire in Great Britain concluded that ducks attract the most humor and silliness. Across cultures and languages, the word *duck* is found to be inherently funny.

RASTAMMOLE'S TIPS

TIP 1

If you're going to build something out of scale with its surroundings, make sure it's way out of scale! If it is just a little bit off, it will look like a mistake.

TIP 2

Just because it's possible to perfectly replicate real-life structures in Minecraft®, it doesn't mean every build you do should mimic the real world. Build your dreams!

TIP 3

If you're struggling for ideas of what to build, try flipping through a magazine or looking out the window and building the first thing you see. It will help you decide and might offer some interesting challenges.

TAMASHI KYARIA

Shaders and mods: WorldEdit, VoxelSniper
Time to build: 50 days
Blocks used: 4,000,000

THE BUILDER

The BlockWorks team is known for its unusual builds and for creating incredible structures in a variety of different styles. Some are entirely visual builds, made simply for the pleasure of constructing them and for players to admire; others make perfect mini-game maps, featuring hidden areas filled with all kinds of interesting places to play games in.

BlockWorks builders come from all over the world and from a variety of different backgrounds. While many are students, the team also includes a chef and a firefighter, among others.

Tamashi Kyaria is a truly epic build, and it provides the perfect opportunity for a highly unique server spawn or mini-games map. There are numerous structures both on top and inside this huge pachyderm, which serve as portals, stores, or information areas. The tethered airship gives a majestic viewpoint—an ideal position for any player's entry point.

This legendary beast is tasked with transporting souls across different realms. The elephant features a small village and farms on its back, and its stomach, which contains a small town, is also accessible.

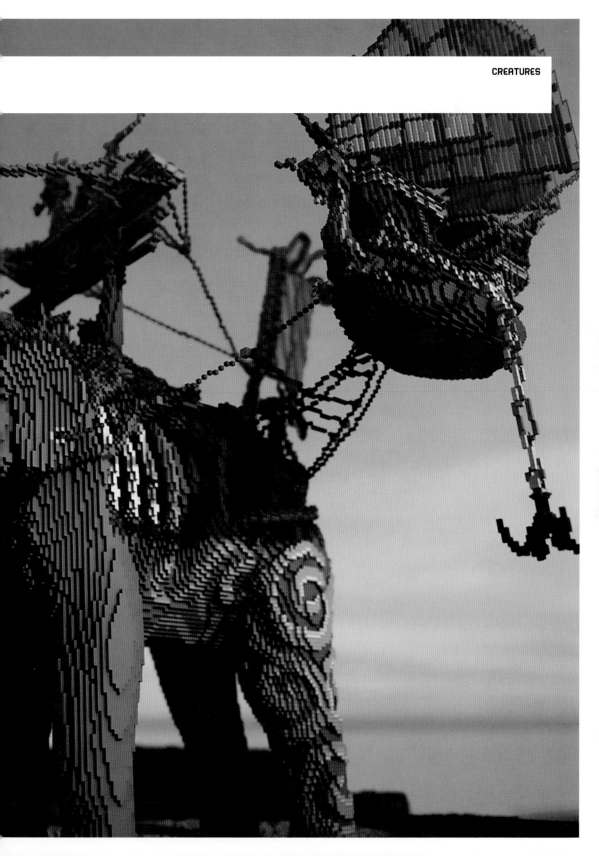

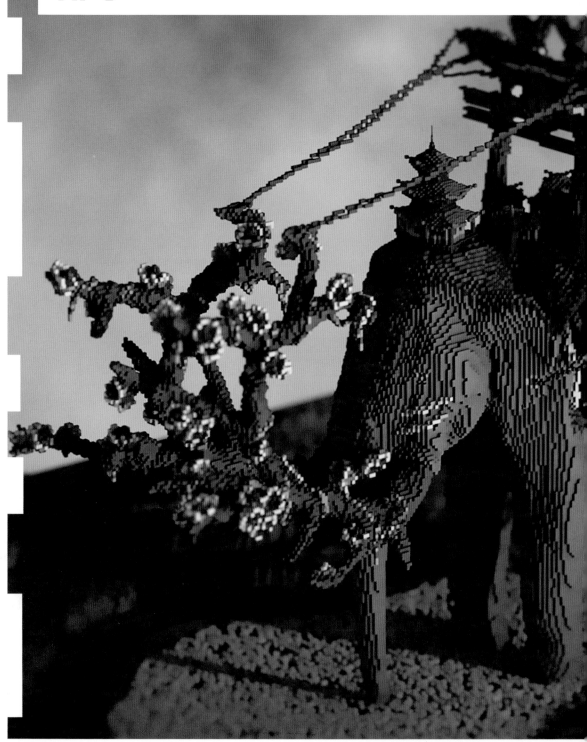

TIPS

Elephants have been used as working animals for transport and carrying since they were first used by the Indus Valley civilization in around 3000 BC. Even as recently as the year 2000, there were 16,500 working elephants in Asia. They are highly intelligent mammals and can respond to more than 30 commands. In Thailand, elephants digest coffee beans, which are then used to make Black Ivory Coffee, which is mild and less bitter than other coffee. This is because the protein has been broken down in the elephant's stomach before the beans are collected from their droppings.

BLOCKWORKS' TIPS

TIP 1

Creating a single structure can look dramatic, and you can also include lots of surprises to discover within it.

TIP 2

When building an organic structure such as an animal, focus on getting the curved shapes right first, and worry about the other details later.

TIP 3

If you're making a mythical fantasy creature with lots of additional weighted objects, try to balance out the elements and consider whether the creature could actually take the weight.

ANIMALS

Shaders and mods: Sonic Ether's Unbelievable Shaders
Time to build: Two to three hours per animal

THE BUILDER

French 18-year-old student Michael has a gift for organic builds. He loves drawing and music and is fascinated by all kinds of creative endeavors. Over the years, he has worked on his building technique in Minecraft® to arrive at a point where he is able to produce remarkable animals. In each one, he combines realistic shapes with fantasy to produce living creatures that break out of the blocky world.

Michael prefers to build alone, but he sometimes works alongside cinematic producers, YouTubers, terraformers, server admins, and mod and shader developers. They all combine their skills to produce a strong, talented community.

Creating this build was how Michael developed his skills in organic building in Minecraft. The challenge of producing shapes found in nature helped him develop a technique he now uses for all his animal builds.

ANIMALS

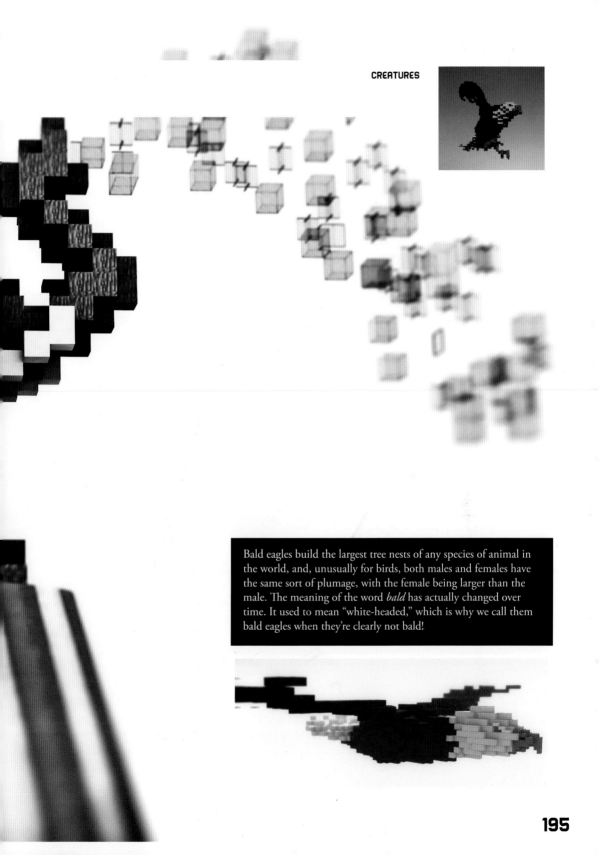

Bald eagles build the largest tree nests of any species of animal in the world, and, unusually for birds, both males and females have the same sort of plumage, with the female being larger than the male. The meaning of the word *bald* has actually changed over time. It used to mean "white-headed," which is why we call them bald eagles when they're clearly not bald!

CHINESE NEW YEAR DRAGON

Shaders and mods: Camera Studio Mod, OptiFine,
Sonic Ether's Unbelievable Shaders
Time to build: 20 hours
Blocks used: 10,000,000

THE BUILDERS

TheReawakens is a creative build team made up of
players from all over the world. Their goal is to create
epic builds and have a great time together. The point of
TheReawakens is not to be the best, but to do what they
enjoy most. The ages of the team members range from
nine to thirty-six.

Unlike many Minecraft® teams, TheReawakens
don't plan to grow into a big, multi-server community.
Instead, they want to keep the team small and personal
and continue to be able to incorporate all their
members' favorite things to do in the game.

The members of the team share a love of building in a
medieval theme; however, they often incorporate other
styles and use several different building techniques.
There is little rhyme or reason to how the team chooses
what to build. More often than not, their builds are the
result of finding a fun image from the Internet and just
going with it.

This dragon was made for Chinese New Year in the
Year of the Sheep/Goat/Ram. In fact, there's a pixelated
goat in the backdrop of the build! It is common for
the team to create builds for special holiday events like
this, and with such international members, there are
many interesting holidays to find inspiration from.

The build began with the spine of the dragon to make
a shape on which to base the whole body. The head was
created separately and then attached, as were the feet.
Then, the backdrop was built around the beast, with
the big pink tree swirling into view.

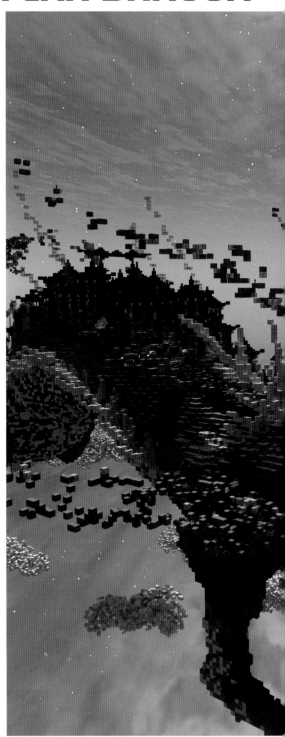

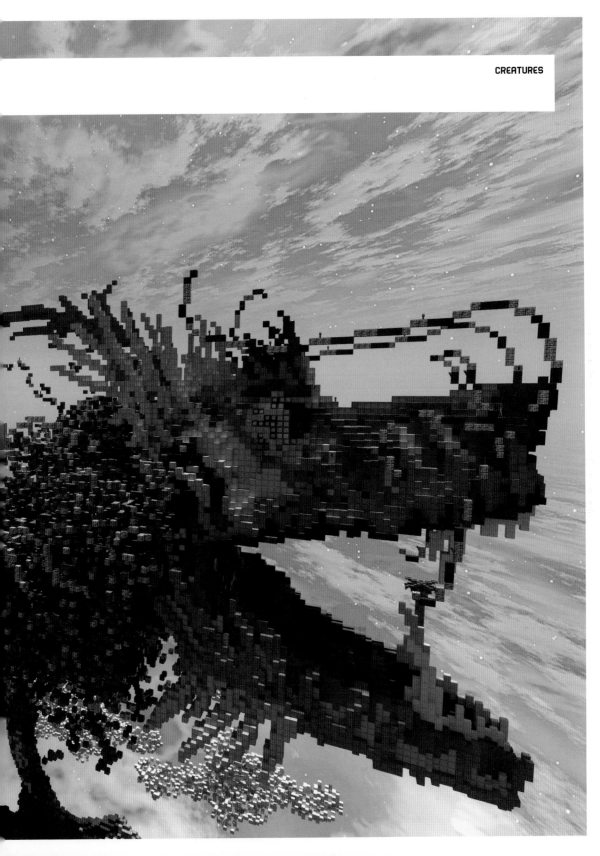

TUTORIAL

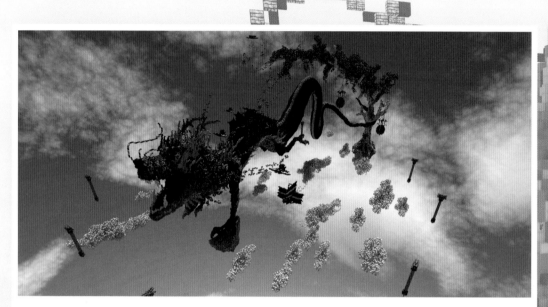

You can create beautiful Eastern-style trees with pink leaves using this tutorial. To create nice structure builds, the surrounding organics are always important. If the build is in a perfect environment, the experience of viewing it will be greatly improved.

1

MARK OUT

Start by marking out the desired dimensions of the tree. Make a column 21 blocks high and mark out the base with a nine-block diameter.

2

TREE BASE

Now add the bottom part of the tree, making small roots in the ground below. Fill in the marked-out area with blocks and make the base of the tree.

3

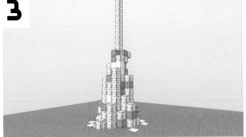

TREE BOTTOM
Add blocks halfway up the tree. Make it thinner and thinner the higher you get. You should now be at a height of 11 blocks. Use different materials for the tree to give it more detail.

4

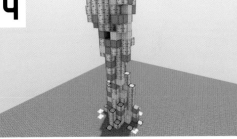

TILT
Add a piece like the one from the tree base to the column. Make it thicker as it comes to the top of 21 blocks. Remember to tilt it to one side a little to make it look realistic.

5

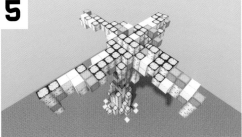

MAIN BRANCHES
Next, add the four main branches to the top of the tree. Add one to each side of the tree and remember to vary them for a more natural look.

6

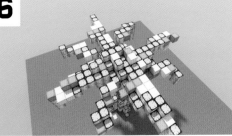

EXTRA BRANCHES
Add branches in between the existing branches. This makes the top fuller and easier to cover with leaves later on.

TUTORIAL

7

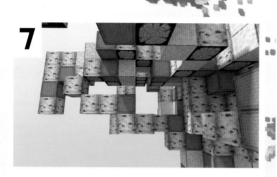

SUPPORT BRANCHES

Add support branches to the main branches. Build them underneath, so that they extend right out from the trunk to the center of the main branches.

8

LEAVES

Start adding leaves to the trunk from the bottom of the tree up to the middle. Use both pink wool and clay.

9

TREETOP LEAVES

Now add leaves to the top. For this particular tree do not cover it all, but do cover both on top and below.

10

LONG LEAVES

Add long pink leaves hanging from the end of each branch. Make those hanging from the main branches the longest, as they are the biggest.

TIPS

11

LANTERNS

Add small Chinese lanterns around the tree, along with torches to light it up when placed.

12

SURROUNDINGS

Now place your tree in its environment. This one is on a floating island.

THEREAWAKENS' TIPS

TIP 1

When working with huge organics like the dragon, it is always important to start by making the outline of the body. When you have finished the body, start adding the extras, such as head and feet—that way you have more control over the size of your creation.

TIP 2

When building big objects, avoid using too much of the same material. The dragon's upper body is red, but try not to use just one type of red material. You could use colored clay and wool to give it much more depth.

TIP 3

Always think about new ways to make your build original. How will it stand out from the other builds in the same category? Dragons are pretty popular things to build in Minecraft®, but adding a city on its back would give it a whole new dimension!

Chinese New Year falls between the end of January and the end of February. The Dragon Dance, often performed in Chinese New Year festivals, is believed to bring good luck. The longer the dragon, the more luck it brings. In Chinese culture, the dragon represents power, fertility, dignity, wisdom, and auspiciousness. It is designed to look both frightening and benevolent, which this build reflects perfectly.

THE KRAKEN

Server: play.reawakens.net
Shaders and mods: Camera Studio Mod, OptiFine,
Sonic Ether's Unbelievable Shaders
Time to build: 20 hours
Blocks used: 10,000,000

THE BUILDERS

The Kraken was also created by TheReawakens. The
team originated in Denmark but quickly became
international, with builders from all over the world
joining their creative server to work together.
TheReawakens server was started in 2011 when the
founding members were at school together. Since
then, 20,000 visitors have dropped by the server to
see their builds.

The team members prefer building medieval creations,
which offer a unique level of detailing on the buildings
of that period. But they don't feel bound to the theme
and often build organic or futuristic structures too.

The Kraken began life as a small side project as part of
a bigger island-city build called Stormfeld. The city is
a snowy, medieval seaside town, featuring cathedrals,
castles, houses, and ships. The sea seemed rather empty
and dull in comparison, and then The Kraken was born!

To begin with, the team started building The Kraken in
a flat world, outside of the water, making the bottom
part of the stomach and adding the arms sticking out
in different directions. Once the arms were complete,
they began working on the head, trying to form a
realistic octopus shape, which was tough to get right.
Next, the overlay on the body was created, covering the
top part with ice for skin. Finally, the whole structure
was moved to the water in front of the city, posing an
imminent threat!

There are only two regrets the team members have: First,
they wish they had made it bigger, more imposing, and a
little more scary, which leads to the second change
they'd make—getting rid of The Kraken's moustache,
which is definitely not scary!

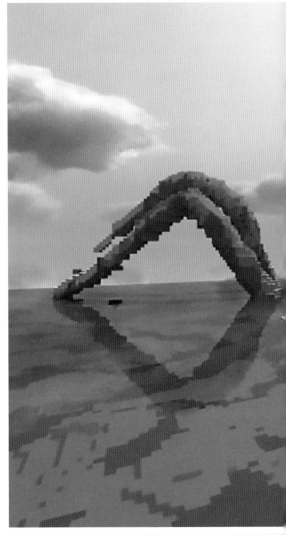

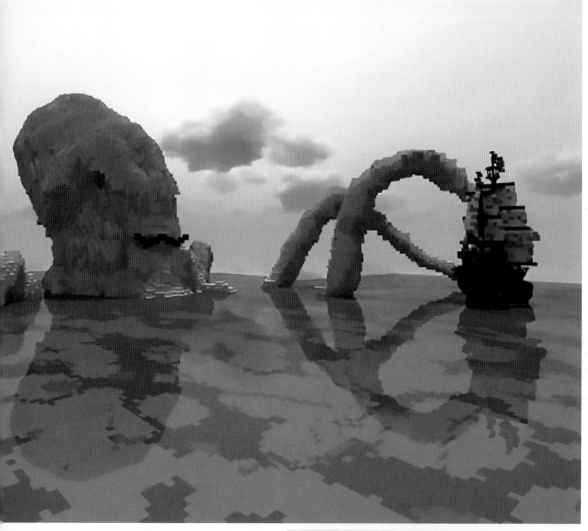

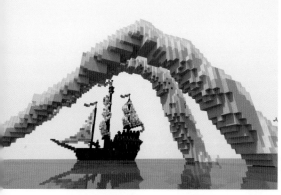

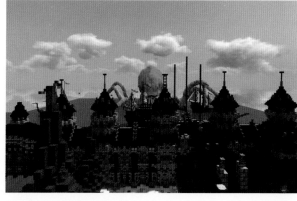

TUTORIAL

To create a shipwreck, first build a basic ship, and then later turn it into the wreck a kraken would have caused. The ship is a small medieval-style vessel, with three decks and a big crack in the center of it. First, you'll see how to make the framework and masts, and then increase the detail while wrecking it, adding features as you go along. This is quite a challenging little build, but the tutorial should help.

1

BASE
Start by creating the simple base of the ship. It should be a total of 23 blocks long and five blocks wide at the middle part of the ship.

2

FRAMEWORK
Now add the framework for the whole ship. Use logs to make the frame stand out.

3

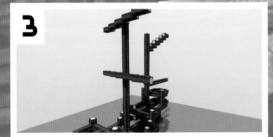

MASTS
Add the masts to the ship. Make one tall in the center, with two horizontal beams, and then one on the deck, with vertical beams behind it.

4

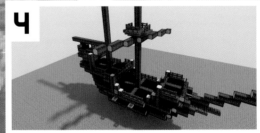

FLOORS AND RAILINGS
Make the floor for each deck with railings along all the sides. Remember to add a platform to the front mast as a lookout post.

5

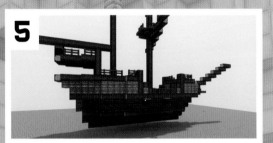

WALLS
Add the walls using dark wood for the bottom floor and light wood for the upper. Remember to add holes for cannons in the lower deck.

6

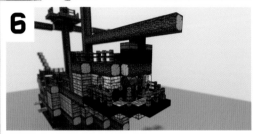

CAPTAIN'S QUARTERS
Add the captain's quarters. As it is a special part of the ship, you could use a mix of glass and gold to also get some color into the build.

7

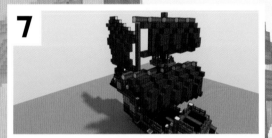

SAILS
Now it's time to create the sails. It is important that they are a bit wavy, as the wind is hitting them. Shape them to the beams.

8

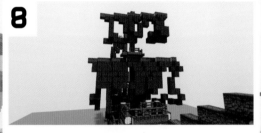

THE "WRECK" LOOK
Next, rip apart the sails you just made to give the ship a realistic wrecked look. Remove random lines in the sails until you're satisfied with it.

9

HOLE
Now you need to add a hole in the ship. Make a crack behind the front sail from the deck to the bottom of the ship. Make it wider at the top.

10

SMASHED PARTS
Move the two ship parts away from each other by six blocks and add floating wood parts for the smashed parts of the ship. Add both in the water and floating on top.

TUTORIAL

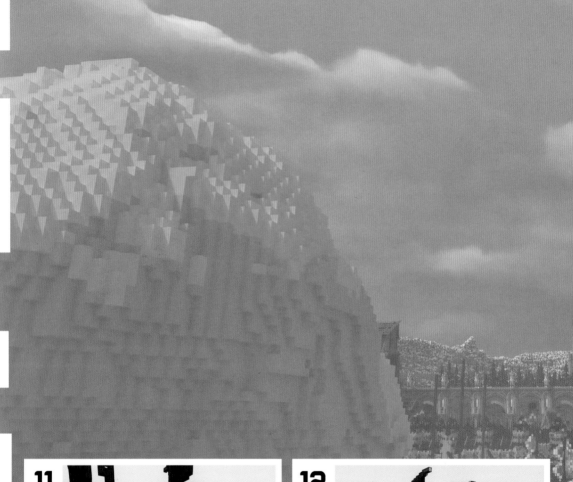

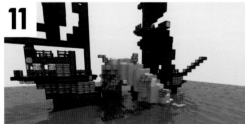

11

KRAKEN ARM
Now add the arm that smashed the ship, placing a kraken arm in between the two ship parts.

12

FIRE
Finally, add some fire to the ship, breaking more parts off the front. Add more debris, strewn around.

TIPS

A kraken is a mythological Scandinavian sea monster. The earliest references to krakens were in the 13th century in Icelandic legends. They were said to be able to swallow whole ships. Even as late as the 18th century, warships destroyed in storms were sometimes reported as having been lost to a kraken.

THEREAWAKENS' TIPS

TIP 1
When creating things meant to sit in water, it is always a good idea to start by building them on dry land. That way, you can see what you're doing more clearly. Then, once you're finished, you can drop them down into the water.

TIP 2
If you are building an organic structure like this, avoid using too many different kinds of materials and making it too colorful. Remember, it is a water creature, which would probably try to camouflage itself. Make it nice and simple, and then maybe add a cool pattern.

TIP 3
Always keep in mind how you might make your build even cooler. To tell a story, TheReawakens added a shipwreck close to their kraken.

PARROT'S KINGDOM

Shaders and mods: OptiFine, WorldPainter
Time to build: One month

THE BUILDER

"Rastammole" tends to make unusual structures led by his imagination. With every build, he likes to try out wildly different things in the game.

Parrot's Kingdom was Rasta's first attempt at working with the WorldPainter tool. Using the interactive map generator, Rasta was able to sculpt the terrain of his island world.

The idea to create the kingdom came from the simple thought of where he would like to take a summer vacation. Looking for somewhere tropical to visit, Rasta decided to try creating his own tropical island and set about making this map with his friend, "Moustafa74."

Starting with a water world, he began by generating and molding the terrain before setting to work on the flora and fauna. Adding vegetation took considerable time, but the really beautiful touch was his animal life. The island is peppered with birds and butterflies, which stand out spectacularly with bright, vibrant colors.

It is difficult for Rasta not to notice all of the little mistakes he feels he made, mostly because this was his first experience with WorldPainter and really an exercise in learning how to use it. He plans to remake the map, adding more birds and including a number of waterfalls.

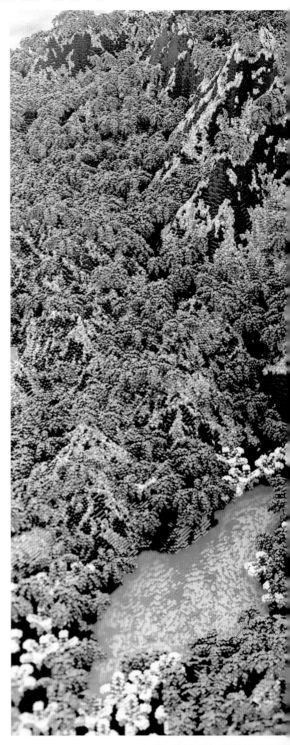

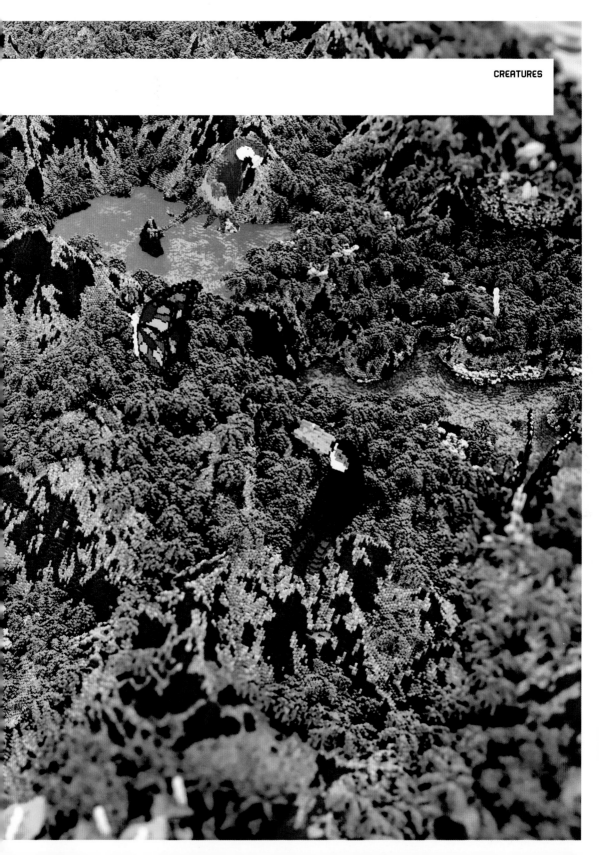

TUTORIAL

1

NEW WORLD
Create a new world in WorldPainter. Start with a flat water map, then put the level of your world five blocks under the sea level. Use stone for the surface material.

2

BRUSH SETTINGS
Select the height tool and go to the brush settings to put a limit on your brush. Remember that your sea level is at 62, so set the brush limit at 65, always three blocks up, and then you can apply your brush and create your world.

3

MOUNTAINS
Remove your brush settings and put the intensity of your brush at 100 percent for the mountains. Apply your brush to the island.

4

COLOR
Add some color to the island. Select "global operations" in the tools, and then select "fill with terrain type." Choose grass and check "37° below," then click "go."

5

BEACH

Next, add some beach to your island. Select "global operations" again and "fill with terrain type." Choose sand, and check "34° below" with the option "at or below 64," then click "go."

6

MOUNTAIN COLOR

Add color to your mountains. Select your material—in this example it is brown clay. Select a constant circle brush. In brush settings, put the intensity at 100 percent and select "above 55°," then you can apply it to your mountains. To create a gradient, use another clay with above 65–70°.

7

TREES AND FLOWERS

Select "add a custom object layer" when you are in the window and "add one or more objects" to select schematics of your trees.

8

TREE BRUSHES

Next apply tree brushes. Put your brush setting at 15 percent, only on grass and below 30°, and then apply your brush to the island.

TUTORIAL

9

GROUND PLANTS

Add some flowers and plants on the ground. Select a custom plants layer and which one you want to use, then apply it.

10

CAVE

Add a custom cave layer. Select it in the custom layer, and then you can create your own cavern with custom settings.

11

SET EXPORT

Set your export by adding a random cavern with a max level at 65 and select "caverns and chasms break the surface."

12

OPEN!

Finally, it's time to export your map and open it in Minecraft®!

TIPS

There are 372 known species of parrot, and they are considered among the most intelligent birds in the world. The species are wide-ranging, particularly in size—there are parrots that are just three inches long, and others that are more than three feet in length. Although we think of parrots as mimics, some have been known to learn more than 1,000 words and can respond to questions.

RASTAMMOLE'S TIPS

TIP 1

The best way to learn how to use any mod or tool in Minecraft is to use it! Don't be frightened to try out new ways to build that are a little outside your comfort zone.

TIP 2

Creating structures block by block is admirable and will teach you a lot, but using tools to speed things up and finish off a long or complicated job more quickly isn't cheating!

TIP 3

Terraforming is great fun, and there are builders who dedicate themselves entirely to honing their skills to create the backdrops for incredible structures. Give it a try!

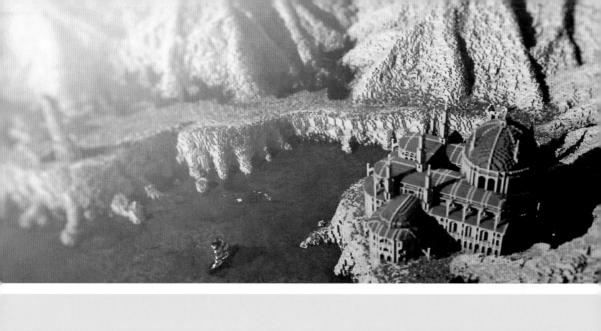
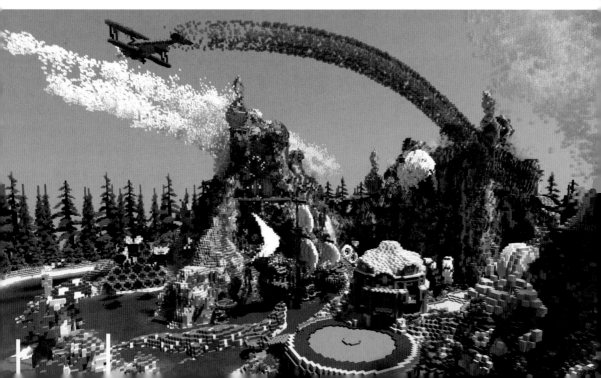

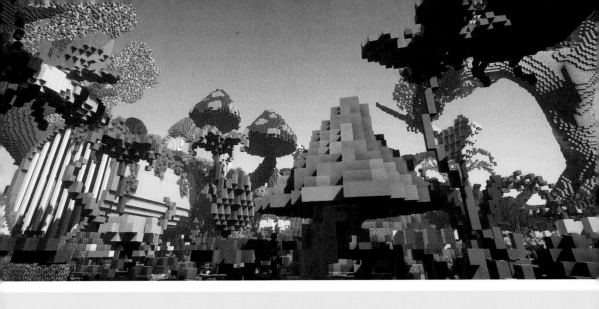

CHAPTER 5

ORIGINAL WONDERS

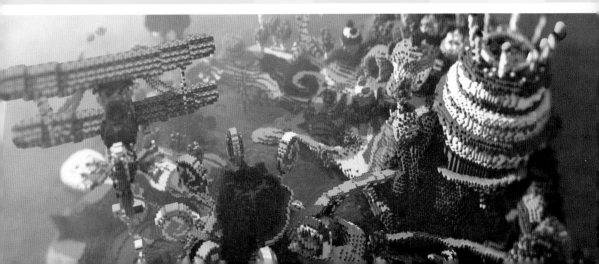

NEVERLAND

Shaders and mods: WorldEdit, VoxelSniper
Time to build: Seven days
Blocks used: 14,000,000

THE BUILDER

James from BlockWorks had a strong interest in art and design from a young age and design of space has been a lifelong fascination for him. He has worked on the aesthetics of builds in Minecraft® for a long time and is now excited to learn more about dealing with the practicalities of physics in design.

James manages a 25-strong team of pro-Minecrafters, and organizes the builds, often on a commission basis. With this type of discipline, the client provides the starting point for the structures they make.

Neverland was commissioned for a Spanish-speaking server network run by two of Minecraft's largest YouTube stars, "Willyrex" and "Vegetta." The brief they were given was for a child's wonderland; full of color, adventure, and all the things a child would wish for. Multiple sources of inspiration were used for this build, including fantasy elements from children's stories like *Peter Pan.* The build functions as a spawn map—an area that players arrive at when they first log into a server. The build also provides portals to the various other maps and games hosted on the same server. The portals were deliberately located apart from each other to encourage exploration and travel.

Beginning with the terrain, the team created a unique landscape, including streaks of color throughout the rocky mountains. Waterfalls and streams trickle down the mountains into the water, which surrounds the map, bordered on the outer edge by a dense forest of enormous trees. Once the terrain was in place, the team mapped out the locations where the players spawn and for the travel portals. Caves were carved out of the mountain, and walkways and arches constructed. Finally, they furnished the map with colorful decorations like rainbows, lollipops, and flowers.

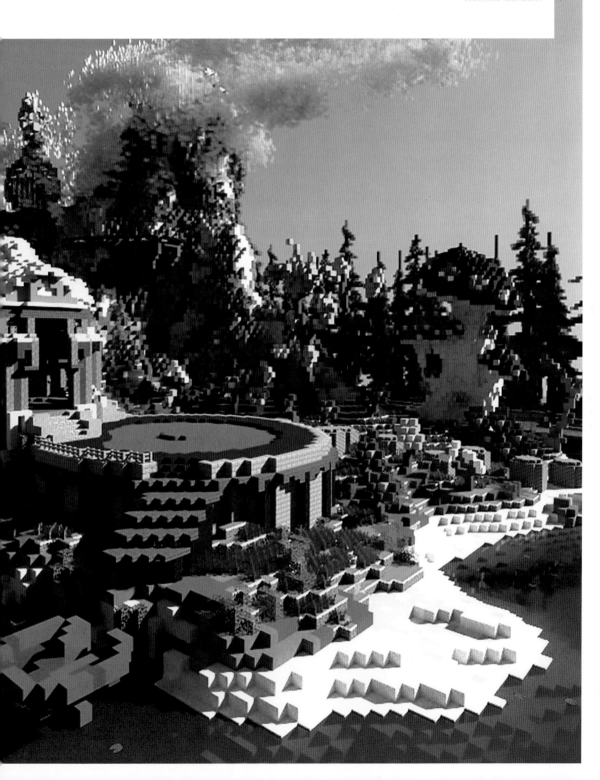

TIPS

The build references a number of fantasyland features, including Neverland from the book *Peter Pan*. The author, J. M. Barrie, explained that "Neverlands" are found in the minds of children, and that each is more or less an island, but never the same for every child. They are compact lands where adventures are never far away.

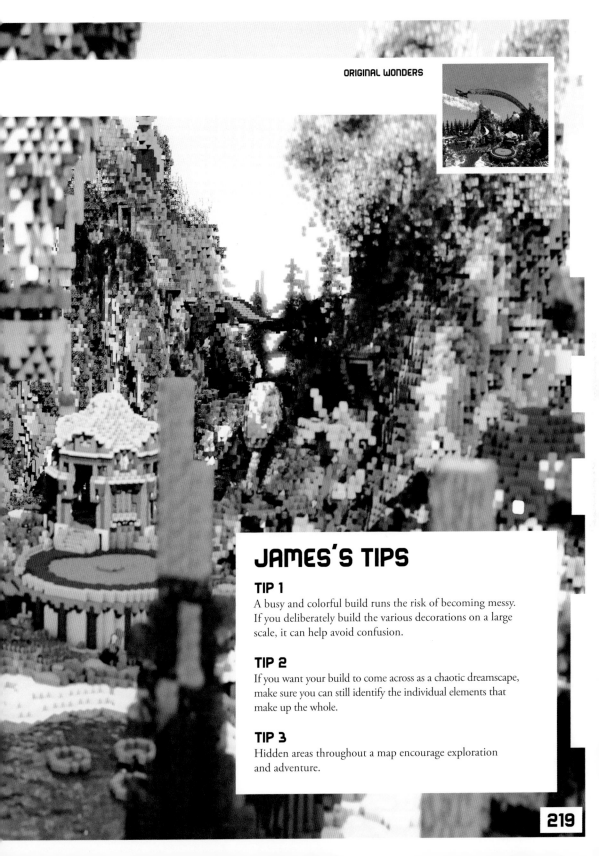

JAMES'S TIPS

TIP 1

A busy and colorful build runs the risk of becoming messy. If you deliberately build the various decorations on a large scale, it can help avoid confusion.

TIP 2

If you want your build to come across as a chaotic dreamscape, make sure you can still identify the individual elements that make up the whole.

TIP 3

Hidden areas throughout a map encourage exploration and adventure.

TANK CATHEDRAL

Shaders and mods: Sildurs Vibrant Shader, Sonic Ether's Unbelievable Shaders, Forge, OptiFine HD
Time to build: Nine hours
Number of blocks: 150,000

THE BUILDER

Pacôme Pretet is a French 18-year-old law student who lives on the tropical Reunion Island near Mauritius. Living in such an environment means Pacôme can get plenty of scuba diving done, but his Internet connection is terrible! Despite his tropical backdrop, he's an old-school geek who loves board games, role-playing, movies, and video games.

While architecture is his true passion, Pacôme likes to keep work separate, which is why he has decided on a career as a lawyer and explores his building ideas in Minecraft®.

The famous French YouTuber "TheFantasio974," who has 1.5 million subscribers, lives on the same tiny island as Pacôme. It was from watching his videos that Pacôme gained an interest in Minecraft and he bought the game. He soon discovered the international community, where everyone knows each other and someone always lends a hand.

While he prefers to build alone, Pacôme is a member of the Deep Academy, an international community of 31 members, who he considers to be his gaming family. While they are widely different people of various ages, backgrounds, and interests, they still love each other dearly, just like any other family.

Not a fan of organic builds or modern minimalist styles, Pacôme sticks to medieval, baroque, and Victorian architecture, preferring to mix them together and not follow strict rules about what goes with what.

Pacôme's friend, and the community manager of the Deep Academy, Skrill, gave him the idea for building the cathedral on a tank. He went forward with the project just to make Skrill smile and definitely not as any commentary on religion or to start a polemic. He just liked the idea and thought it would be fun!

Having never built anything like it before, it was a challenge early on to get the tank right, and he made several mistakes along the way. The mistakes became a part of the build because, as Pacôme says, "There are no mistakes in art." Around 80 percent of the time spent on the build was dedicated entirely to the tank. The cathedral was simple in comparison.

Pleased with the results, Pacôme learnt through this project that he can build what he wants, not just what he already knows. His next project is a neo-Gothic and baroque-style university.

Although we think of tanks as a vehicle of modern warfare, first utilized during the two world wars, they are in fact an ancient concept. Leonardo da Vinci created sketches of tank concepts in the 15th century. At the turn of the twentieth century, H. G. Wells described the armor-clad vehicles quite accurately, albeit as steam-powered. Just 13 years later, tanks were being used in the First World War. The tank in this structure looks much like the M4 Sherman, which was the most common tank used by the Allied forces during the Second World War. They weren't quite as good as the German Panzer, but there were a lot more of them, and they had better guns.

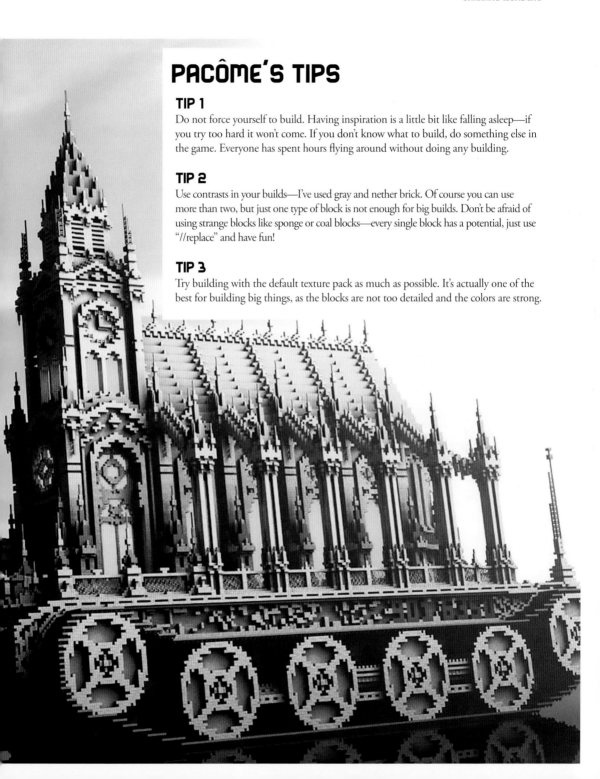

PACÔME'S TIPS

TIP 1

Do not force yourself to build. Having inspiration is a little bit like falling asleep—if you try too hard it won't come. If you don't know what to build, do something else in the game. Everyone has spent hours flying around without doing any building.

TIP 2

Use contrasts in your builds—I've used gray and nether brick. Of course you can use more than two, but just one type of block is not enough for big builds. Don't be afraid of using strange blocks like sponge or coal blocks—every single block has a potential, just use "//replace" and have fun!

TIP 3

Try building with the default texture pack as much as possible. It's actually one of the best for building big things, as the blocks are not too detailed and the colors are strong.

TUTORIAL

Tanks are hard, but the front facade of a cathedral is easier than you'd think. It's a very important part of the build and a good place to start. This way of building is the one most commonly used by mega builders—you can use it to build anything, in any style.

1

BLOCK COLORS
Choose the blocks you want to use. Try placing all the blocks so you can see if the colors work together. It is easy to pick blocks by building. Gray and magenta are used here for contrast.

2

PILLAR
Start by building a pillar, and keep it simple. The pillar will define the size of the build. By doing this, you already know the size of the final result, so it is a very important step.

3

PILLAR DETAILING
Detail your pillar. This one looks Gothic. It has sharp roofs on the top to increase the verticality of the build. Having a contrast between roofs and the rest of the build looks good.

4

PASTE
Paste the pillar using WorldEdit (//copy, //flip, //paste). Try to have some space between the two pillars. There is no secret to how it looks, just decide what you think looks good. Always keep a block right in the middle of it, so you can flip it more easily.

5

ARCH
Connect the two pillars using a simple arch with a little bit of nether brick for contrast and fill the pattern. Do not use something too flashy—it is just for the background of the wall.

6

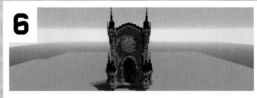

MAIN DETAILING
Add the main details; use another block, with stairs if possible. Add a rose window and a gate, keeping it simple. A big build needs less detail than a little one!

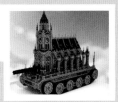

7

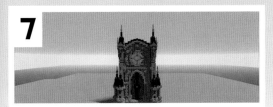

FINISH PATTERN
Add small details to finish the pattern. Take care not to overload the wall with pointless detailing. If you don't know how to detail something, it is sometimes better not to. If you want to put depth in your pattern (this one is quite flat) remember that often more depth equals less detail.

8

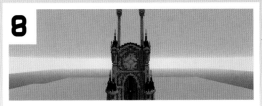

ANOTHER PILLAR
Build another pillar and paste it for the second part of the pattern. Align it perfectly with the other two—a mistake now can cause problems later!

9

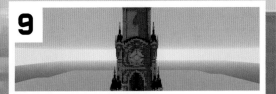

MARK THE CONNECTION
Pacôme did not build an arch, but used a simple detail with cobblestone to mark the connection between the pillars.

10

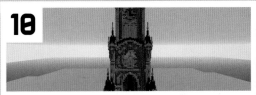

MORE DETAILING
Detail with a clock, a window, another rose window, a balcony—keep it simple but creative! Use the same colors. Just build the shape on the stone, and then replace the blocks behind.

11

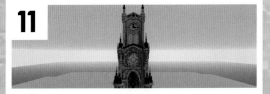

ROOF
Start the roof. This is a simple neoclassical roof, and for the Gothic aspect, you can just build spikes on the top of the two pillars to increase the verticality again.

12

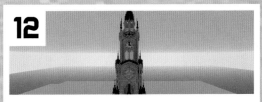

BELL TOWER
Finish the roof by building a bell tower. This one is not very Gothic, but it looks pretty nice. Try to do something thin, and look for inspiration from the Internet, in your city, in books and generally everywhere around you!

CANDYLAND

THE BUILDERS

BlockWorks are often required to create builds of wildly different styles to a standard and speed seldom seen in the Minecrafting world.

Their manager, James, feels that the greatest gift Minecraft® offers is inspiration. It gives everyone creative freedom by offering them a tool with a starting point but no end. The game has managed to develop a huge following, which has fostered a dedicated community whose central tenet is putting high value on user-created content. It is within this culture that professional build teams such as BlockWorks have been able to form and thrive.

With an incredibly varied portfolio that includes classical architecture, medieval builds, and futuristic cityscapes, Candyland stands out as a fun, frivolous, and frankly rather tasty world!

The challenge with this structure was to create what appears to be an island—with buildings, parks, paths, and an airplane—but make every single object also resemble an edible treat. It is a land formed of buildings made of cakes, made of bricks, made of pixels! The key was making all of those things apparent at the same time, without forgetting to give it a sense of atmosphere and cohesion.

The colors also presented a challenge. The team worked with a limited palette but still kept the build bright. It was a difficult balancing act, but they pulled it off perfectly.

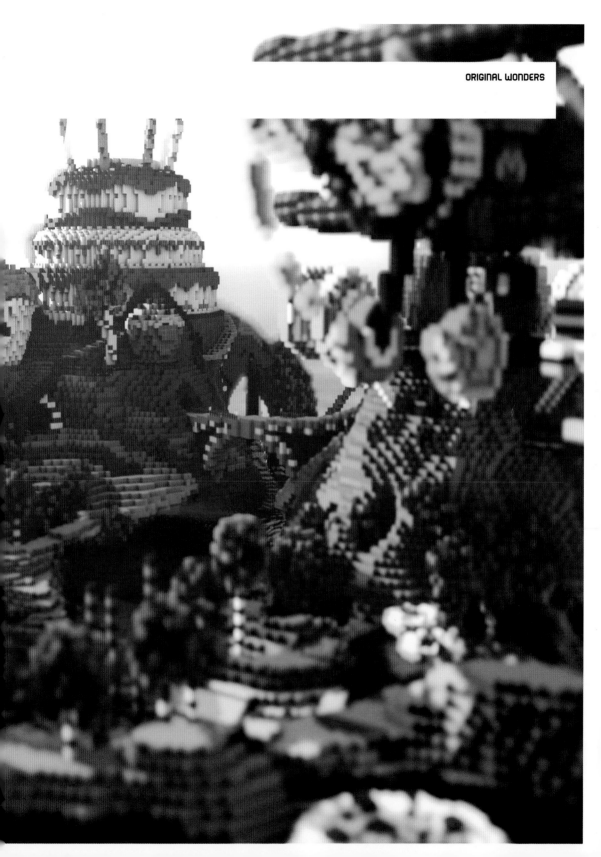

TIPS

BLOCKWORKS' TIPS

TIP 1
Always decide on a color palette at the start, even if you plan to make your build very bright. Don't just use a bit of everything, or it may not look as colorful as you had hoped.

TIP 2
When creating objects at an inflated scale, consider their proportions in relation to one another so that your build still makes sense to the eye.

TIP 3
With a very busy structure, try to have one element that becomes the focus of the whole piece. In this case it is the airplane.

The most famous candy house appears in the Brothers Grimm fairy tale *Hansel and Gretel*. In the story, the children, who are abandoned in the woods, find a cottage made of gingerbread and cakes, with windowpanes made of clear sugar. The original tale may date back as far as the 14th century, appearing during the medieval period of the Great Famine. The tale of the house made of confectionary appears around the same time, in a manuscript about the mythical Land of Cockayne, which is a land of plenty where everything is luxurious and all you could ever want is close at hand.

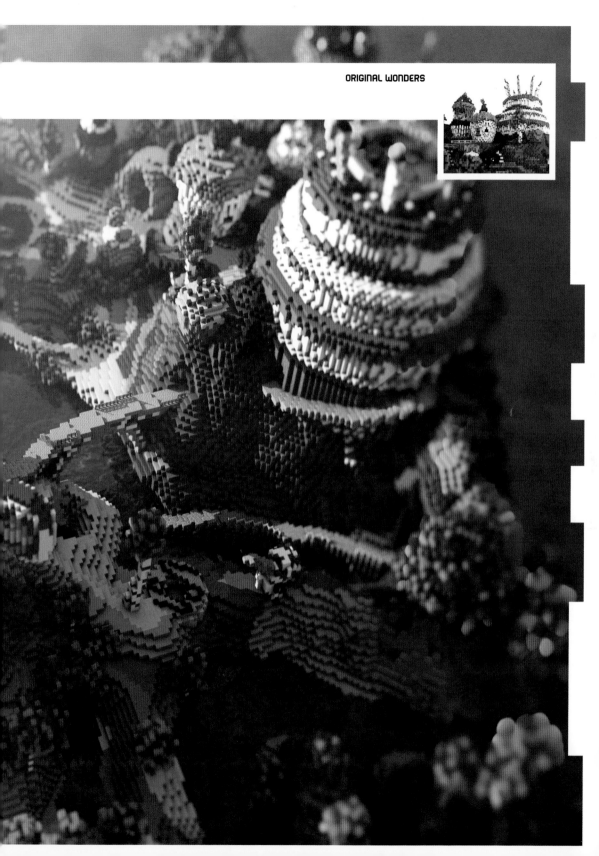

LITTLE GARDEN

Shaders and mods: Sonic Ether's Unbelievable Shaders

THE BUILDERS

Michael is an 18-year-old student from France who loves rap music and writing his own lyrics, drawing, and building in Minecraft®. Like many Minecrafters, Michael was first attracted to the game after viewing building tutorials on YouTube. The French YouTuber "Aypierre," whose "Let's Play" videos brought his attention to the survival aspect of Minecraft, heightened Michael's interest. As his interest developed, Michael turned to the creative side of the game, joining his server's staff and eventually coming to work in his current community, the group LordBlock.

Little Garden grew out of Michael's original idea to create a plant-and-insect map. This was an opportunity to practise organic building and creating natural shapes, which offer many challenges in a game where everything is created using just blocks. The final result retains the low viewpoint of small creatures to produce a very striking, and unusual, build.

Michael had to learn to work slowly when creating Little Garden, feeling that when new to the game, he had a tendency to work too fast and forget key elements. While happy with it when it was first completed, Michael now sees areas he'd like to improve on. Minecraft is all about practice and skill building over time, in order to master every part of the process. Michael plans to continue to test and hone his building skills.

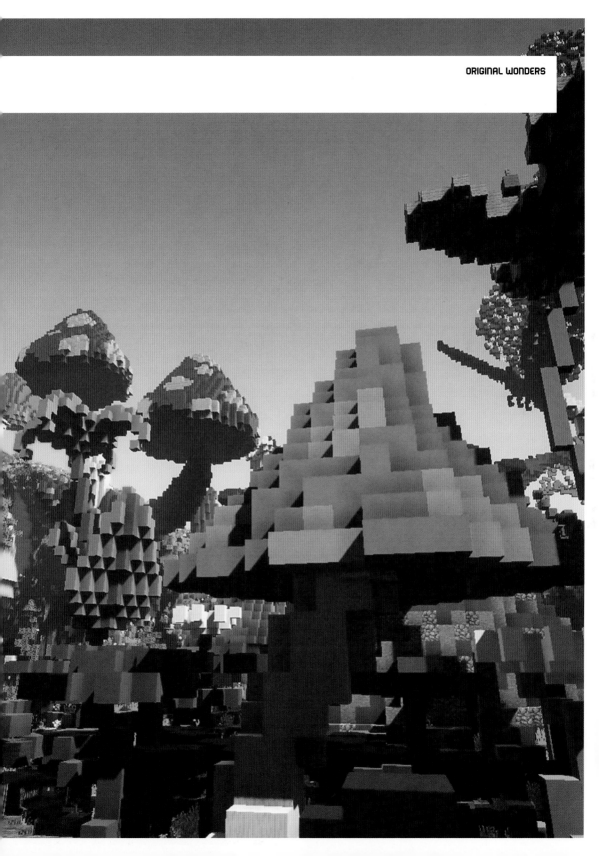

TUTORIAL

This is a simple tutorial to create one of the most colorful elements in the Little Garden. Mushrooms and toadstools are something we often think of when imagining a fairy garden or fantasy forest setting, where elves and pixies might live. They offer an ideal way to introduce almost unnaturally bright colors to punctuate the greenery around them, and a rather weird and wonderful shape. Along with flowers and insects, they can help establish a scale so that you can bring the player down to see a pixie's-eye view!

1

BASE
Define the radius of the base.

2

STEM
Begin working on the shape of the stem.

3

FILL
Fill out to complete the shape.

4

STRETCH
Stretch out the stem.

5

TOP
Define the radius of the higher part.

6

RIB
Make the rib of the higher part.

7

FILL
Fill to complete the shape.

8

OUTLINE
Add an outline to the higher part.

9

COLORIZE OUTLINE
Colorize the outline with a different color on the higher part.

10

MARKS
Add some marks.

TUTORIAL

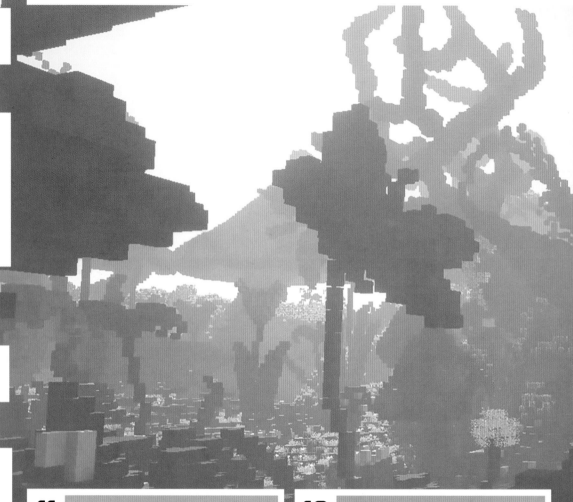

11

SMOOTH AND SHAPE
Finish smoothing out the shape and randomize the mushroom with some unique shaping.

12

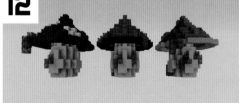

COLORS
Add highlights and definition by using different colors on the outline.

Little Garden features some plant life straight out of a fantasy kingdom. The organic mushrooms are similar to real-life fly agaric toadstools. They can have a rather unpleasant hallucinogenic effect if consumed, including micropsia and macropsia, where a person's perception would be altered to see things as abnormally small or large, like Alice's experience in Wonderland, or this Little Garden's low viewpoint. Unlike the lovely fairy fantasy of pretty toadstools, fly agaric is poisonous and not something anyone should ever eat. Building them in Minecraft®, though, is completely fine.

MICHAEL'S TIPS

TIP 1

One important thing to remember when choosing colors for organic builds is to try to use different shades of the same color for a natural gradation and stick to colors found in nature, where possible.

TIP 2

When creating an organic shape, begin with a frame or skeleton to get the proportions to match different objects.

TIP 3

You can use editing tools like VoxelSniper to help create large-scale organic shapes. Generate some blocks with WorldEdit first. Then use the voxel command "/b e lift" to make the general shape, then smooth it with the command "/b eb melt" (betterbrush plugin) or "/b bb".

REYNARD CLIFFS

Shaders and mods: Mr Meeps shaders, Sonic Ether's Unbelievable Shaders, Mineshot, DaFlight, VoxelSniper, WorldEdit
Time to build: Three Months

THE BUILDER

Mike Anderson is known as "FreshMilkyMilk" in the Minecraft® community. He's an 18-year-old student studying engineering and graphic design in Colorado. Despite Minecraft being viewed by many as a game for kids, Mike likes to make very professional, high-quality renders and uses the game to hone his skills in graphics, with programs such as CINEMA 4D.

Having spent his early Minecrafting days playing the Xbox 360 version, Mike started to become frustrated with the console's limitations and gravitated to the PC version, giving him access to a wide variety of mods. He plays with friends on the Ardcraft server, building mostly Middle Earth–inspired locations.

Mike built Reynard Cliffs mainly by himself, but with some help from friends "oriour," "Glovenator," "Thatruben," and "dags," each using their own unique style. As a huge *Lord of the Rings* fan, Mike enjoys creating medieval-style buildings. Mike envisages Reynard Cliffs as a seaside retreat for nobles, protected by the cliffs that surround the bay.

Mike began the build by creating a wool outline of the terrain and made the cliffs using VoxelSniper, a map-editing tool that allows for terraforming on a grand scale. He used stone, grass, and dark stone materials, and then added the water and mountains—which was an arduous job—using the terraforming Voxel tool. One mistake that may have added a little more drama to the build was making the mountains too close to the cliff edge, so the main road is a little dangerous to traverse.

Finally, the main palace, built by friends "oriour" and "Thatruben," was pasted into the build. Mike's renders help to bring the drama and the beauty of the setting to life.

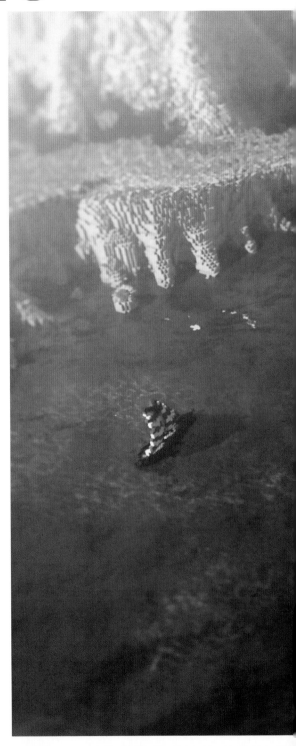

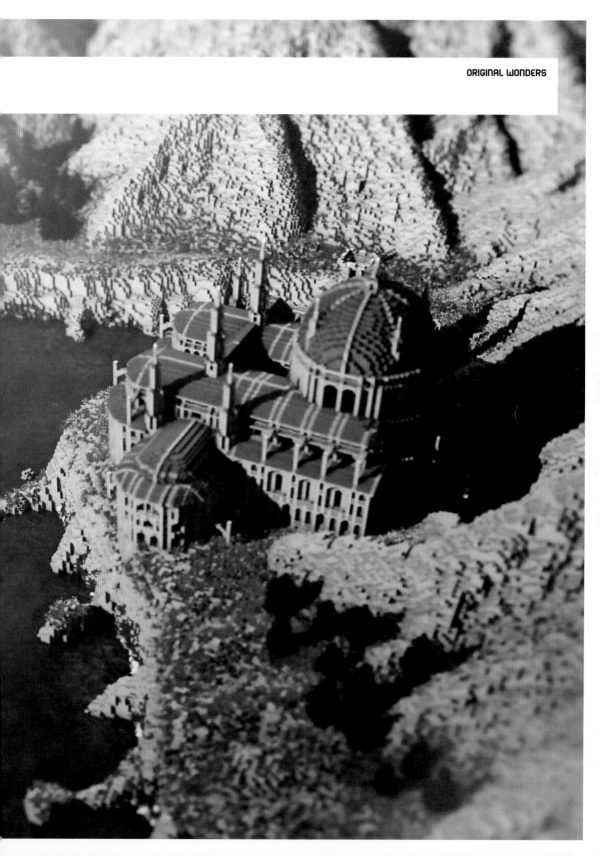

TUTORIAL

In this tutorial you will learn how a render is made. This is a three-dimensional image with more detail, better lighting, greater draw distance, and more dramatic effects than you would get by taking a simple screenshot of your build in-game. This render is of the map of Reynard Cliffs and covers the basics of how to produce a rendered image. These images can be made in programs such as Maya, CINEMA 4D, and Blender. The programs can cost up to $1,000 and need patience and time to learn how to use. Producing these types of images is not a skill that everyone can master. It takes a good eye to create perfect lighting, and you need to visualize an area and be able to translate that into another 3-D program. The results are well worth the effort, though, and are a great way to enhance and show off your build.

1

EXPORT
The first step is to get the world file into Mineways—a free, open-source program for exporting Minecraft models for rendering (http://mineways.com). Export to an .obj file. Texture files are also used in this process, and this is what the rendering program uses to make a 3-D object with textures and color.

2

IMPORT
Once Mineways is done exporting, the files are imported into CINEMA 4D. (http://www.maxon.net)

3

TEXTURES AND COLOR
The object is given textures and colors, and objects such as torches will be given a light glow with emitting light.

4

FLOOR
Add a floor or environment to the scene so that the surrounding area acts as a photoset.

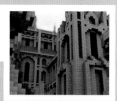

CAMERA ANGLE

Next, find a good camera angle. This involves moving around the scene and finding the perfect spot to show off the build.

LIGHTING

Once a good angle is found and a camera is added, begin the lighting. The first thing to do is to find which environment the build needs to be in—this could be dark and cloudy, or bright with sunlight.

SKY

Add a sky according to the lighting preference and adjust it for the best look.

LIGHT SOURCE

Add a light source, such as sunlight. Edit it to your needs, such as volumetric or ray-traced light, which work well for high-angle shots. Move the light around to give the scene the maximum possible effect.

TUTORIAL

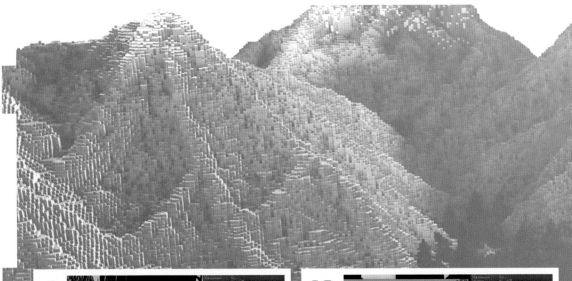

9

CAMERA EDIT
Edit the camera to show depth of field and other various lighting options.

10

RENDER
After some tests, render the final image. This can take a while, depending on the image size and the scene's complexity.

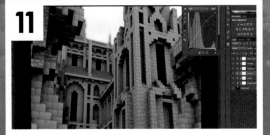

11

FINAL EDITS
Use Photoshop for your final edits, such as color correction.

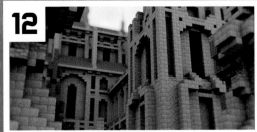

12

EXPORT AND UPLOAD
The image is then exported and can be uploaded to image sites, such as Imgur or Minus, and posted on social media to show off to the world!

TIPS

While fantasy castles sat on the edge of cliffs aren't exactly common, there is one that evokes the feel of Reynard Cliffs perfectly—the Swallow's Nest is a neo-Gothic chateaux built in 1911 for the German oil millionaire Baron von Steingel. The castle teeters high on the Aurora Cliff, overlooking the Crimean Black Sea.

MIKE'S TIPS

TIP 1

Visualize the project before making it. The hardest thing to do is to try to make something that you don't have a vision for. Pinning out the shape of what you have in your head with wool blocks works well. It is the easiest way to get a project going. Remember also to keep an idea in mind of how it will work out.

TIP 2

Work with people you know and like. Mike knew his helpers and their capabilities for over a year. For instance, some people can do terrain well, while others can work on large buildings. Everyone Mike worked with produced something special and contributed in their own way.

TIP 3

Have a style that you enjoy and can have fun with. Mike likes fantasy realms, so making things breathtaking and epic is what he aims for. Sometimes things can get tedious, but you just need to push on to produce something really impressive.

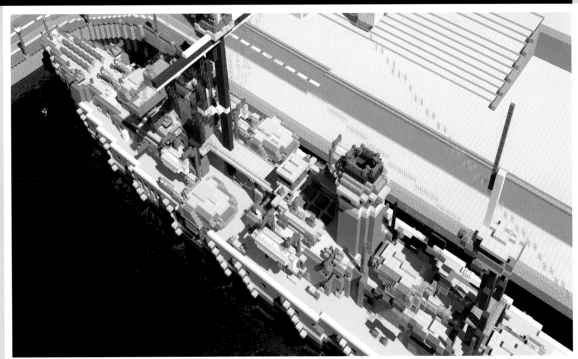

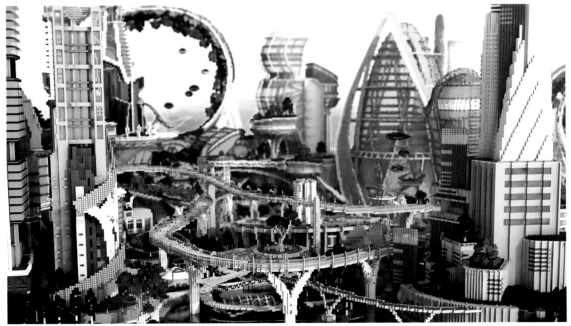

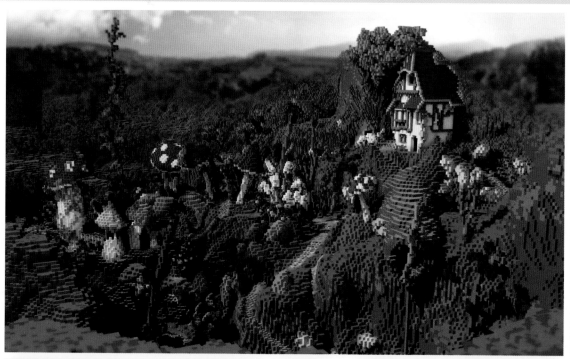

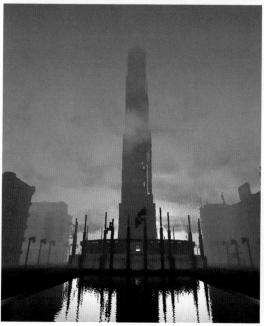

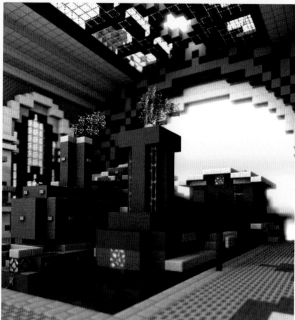

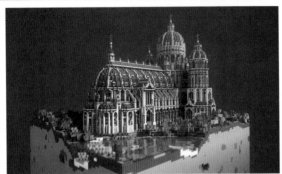

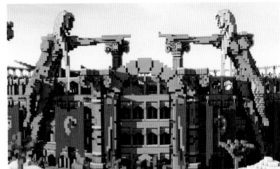

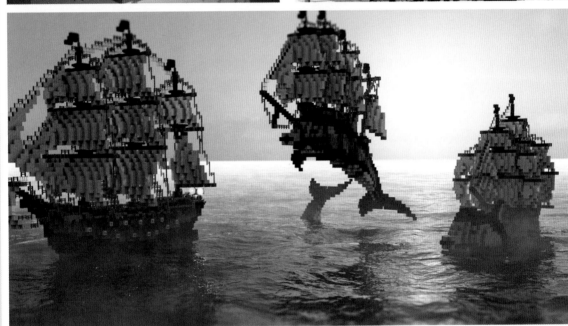

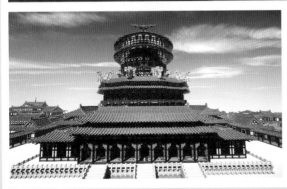

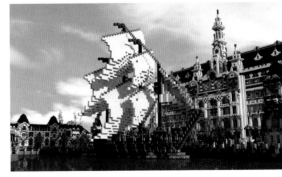

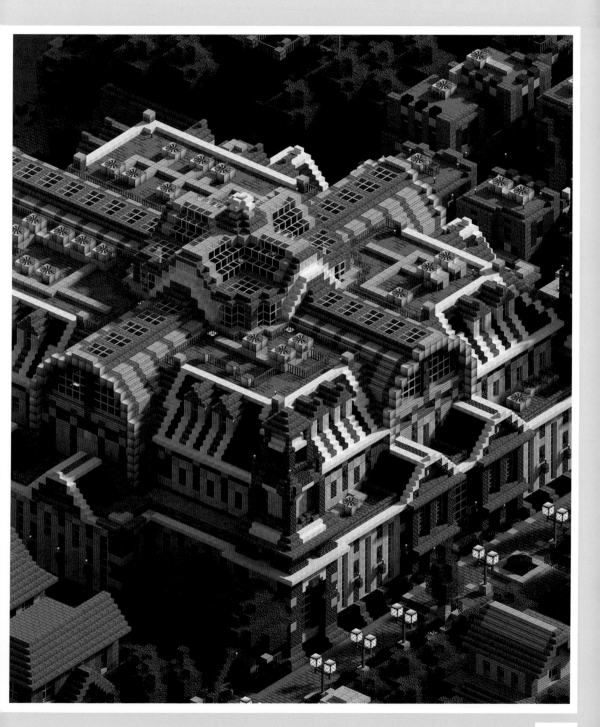

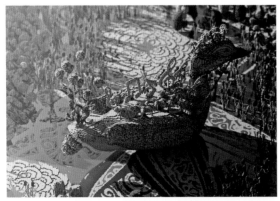

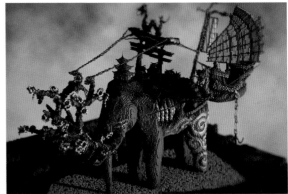

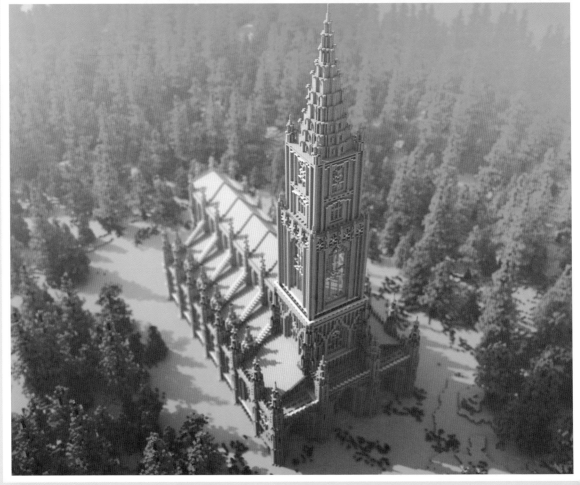

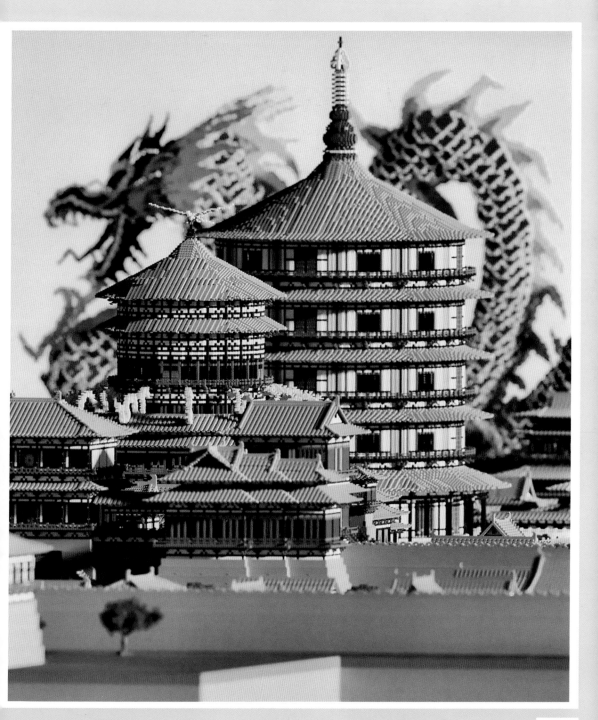

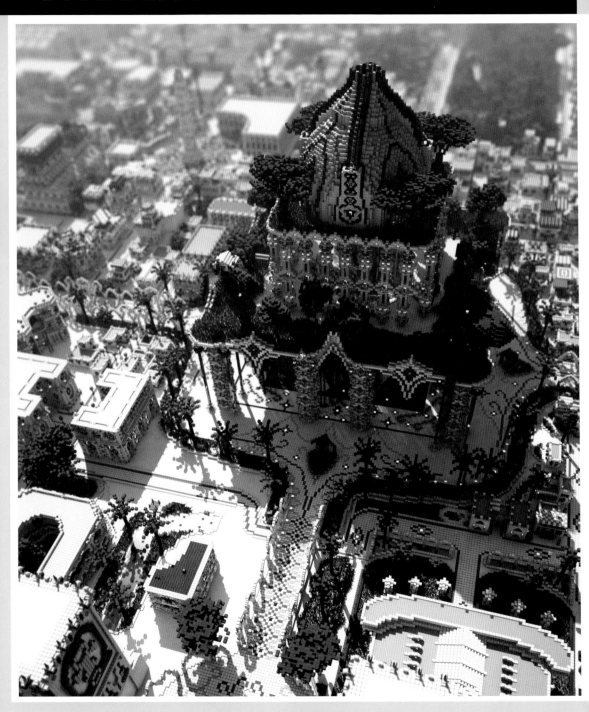

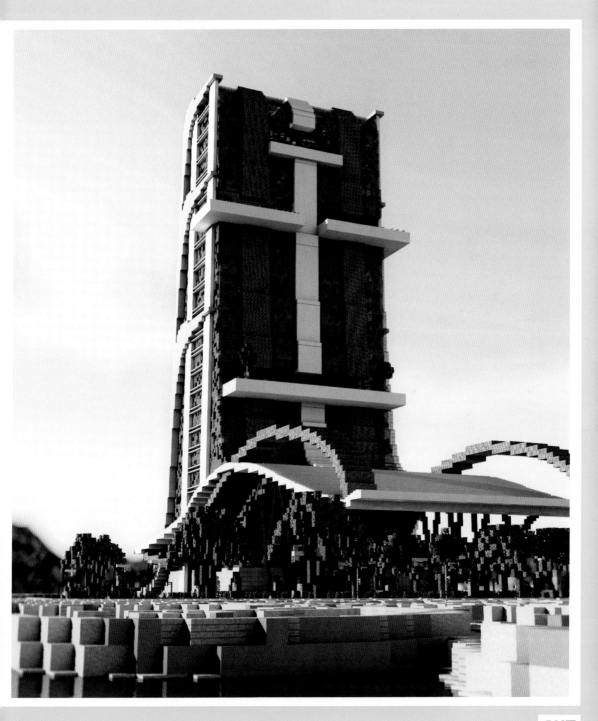

CONTRIBUTOR DIRECTORY

Coliseum
Team: BlockWorks
Web: http://blockworksmc.com
YouTube: https://www.youtube.com/user/BlockWorksYT

Mayan Temple
Team: Patrix
Twitch: http://www.twitch.tv/patrixcraft/profile

Cathedral
Team: Patrix
Twitch: http://www.twitch.tv/patrixcraft/profile

Bern Minster
Team: Julian (Oakley09)
Twitter: oakley09

Luoyang
Team: EpicWork China
YouTube: https://www.youtube.com/user/EpicWork4Minecraft

La Momie
Team: Rastammole
Twitter: @Rastammole

Belweder Palace
Team: Jan (Gigeno)

St. Peter's Basilica
Team: Brauhaus der Hoffnung
Web: http://www.worldofmine-craft.de
YouTube: https://www.youtube.com/user/BrauhausTV

The Giza Plateau
Team: Niclas (Goopen)
Web: https://mineville.nu
Twitter: https://twitter.com/kankroon

Hungarian Parliament
Team: Brauhaus der Hoffnung
Web: http://www.worldofmine-craft.de
YouTube: https://www.youtube.com/user/BrauhausTV

Taj Mahal
Team: Ellowat
YouTube: https://www.youtube.com/user/Ellowat

Federal Palace
Team: Julian (Oakley09)
Twitter: oakley09

Opera House
Team: World of Keralis
Web: http://www.keralis.net
YouTube: https://www.youtube.com/user/Keralis

Museum of Natural History
Team: Broville
Tumblr: http://oldshoes.tumblr.com
YouTube: https://www.youtube.com/user/olshooz

Beijing National Stadium
Team: Robbert (Vaterloader)
Web: mc.vaternetwork.eu
YouTube: https://www.youtube.com/user/ThatAwesomeUsername

Oasis Casino
Team: Owls
Web: @OwlsMC
YouTube: https://www.youtube.
com/channel/UCCgxJ3Vq_fTNx-
1q0NnPYVGw

BN Tower
Team: Broville
Tumblr: http://oldshoes.tum-
blr.com
YouTube:https://www.youtube.
com/user/olshooz

Bertley Train Station
Team: World of Keralis
Web: http://www.keralis.net
YouTube: https://www.youtube.
com/user/Keralis

Space Shuttle
Team: Corpeh
Twitter: @Corpeh
YouTube: https://www.youtube.
com/user/Corpeh

Dreadnought Battleship
Team: World of Keralis
Web: http://www.keralis.net
YouTube: https://www.youtube.
com/user/Keralis

Airport
Team: World of Keralis
Web: http://www.keralis.net
YouTube: https://www.youtube.
com/user/Keralis

Railway Station
Team: Brauhaus der Hoffnung
Web: http://www.worldofmine-
craft.de
YouTube: https://www.youtube.
com/user/BrauhausTV

Didapper Dolphin Convoy
Team: Jimjabway
Twitter: @Jimjabway

What the Duck?
Team: Rastammole
Twitter: @Rastammole

Tamashi Kyaria
Team: BlockWorks
Web: http://blockworksmc.com
YouTube: https://www.youtube.
com/user/BlockWorksYT

Animals
Team: Sak_Kraft
Twitter: @Sak_kraft
YouTube: https://www.youtube.
com/channel/UCUM3FNH91nO_
FwLFql7M8QQ

Chinese New Year Dragon
Team: TheReawakens
Web: http://www.reawakens.net
YouTube: https://www.youtube.
com/user/TheReawakens

The Kraken
Team: TheReawakens
Web: http://www.reawakens.net
YouTube: https://www.youtube.
com/user/TheReawakens

Parrot's Kingdom
Team: Rastammole
Twitter: @Rastammole

Neverland
Team: BlockWorks
Web: http://blockworksmc.com
YouTube: https://www.youtube.
com/user/BlockWorksYT

Tank Cathedral
Team: Whisper974
YouTube: https://www.youtube.
com/user/DeepAcademyMC
Twitter: @Whisper974

Candyland
Team: BlockWorks
Web: http://blockworksmc.com
YouTube: https://www.youtube.
com/user/BlockWorksYT

Little Garden
Team: Sak_Kraft
Twitter: @Sak_kraft
YouTube: https://www.youtube.
com/channel/UCUM3FNH91nO_
FwLFql7M8QQ

Reynard Cliffs
Team: FreshMilkyMilk
Web: http://freshy.me/#fresh-
milkymilk
YouTube: https://www.youtube.
com/user/Freshmilkymilk/

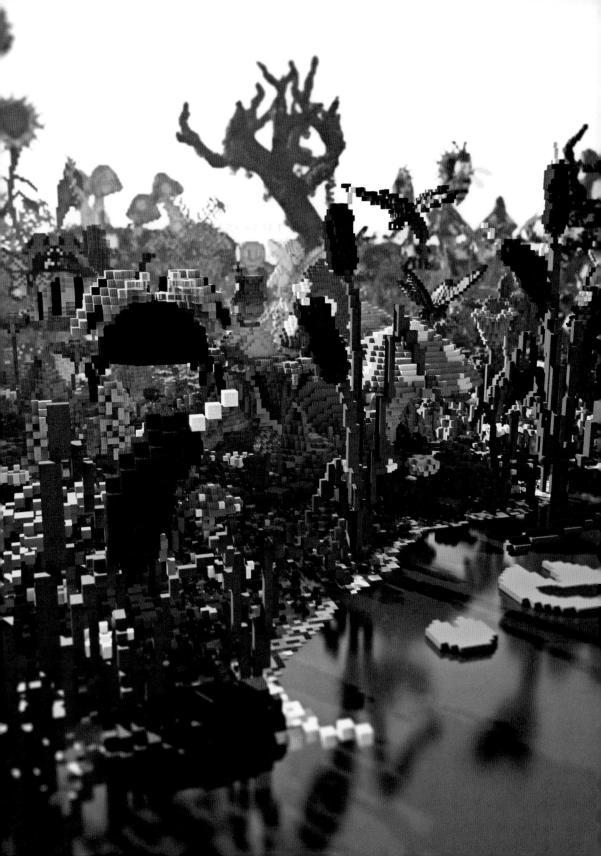

PICTURE CREDITS

INDEX

ABOUT THE AUTHOR

KIRSTEN KEARNEY HAS BEEN A GAMES JOURNALIST FOR A DECADE. SHE BEGAN HER CAREER AS A RESEARCHER AND PRODUCER IN BROADCASTING AT THE BBC. SHE HAS WRITTEN REVIEWS, COLUMNS AND FEATURES FOR MANY GAMES MAGAZINES AND WEBSITES IN THE UK AND IS THE EDITOR IN CHIEF OF THE HIGHLY SUCCESSFUL GAMES MEDIA WEBSITE: WWW.READY-UP.NET. HAVING WRITTEN A VARIETY OF IN-DEPTH PIECES ON VARIOUS GAME GENRES AND SPECIFIC SERIES AND FRANCHISES OVER THE PAST 10 YEARS, KIRSTEN HAS A PARTICULAR INTEREST IN MINECRAFT® AND USER-CREATED CONTENT. SHE IS THE AUTHOR OF *BLOCK CITY: HOW TO BUILD INCREDIBLE WORLDS IN MINECRAFT.*

ACKNOWLEDGMENTS

This book is dedicated to Max Danger Kearney, a truly great guy.

Love and thanks for all your support to my family; Charlie, Jean, Tina, Rob, Auntie Maureen, Uncle David, Lorraine, David, Louise, Billy, Nathan, Kevan, Seonaid, Niall and Dan.

Thanks to some special friends who helped make life better this year; Clair Cowan, Sarah Luty, Susan Urquhart, Katia Rinaldi, Linda Renwick, Kirsty Miller, Catherine Happer, Kate Billingham, Eleanor Saunders, Walter Fraser, Mike Slevin, Kristan Reed, Susan Marmito, Jo Turner, Lauren Holowaty, Ryu, Zelda, Link, Angelina Jolie and gin.